creative landscape painting

creative landscape painting

BY EDWARD BETTS, N.A., A.W.S.

WATSON-GUPTILL PUBLICATIONS/NEW YORK
PITMAN PUBLISHING/LONDON

To Peter, John and Wendy

Copyright © 1978 by Watson-Guptill Publications

First published 1978 in the United States and Canada
by Watson-Guptill Publications,
a division of Billboard Publications, Inc.,
1515 Broadway, New York, N.Y. 10036

Library of Congress Cataloging in Publication Data
Betts, Edward H 1920-
 Creative landscape painting
 Bibliography: p.
 Includes index.
 1. Landscape painting—Technique. I. Title.
ND1340.B42 1978 751.4′5 77-16772
ISBN 0-8230-1080-5

Published in Great Britain by Pitman Publishing Ltd.,
39 Parker Street, London WC2B 5PB
ISBN 0-273-01208-8

Manufactured in U.S.A.

First Printing, 1978

My thanks to

Donald Holden, Editorial Director of Watson-Guptill Publications, who conceived this book;

my fellow artists, whose superb paintings helped make my text more meaningful than it would otherwise have been;

the art galleries, museums, corporate collections, and private collectors whose helpfulness and cooperation were indispensable to the task of locating and reproducing many of the paintings that serve as illustrations;

the readers of *Master Class in Watercolor*, whose extremely enthusiastic response gave me the encouragement needed to continue with the present book;

Marsha Melnick, Senior Editor and guide, whose watchful eye and constant reassurances were there when I needed them most;

my wife and family, for never relinquishing the hope that I would eventually put away the typewriter and get back to the studio.

CONTENTS

INTRODUCTION 8
1. DESIGNED REALISM 12
2. LOW HORIZON 14
3. HIGH HORIZON 16
4. AERIAL VIEW 18
5. UPWARD VIEW 20
6. DETAILED FOREGROUND 22
7. FRAMING WITH FOREGROUND ELEMENTS 24
8. LONG HORIZONTAL COMPOSITION 26
9. NARROW VERTICAL COMPOSITION 28
10. IN THE MIDDLE OF A SUBJECT 30
11. EXTREME CLOSE-UP—REALISTIC 32
12. EXTREME CLOSE-UP—ABSTRACT 34
13. OVAL OR CIRCULAR FORMAT 36
14. REFLECTIONS IN A WINDOW 38
15. BACKLIGHTING 40
16. SHADOWS FOR DESIGN INTEREST 42
17. UNUSUAL CROPPING 44
18. CORRECTIVE CROPPING 46
19. WHITE AS A MAJOR AREA 48
20. DISTORTION OF SCALE 50
21. SKY AS LANDSCAPE 52
22. ATMOSPHERIC TREATMENT 54
23. PAINTING FROM MEMORY 56
24. IMAGINATION AND FANTASY 58
25. CLOSE-UP FRONTAL VIEW—REALISTIC 60
26. DISTANT FRONTAL VIEW—ABSTRACT 62
27. SIMPLIFICATION—REALISTIC 64
28. SIMPLIFICATION—ABSTRACT 66
29. STYLIZATION—DECORATIVE 68
30. STYLIZATION—REALISTIC 70
31. MULTIPLE VIEW OF A SINGLE SUBJECT 72
32. USE OF LARGE EMPTY SPACE 74
33. LANDSCAPE AS STRATA 76
34. ALLOVER TREATMENT IN SMALL UNITS 78
35. DISTORTION FOR DESIGN 80
36. DISTORTION FOR EXPRESSION 82
37. SEMIABSTRACTION 84
38. INTENTIONAL AMBIGUITY 86

39. TEXTURE IN LANDSCAPE 88
40. GESTURAL LANDSCAPE—SEMIABSTRACT 90
41. GESTURAL LANDSCAPE—ABSTRACT 92
42. GEOMETRY IN LANDSCAPE—REALISTIC 94
43. GEOMETRY IN LANDSCAPE—ANALYTICAL 96
44. GEOMETRY IN LANDSCAPE— ABSTRACT, INTUITIVE 98
45. IMPROVISATIONAL LANDSCAPE 100
46. PHENOMENALISTIC TECHNIQUES 102
47. PERSONAL SIGNS 104
48. LYRICAL SYMBOLS 106
49. INTELLECTUAL SYMBOLS 108
50. PERSONAL SYMBOLS 110
COLOR GALLERY 112

 Primary Colors 113
 Single Dominant Color—Warm 114
 Single Dominant Color—Cool 115
 Muted Color 116
 Accents of Bright Color 117
 Low Key 118
 High Key 119
 Low Color Contrast 120
 Accents of High Color Contrast 121
 Intensified Color 122
 Color Mosaic 123
 Color Masses 124
 Color Patterns 125
 Color as Mood 126
 Color as Space—Warm and Cool 127
 Color as Space—Structural Color 128
 Color as Space—Intentional Reversal 129
 Invented Color 130
 Color as Light 131
 Flowing Color 132
 Diffused Color 133
 Color Glazes 134
 Color Reticence 135
 Color Shock 136

NOTES ON COLOR 138
STUDIO NOTES 144
BIBLIOGRAPHY 149
INDEX 150

INTRODUCTION

There is a story, probably apocryphal, about John Singer Sargent's method of selecting subjects for the informal on-the-spot paintings that he executed during his various Continental vacations. The famous portraitist, weary of the flood of commissioned works, would hire a cab to drive him out to the open countryside. At some random point, he would call the cab to a halt, disembark with his painting gear, and arrange with the driver to be picked up later in the day. Once left alone by the roadside, he would shut his eyes, turn around three times, then open his eyes and sit down to paint whatever view happened to present itself.

It was, of course, a tribute to his immense virtuosity that he could often make a successful painting out of virtually no subject at all; he could transform the most casually selected landscape into a vivid study of color, light, atmosphere, and texture, woven out of richly brushed slashes and jabs of paint. But not all artists possess Sargent's power to transcend the limitations of an unappealing subject—coupled with an open disdain for pictorial composition. His habitual approach to nature was largely what might be called a "snapshot" esthetic: elements haphazardly selected and casually composed, with little or no conscious organization of the subject matter into the kind of sustained, more profound visual experience that could be termed a work of art.

Times have changed, I think, to the extent that Sargent's easygoing methods are no longer entirely acceptable to us. It is no longer sufficient simply to confront nature, paint what is there, then pack up and go home.

Admittedly, Sargent never made any pretense that his landscape sketches were more than what they seemed to be: swiftly noted images done purely for his private relaxation and enjoyment. Nevertheless, I use him here as a symbol of a general attitude toward picture making that persists today in the minds of numerous painters, both amateur and professional. They seem quite content to paint, literally and unimaginatively, pretty much what the eye sees. Although they may demonstrate considerable skill and taste, somehow the fact remains that their work closely resembles the work of hundreds (or thousands) of other painters who have adopted the same conventional approach to the art of landscape. And then they never cease to wonder why their work does not rise above the crowd; why it remains unrecognized in terms of exhibition acceptances and awards; and why it may be quite competent, yet also remain quite anonymous. This book is an attempt to open up some eyes and minds: to encourage artists to discover the various means by which they can put more into—and get more out of—their landscape paintings.

GOING BEYOND TECHNIQUE. As beginning painters, we are usually most absorbed by technique—getting control over our materials and acquiring skills—and often we are grateful just to have a picture come out looking reasonably like its subject. During that period, accurate representation becomes a triumph of sorts, and it is only sometime later that we come to realize there is considerably more to painting than a good eye and sound technique. The first hurdle may have been overcome, but now we find yet another one ahead: learning to put our skills to some purpose—to express, to interpret aspects of nature, to search out and reveal nature's underlying design—to *understand* nature. This is the landscape artist's ultimate challenge.

So, after years of disciplined study, we are ready to tackle the problems of painting on a more creative level. Cézanne wrote that "painting is meditation with a brush," which is to suggest that brush and paint are merely vehicles for giving form to primarily mental conceptions; that deep intelligence must be brought to bear upon the act of painting; that the mind plays just as important a role as technique in the formation and presentation of graphic images. Following that line of thinking, I would say that developing a creative imagination or a creative viewpoint means beginning to comprehend nature and constructing paintings whether realistic or abstract that press beyond the casual, the ordinary, and the conventional toward an art that is more personal and inventive.

THE FIRST DECISIONS. Before brush ever touches canvas or paper, there are three fundamental kinds of decisions to be made:

(1) *What* is the subject of your picture?

(2) *Why* did you respond to that particular subject?

(3) *How* should that subject matter be presented in terms of composition, color, lighting, pattern or design, and technical methods?

SUBJECT. In one sense, *what* you paint is of very little importance—or even of no importance at all. Great subjects do not necessarily make great paintings; greatness lies in what the artist makes of the subject in terms of organization and personal expression. An artist can envision a painting in what seems like the most un-

8

promising situation: it is quite possible, for instance, to make a magnificent painting out of the most humble barnyard still life. And it is equally possible to make a garish mess out of an impressive sunset, or a cheap illustration out of some profoundly tragic human experience.

On the other hand—and this is particularly true of representational painting—the choice of subject can be the most important single factor in getting a picture under way. Actually, it is not so much a matter of *choosing* a subject (though that is generally what artists think they do) as a matter of the artist *responding* to some visual situation. The artist sees something that triggers reactions which lead to an urge to translate the subject into some kind of pictorial form.

We still do not understand precisely what causes a creative person to respond as he does to specific subjects. Most likely, it is some kind of interaction of external visual stimuli with the artist's inner world of the subconscious. My former teacher Julian Levi offers one possible explanation of this mysterious process: "There is another aspect of an artist's choice of his subject matter which I think could be profitably explored. It is that I believe he is affectively related to certain forms and designs. I believe his choice is channeled by the compulsion to find an objective vehicle for inward plastic images."

Along the same lines, I am reminded of these words by Sir Thomas Browne: "We carry within us the wonders we seek without us."

And I recall an article on Henry Moore that mentioned his habit of collecting beach stones as sources for his sculptural ideas. Readers from all over the world sent Moore some 20,000 beach stones, but he kept only two. Commenting on that fact afterward, he noted: "I choose to see with excitement only those pebbles which fit my existing form interest."

For whatever reasons, the spark set off by the artist's response to a subject is what leads to the forming of an image; it gives the artist something to work with, to manipulate in painterly terms. The fact that something outside himself has affected the artist intimately means that he now has something to communicate. In other words, if you are genuinely excited about your subject, then you stand a very good chance of sharing that excitement or that vision, by means of your art, with someone else. In any case, do not paint a picture just to keep yourself occupied, or use subjects simply because you have seen them handled successfully by other painters. Search out those landscape forms that touch you deeply, and make them the core of your art.

I would suggest, too, that working with a wide range of subject matter is *not* necessarily the best approach. Some variety is probably necessary if only to prevent boredom on the part of both the artist and his audience; on the other hand, I have observed that most great art seems to arise out of a painter's obsessional relationship to a favorite subject. I am thinking here of Winslow

Homer's sea paintings; Burchfield's infatuation with the seasons and rhythms of nature; Georgia O'Keeffe's New Mexico; John Marin's Maine; or Andrew Wyeth's seemingly endless series of paintings of Cushing and Chadds Ford, with neither theme being anywhere near exhausted. All these painters, and others like them, have dealt with a fairly limited range of subject matter; but instead of becoming repetitious, they have turned their visual obsessions to positive use and probed their recurrent motifs with ever-greater depth and intensity.

While travel may be broadening to some people, the first temptation is to see and paint only the obvious, the picturesque. But the best landscape paintings result from a continual effort to know a given landscape area as profoundly as possible over a long period of time, to bypass the surface view of things in order to get at essences.

RESPONSE. Determining the subject for a painting is only the very beginning. From that point on, it is important that you clearly identify and then sustain whatever that initial response was. If you know *exactly* what it was that struck you so forcefully, then it will be easier to project that particular quality with equal force and clarity in your painting. But what sometimes happens is that the painter is not sure just what most attracted him to his theme; his picture tends to be vague about why it was painted in the first place, with the result that spectators are uncertain of the viewpoint behind the painting.

Ask yourself, therefore, what you are most concerned with as you paint. Is it sheer beauty? Is it a message? Or is it color, light, pattern, space, weather, mood, or shape relationships?

I suggest that "beauty" is too vague a term. It must be defined further in the artist's mind to prevent the picture from falling into the trap of being banal or saccharine. *Why* beautiful? Probably because of color, light, shape, pattern, or any of various other possible sources of esthetic delight. There are serious dangers in responding to a subject merely because it is "beautiful," unless that beauty can be translated into art existing on a higher plane than a travel poster or a page from *Arizona Highways*.

Didactic painting—painting with a message—is also risky, because too often the artist's message or idea becomes more important than the visual means through which it is presented. Form should reinforce content in a partnership of equals: pictorial organization should not be neglected in favor of too strong an emphasis on content. It may be an age-old battle, to be sure, but I think by now it is generally agreed that when a social, psychological, or sentimental message predominates, art goes out the window.

With the artist's response and underlying viewpoint toward the painting firmly established, he can then begin to search for the best methods to communicate his own interest in the subject. But the difficult thing for some painters is to cling to their original conception,

despite all the complexities involved in the actual execution of the painting. As they get deeper into the development of the picture, they can be easily distracted by technical concerns, problems of color or composition. Before they realize it, their guiding initial response has gotten lost in the shuffle.

Write notes to yourself, tack up reminders on your studio wall, place your first sketches right next to the easel—whatever it takes—but do not lose sight of what you originally wanted to say. If you can hang onto that, you will be in full control of your painting at all times, and you will have a firm rationale behind all your pictorial decisions while the picture is in progress. After the picture is completed, look at it objectively and check it out to make sure you have expressed exactly what you had in mind from the very start.

FORMAT. If you have answered the first two questions—the *what* and the *why*—to your satisfaction, there are still two other questions to consider before you begin the painting.

The matter of composition gets first priority. The general arrangement of areas within the rectangle of your canvas or watercolor sheet is the spectator's first impression of your painting. In art school, I was taught that composition is 90 percent of the picture: if the composition is weak, so is the entire painting.

As a student, I remember blocking in a figure subject on my canvas and feeling it was the very finest piece of drawing I had ever done. The instructor vigorously praised the blocking-in but went on to say that the figure was an inch too low on the canvas. My jaw must have dropped a mile, so he added: "Go ahead, take your turpentine and wash it right off—if you haven't got the courage to do it now, you never will." So I took a paint rag and turps, wiped it out, and re-drew the figure a shade higher on the canvas. Sure enough, though my drawing was nowhere as good, *the composition was right*!

It has always unnerved me to watch students sit down in front of a subject—figure or landscape—and start right in to draw or paint. Whether through enthusiasm or impatience (or thoughtlessness), they barge into the work without taking time to consider what they are about to do. Perhaps this very aspect of the creative process is what separates professionals from students and amateurs. Thought must be given to just what the subject is, what is involved, how it can be placed most effectively within the picture dimensions, and how it relates to those four edges of the rectangle. Another point to be decided is how the composition can best project the subject, as directly and interestingly as possible.

I would strongly advise against settling too easily for your first view of the landscape. Your first view might indeed be the one you finally settle on, but this should be decided only after you have tried seeing the motif from several different angles, or considered several different ideas of color, light source, and pattern. When you have surveyed all the possibilities of expression and structural organization, then you can decide if your first impulse was really the best one. If so, go ahead with the picture. But at least you have assured yourself that all the possible compositional variations have been exhausted, and you are now left with the only one fully appropriate to both your theme and your creative viewpoint.

In order to make your work as individual as possible, try for the personal, the offbeat, the unusual. Make your overall plan as arresting and expressive as you know how. Your mission is to interest your audience in what you have to say, and to say it in your own way rather than rehash the ways used by Corot, Boudin, Constable, Turner, Monet, Inness, Homer, Chase, or Hassam, to name only a few eminent landscape painters.

Of course, some of my younger students have gone to the opposite extreme and made a fetish of newness—of being "now" (whatever that means). They feel they can push forward the frontiers of contemporary art if they devise something entirely new. But newness or novelty per se can be merely gimmicks, and gimmicks do not last long. They wear out quickly and become dated clichés. The artist then finds himself trapped among his own strained mannerisms. The search for novelty for its own sake is not what I am talking about. What I do believe in is the painter's responsibility to try for the most genuinely personal view and to avoid the mediocrity of easy solutions to landscape problems.

Thus far, I have been directing most of my remarks to painters of the realist persuasion. If we turn to the abstract approach, subject matter is still no more than a point of departure. The subject becomes a stimulus for redesigning nature, for analyzing planes, for expressive distortions. The subject serves as a framework on which a painting is built; it is the way in which creative imagination blends perceived reality with geometry or lyricism that determines the character, quality, and success of the finished picture.

The abstract painter works within a very limited picture space, creating depth by means of planes and color relations, instead of perspective or illusionistic depth. Instead of descriptive tonal color, the abstract painter works with creative color, for purely expressive purposes or to create formal arrangements of color areas that are to be enjoyed for their own sake. Instead of knowing in advance what the finished painting will look like, many abstractionists improvise: that is, they start without any specific theme and discover it only as they work—discovering it through the painting process itself. Abstract painting, then, is another way of going beyond conventional imitative painting toward a more personal interpretation of the world around us.

Linked very closely to composition are such elements as lighting, pattern, and stylization or design. All these demand your attention if you are to explore your motif thoroughly before embarking on the actual painting.

Some artists find it possible to visualize all these elements in their heads; but like those bright ideas that occur during the night and turn out to be wildly impractical in the light of day, our mental vision of a painting is often far ahead of our real ability to achieve it. I would recommend doing thumbnail sketches or small ink-and-wash drawings so you can evaluate the effectiveness of your various ideas for the picture you plan to undertake. These sketches should be done as broad masses of value, with as little specific detail as possible, since you do not want to squander all your enthusiasm in sketches and have no reserves left when it comes time to paint.

MEDIUM. Finally, with your picture format worked out, either mentally or in the form of sketches and studies, it is time to decide what medium is most suitable for your subject.

Many painters specialize in a certain medium and are known as oil painters or watercolorists exclusively, for example. But if you happen to be equally at home in several media, you will have to decide on the particular advantages or disadvantages of oil, acrylic, or watercolor in relation to your specific landscape theme. Frequently, you can visualize a certain motif as being a "natural" for a certain medium; but in the event that the medium does not suggest itself so readily, you have to ask yourself some preliminary questions. Does the subject seem to require an opaque or a transparent treatment? Would that landscape subject lend itself to a complex sequence of opaque, semi-opaque, and transparent washes (acrylic), or would it be possible technically to capture those textures and effects in a few quick washes (watercolor)? Do you need the subtle, meticulous blending that is possible only in oil, or do you want the hard-edged color shapes that work best in acrylic?

If you generally get your best effects in a particular medium, it is probably most sensible to restrict yourself to that favorite medium, and not fight an uphill battle against a technique you find uncongenial to your taste and skills.

Many subjects can be handled equally well in all three major painting media, but keep in mind that other subjects may lend themselves most naturally to only one of them. Watercolor, in particular, has its limitations. I have noted that wise transparent watercolorists were once very careful about what they chose to paint and selected only sure-fire "watercolor subjects." Today, however, with the growing popularity of "aquamedia"—overlapping several water-based media within a single picture, often combining opaque and transparent passages—watercolor has become just about as versatile as oil or acrylic.

Whether you work in a representational or an abstract manner, you must remember that in the long run the completed picture must stand on its own, to be viewed and enjoyed as a self-contained entity. Few if any viewers are likely to compare the real subject with its painted version; nor can the artist always be on hand to explain his work. What does remain is the picture itself, which must stand or fall on its own terms, as an imaginatively ordered group of shapes and colors.

ABOUT THIS BOOK. This book is concerned with seeing landscape and then sorting out the most interesting or arresting ways to translate that landscape into a picture—not just a snapshot, but a fully resolved painting. It is written for the person who has already acquired some familiarity with painting, whether in oil, watercolor, or acrylic, and who has experienced several years of painting outdoors directly from nature. There is absolutely no substitute for this kind of immediate contact with nature's forms and patterns, its variable conditions of light and weather.

But at some point there comes the realization that, in the great majority of cases, the finest landscapes were and are produced in the artist's studio, not outdoors. In the studio, nature is modified, adjusted, arranged; all the pictorial elements are orchestrated into a totality that has more order and cohesiveness than nature itself.

In the pages that follow, I have brought together seventy-four different ways of approaching landscape painting in a creative—not merely descriptive—spirit. Some of these have to do with composition, both realistic and abstract; others are a matter of viewpoint, lighting, color, unusual types of subject matter, or painting processes. The book shows a wide variety of pictorial concepts as they appear in landscapes by many of the best contemporary painters. Twenty-four paintings reproduced in color relate to various color concepts in both realistic and abstract painting. Another fifty paintings are reproduced in halftone. Each painting is a kind of "object lesson." That is, each painting represents a concept—a fresh, personal approach—from which I hope the reader will learn something new. In the text accompanying the painting, I explain the concept and how it works in the particular painting; then I suggest how you might enliven your own work by trying something along the same lines. At the end of the book, I have added a section called "Studio Notes" on landscape painting. These are the sort of thing I find myself saying most often to my students.

My hope is that you will regard this book as a source of many new ideas you can try out in your own painting. Perhaps one idea will suggest a means of rethinking an old picture of yours that did not quite succeed, while another concept may suggest the lines along which your newest painting might be developed. *Creative Landscape Painting* is an attempt to open up some eyes and minds to a number of fresh possibilities and offbeat alternatives and to encourage artists to reject casual, obvious approaches to nature.

1. DESIGNED REALISM

CONCEPT. Does a creative attitude toward landscape painting preclude realistic or representational treatment? Not in the least. But it should be remembered that there is more than one form of realism. I like to break it down into two categories—one I call *direct* realism and the other *designed* realism.

Direct realism is an inheritor of the Impressionist tradition of painting outdoors directly from nature. Usually it is a rather loose, brushy, spontaneous approach, dashed in with an immediacy that puts the viewer right at the scene alongside the artist. The very early works of Rockwell Kent, George Bellows, Edward Hopper, and Andrew Wyeth all reflect this tradition of directness. It is interesting to observe, however, that Kent's landscapes became more stylized in his mature years, that Bellows later straitjacketed his subjects in the grids and diagonals of Dynamic Symmetry, that Hopper became rigorously spare and selective, and that Wyeth ended up with pictures that were very tightly organized and most thoughtfully developed.

In other words, many artists who begin with direct realism in their younger days eventually gravitate toward designed realism—where nature still serves as a strong primary source, but is then put through a picture-building process that is, to varying degrees, more formal and more controlled. In essence they seem to move toward an art in which stability and order prevail over painterly visual realism. If Constable can be said to be the model for many of our contemporary direct realists, Cézanne is the principal progenitor of the current designed realists. Designed realism, then, tends to dispense with the accidental or fortuitous effects that come from working in front of the subjects (or from attempting to re-create those effects in the studio). It is a studio-oriented art in which the artist contemplates, revises, and reorganizes the raw material of nature into formal, controlled, and tightly organized relationships.

Its point is to rid the picture of localized details, to push toward a more universalized handling of the subject, and to realize that the artist's urge toward order is more important than simply a knowledgeable eye and a virtuoso technique. Generally speaking, direct realism is associated with 19th-century attitudes, whereas designed realism is allied more closely to 20th-century attitudes.

PLAN. Direct observation and experience is, as usual, the starting point for any realist landscape. Paintings done on the spot have a freshness and vigor that is irresistible. Their sketchiness is a great part of their charm. But when it comes to picture-building, we have to prepare for it by carrying the sketch's basic material a step or two further in the form of thumbnail sketches and studies. To start with, it is a good idea to identify and eliminate the nonessentials. The next step is to stress the design that is inherent in the subject. Try raising or lowering the horizon. How can light be used to dramatize the forms and the compositional patterns? And of course, consider the colors. Don't mindlessly imitate the colors that are there, but consciously work for more satisfying relationships. Ask yourself if any areas can be altered or shifted to make a more readable or arresting arrangement. And are there ways to make the picture less predictable?

The advantage of the designed realism approach is that if you like to paint with absolute fidelity to detail, your paintings will have a sense of structure that is lacking in most superphotographic paintings. On the other hand, if you prefer to paint freely and juicily, then your painterly freedom will be firmly anchored to those clearly thought-out decisions about shape, space, light, pattern, and color.

As I have pointed out elsewhere, realism is not in itself bad art, but in a majority of cases, it has been handled unimaginatively.

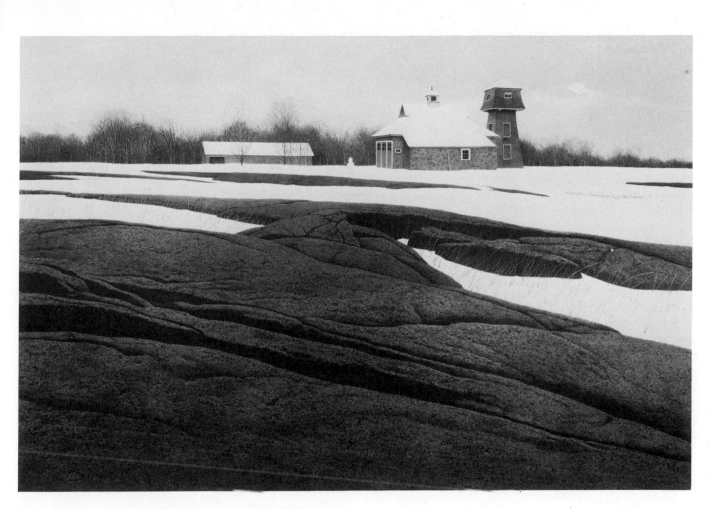

Snow Man by Robert Vickrey, N. A., A.W.S., egg tempera on gesso panel, 24″ x 36⅛″ (61 x 92 cm). Courtesy Midtown Galleries, New York City. Like many who paint in the style of designed realism Robert Vickrey spends months or even years thinking about how he will paint a particular subject. Rather than settle for a conventional close-up view of this farm, he has opened up the space around it and used a large mass of foreground rocks to provide textural interest and to create a deep recession into his landscape. The flowing contours of those rocks act as a foil for the crisply handled architectural forms in the distance; but note that although the rocks and their detailed textures occupy the major part of the picture surface, they lead toward, but do not distract from, the farm buildings. Despite the fact that Vickrey's work is a superb form of sharp-focus realism, all his pictures are built on an underlying element of abstract design. While everything appears to be delineated with equal clarity and precision, Vickrey exerts firm control over the distribution of shapes, values, and patterns, skillfully emphasizing and subduing various areas of the picture. By no means a snapshot view of nature, this is a carefully planned and consciously wrought realism which produces a feeling of permanence.

2. LOW HORIZON

CONCEPT. Although the average landscape painting usually has its horizon placed somewhere between the middle of the picture and perhaps one-third up from the bottom (which is probably the most natural way to view it), using a very low horizon makes a more striking division of the picture surface. A low horizon accomplishes two things: it gives an unexpected, unequal, or asymmetrical relationship to the ground and the sky; and it creates a feeling of great height and an expanse of open space, upward into the sky and deep into the far distance.

The principle of asymmetry is one of the first things we learn in composition. The avoidance of centralized images, such as putting a farmhouse in the very center of the picture, is an attitude toward composition that is fundamental to almost all painting. Perhaps the finest use of asymmetry is found in Oriental painting, where the placement of forms and the surface divisions are handled with the utmost skill and sensitivity. A good part of the satisfaction to be derived from these compositions is their offbeat, unconventional character. In various periods of Western art, artists have utilized asymmetrical compositions both in abstract and representational paintings to avoid monotony and to add interest. The very fact that a large area of sky relates to a thin strip of land below is an eye-catching compositional device that gives a more consciously designed look to the painting.

The second effect of using a low horizon comes in handy particularly when the artist needs to suggest wide-open spaces and stretches of almost infinite distance. It would be extremely difficult, for instance, to project the look of the broad, flat expanses of the American prairie by placing the horizon somewhere near the middle of the picture. But the sense of openness and limitless range of vision is greatly intensified when the sky predominates, and the land elements are severely compressed into the bottom zone of the painting. The sky may be active and filled with clouds, or it might be quite flat and empty. Either way, the low-horizon device, whether applied to prairie, beaches, or deserts, is compositionally exciting and spatially expressive.

PLAN. Instead of situating your horizon in what you might consider its normal position in your picture, try a few sketches showing yourself what would happen if you dropped that horizon line to almost the very bottom of the canvas. Be as daring as you can in using a very large amount of sky area opposed to a very small amount of land area. Decide how much of your landscape subject needs to be included and how much detail is necessary. If you find you cannot cram it all into too small a space, then raise the horizon very slightly. Keep in mind that, although the sky dominates in terms of size, the real subject of your picture is confined to a relatively small zone—the sky, large as it may be, is actually secondary in terms of interest. Above all, you should be trying for an unexpected quality, something more arresting than the standard compositional relationships.

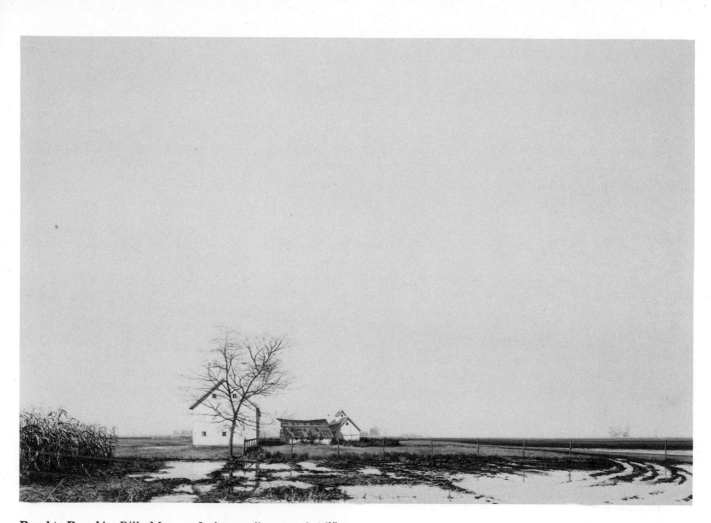

Road to Royal by Billy Morrow Jackson, oil on panel, 16½″ x 23¾″ (42 x 60 cm). Private collection. Billy Morrow Jackson's paintings of Illinois capture the essence of its characteristically flat farmland. One of the many distinctions of this painting, and the source of its greatest impact, is the manner in which the absolute emptiness of the large sky is used as a foil for the extreme detail of the farm scene that has been packed into the strip of land at the base of the composition. The sky is painted with extraordinary reticence as a smooth, pearly gray; nothing happens there except a sense of hazy atmosphere. But in the principal subject below, the artist relishes every detail and lavishes his attention on a great variety of textures, all perceived and rendered with equal precision throughout the picture surface. Whereas the upper portion of the painting is utterly simple and uneventful, the lower portion creates a thoroughly convincing three-dimensionality and an almost limitless recession in aerial perspective toward the distant horizon. Aside from the use of low horizon, this painting also mingles opposites: emptiness versus complexity, simplicity versus detail, and flatness versus texture. Photo Jane Haslem Gallery, Washington, D.C.

3. HIGH HORIZON

CONCEPT. Reversing the low horizon to a high horizon also creates an unequal division of the picture surface. In this instance, there is a very small amount of sky and a very large mass of land that occupies the major part of the picture. There are two major effects of a high horizon. First, it creates a sensation of being up in the air and looking down at the landscape, as if from the vantage point of a low-flying bird. The feeling is not one of standing on the ground and looking straight ahead toward the horizon; rather, it is one of looking simultaneously downward at a slight angle as well as outward and upward.

The second effect of a high horizon is that the picture has a shallower depth. Where a low-horizon painting tends to let the viewer look off into the deepest possible picture space, the bird's-eye view created by a high horizon seems to tilt the ground plane slightly upward so that the viewer looks down *at* the ground mass, not *across* it. Thus the high horizon is useful to contemporary painters who are not only interested in an unusual vantage point for their subject, but who are also interested in limiting the depth of their paintings.

The tilted ground plane is easily applicable to representational painting and can be found in certain landscapes by Corot, Constable, Whistler, Gauguin, Van Gogh, Winslow Homer, Rockwell Kent, and Andrew Wyeth, among others. But this kind of shallow picture space is, at the same time, very much in line with more contemporary concepts in which the painter purposely avoids the deep illusionistic space characteristic of Renaissance paintings, in favor of placing landscape forms in a narrower, more compact space set at an angle to the picture plane.

The high horizon, then, is for the artist who wants to express the feeling of looking down upon his subject—perhaps as if seen from a hilltop, a mountain, a tree, or a high window. The Austrian painter Oskar Kokoschka, for instance, made a habit of requesting top-floor rooms in the hotels where he stayed, and he painted a remarkable series of views of various European harbors and cities from these rooms and hotel rooftops. In all these paintings he consistently used a high horizon.

PLAN. The very high horizon is partly a matter of composition—unequal division of the surface—and it is also a matter of viewpoint. The main thing to keep in mind here is that the sky should be restricted to only a small strip across the top of the picture. The lower you drop that horizon, the more conventional your picture becomes both in terms of the opposition of large and small areas and in terms of viewing landscape.

To start with, I would recommend actually situating yourself well above ground level, anywhere from a high window or rooftop to a very high point of land such as a hilltop or a mountain. Later on, it will be possible for you to work out pictorial compositions simply by dividing the picture with a horizontal band near the top of the painting and then developing various real or imaginary landforms and patterns in the large area below.

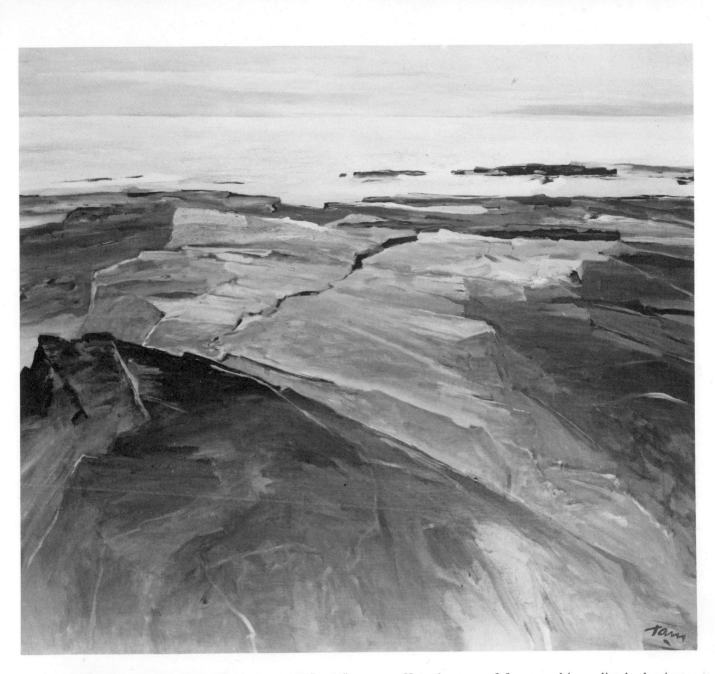

Dark Tide Zone by Reuben Tam, oil on canvas, 40″ x 44″ (102 x 112 cm). Collection Sheldon Memorial Art Gallery, University of Nebraska. If ever a painter could be called a "poet of the geological world," Reuben Tam would be the one. Born on an island, he continues to explore through his art those areas where land and sea meet. Tam never paints directly from nature; his pictures are the result of observation and experience, memory and association. More than any other contemporary artist, he has frequently used a high horizon and an upward-tilted foreground as his most forceful way of propelling the viewer directly into the midst of his landscape. Here the mass of foreground immediately dominates the painting, but then the viewer's eye is led upward and outward by a series of diagonal lines and thrusting rock fissures that guide him to the ocean's edge and the gleam of light on the water. This band of bright water emphasizes the two-dimensionality of the canvas and controlled recession into space. This is not an ordinary picturesque Maine scene, but a painterly equivalent of nature's forces. The use of the high horizon effectively dramatizes these powers in a way no other viewpoint could. Photo courtesy Coe Kerr Gallery, New York City.

4. AERIAL VIEW

CONCEPT. If we look straight down from an airplane, we see the landscape forms directly below us, and the horizon is no longer present as a part of the composition. The aerial view, is, of course, a relatively recent development in the history of painting. But when aerial photographs first came to the attention of artists, it did not take them long to see the parallels between such photographs and the kind of flat patterns and designs that appeared in experimental modern paintings.

In fact, the very flatness of this view relates closely to the two-dimensional treatment of nature in abstract art, where painters consciously avoid painting illusions of depth and limitless space and do all they can to translate the three-dimensionality of landscape into purely two-dimensional terms that "respect" the flatness of the canvas, panel, or paper.

In addition to the flat view with no depth at all, aerial views alter the usual scale of landforms, eliminate all detail, and virtually reduce everything to shapes (geometric and organic), abstract patterns, and textures. Such aerial views are strongly allied to the design relationships used by the Cubists and by artists who deal only in the severely intellectual, nonobjective arrangements of line, shape, and color.

With air travel as common as it is now, many people have had an opportunity to see the terrain from thousands of feet above ground. While the information captured in the average snapshot taken through the window of an airliner is not usually very satisfactory for artistic purposes, the wise painter stores that aerial experience in his memory, and files it away in his repertory of forms for possible use in a future painting.

Some painters prefer to stress the geometric aspects of the aerial view—such as farms or cities—while others emphasize the atmospheric effects and subtle textures of fields and mountains appearing and disappearing in fog or under a light cover of snow.

PLAN. In preparing to develop a painting based on an aerial view, first remind yourself of your own experiences and observations during flights you have made. Think of whatever views you remember that were striking in design or handsome in texture or atmospheric nuances. Next, acquaint yourself with as many aerial photographs as you can—back issues of *National Geographic* or *Life* are good sources. Look up Beaumont Newhall's well-illustrated *Airborne Camera* (Hastings House, 1972). Still other sources are the firms who make aerial surveys for city, state, and industry; they frequently have files of photographs that are a rich mine of varied abstract forms, of shapes and compositions to inspire a painter.

Once you have familiarized yourself with how things look from the air and studied the kinds of forms you will be working with, you can start painting. As you work, keep in mind that you should never copy the forms from a particular photo, but use them loosely as a framework within which to paint. Use photos to suggest design relationships, not to copy line for line and shape for shape.

The aerial view allows you the choice of painting representationally or quite abstractly. Viewed from greater height, detail will disappear, and you will find yourself dealing with big, fundamental forms. Generally speaking, the closer you are to the ground, the more recognizable are the forms. But the higher up you go, the more likely you are to work with completely abstract relationships that may suggest their origin but which are to be enjoyed mainly as pure shape and color, without necessarily being recognizable.

Stress shape. Stress pattern. Stress flat design. Or perhaps combine flat design with fluid or hazy areas. Treat the picture more as a formal arrangement and less as literal description. Your aim should be to get away from ground level and to adopt a viewpoint—real or partly imagined—that deals with the subject in a way that only the breadth of an aerial view can provide.

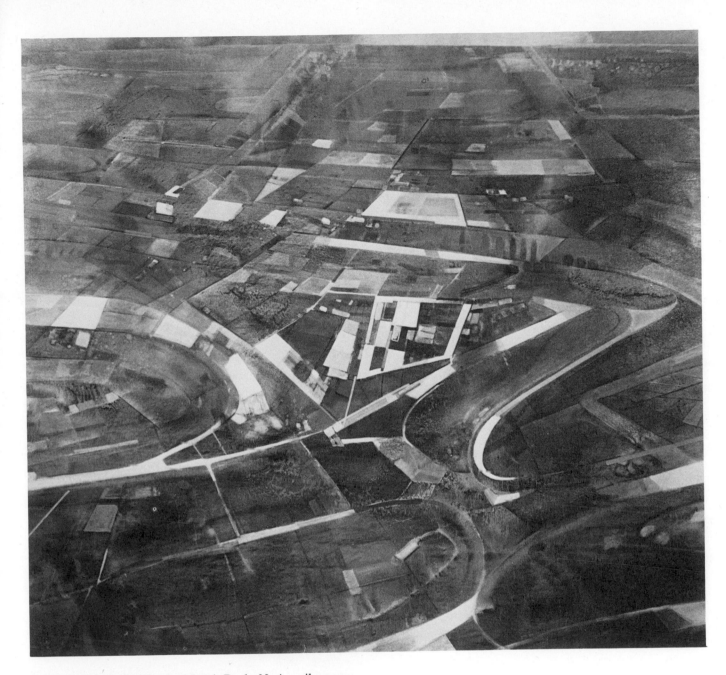

Autumnal Complexities by Margit Beck, N. A., oil on canvas, 72″ x 80″ (183 x 203 cm). At first glance, this painting would appear to be no more than a faithful treatment of a standard aerial photograph, possibly of an area that you might see as a plane begins its approach toward an urban airport. There are what *seem* to be industrial plants, warehouses, a superhighway, and the edge of a city opening out onto spacious farmland. A closer look, however, reveals that Margit Beck has been nowhere near that specific. She paints as if looking down on a landscape that is more imaginary than real. And although her blocky shapes and looping lines suggest buildings and roads, it becomes evident that her principal interest is in the abstract relationships of linear and geometric elements. There is no attempt here to make any literal sense out of this arrangement of forms. By selecting the aerial viewpoint, she has given herself the chance to manipulate shapes and patterns in a sort of crazy-quilt format instead of treating the scene from ground level, as a realistic landscape panorama stretching off into the distance.

19

5. UPWARD VIEW

CONCEPT. If you are not fond of air travel and would prefer to remain on terra firma, there is a less unsettling viewpoint for you: standing on ground level fairly close to your subject and looking directly up at it, without a horizon line.

Photographers discovered long ago that cameras tend to distort perspective, that photos of tall structures such as skyscrapers, bridges, and industrial plants contained some dramatic distortions that were pictorially very striking and expressive. It is very possible that some painters were influenced by such photo images and saw in them great possibilities for unexpected design qualities, in their sense of forms receding sharply upward toward immense heights.

A number of early modernist painters in this country were attracted to the upward view, and such artists as John Marin, Arthur Dove, Charles Sheeler (himself a photographer), Charles Demuth, Preston Dickinson, and Joseph Stella utilized that viewpoint repeatedly. One of Georgia O'Keeffe's most purely poetic canvases, called *The Lawrence Tree*, reveals stars and sky glimpsed among and around the foliage and sinuous branches of a tree seen from an upward view. Even realists such as Edward Hopper and Andrew Wyeth have had a partiality for treating lighthouses towering high above their heads. It is undeniable that with the direct, head-on, eye-level view predominating in the great majority of landscape paintings, the upward view looks excitingly offbeat. From time to time, contemporary artists use it, not as a gimmick, but for its fresh viewpoint and dramatic design possibilities.

PLAN. The fact that the upward view has been used as much as it has in the past fifty or sixty years, does not mean that it has become a visual cliché. Some painters are so afraid of painting a cliché that they virtually immobilize themselves and are reluctant to paint something, just because they know it has been done before. If this upward view provides a more interesting approach to your subject, if in some cases it is indeed the *only* way that seems most appropriate, then I see no reason to paint it from a more conventional vantage point. As long as you employ this concept selectively, when it is genuinely meaningful, provocative, or expressive, and not as your habitual compositional viewpoint, then there is every reason why you should use it with confidence and without apology.

When you are gathering material for paintings, keep a sharp eye out for subjects that are very near you and above you. A Victorian farmhouse can look quaint and picturesque and eminently paintable as you first approach it. That would be the standard view, which might very well end up a fine painting. But as you walk closer, keep looking upward. Notice how the perspective becomes more forced and dynamic; the roofs and gables become sharply angled diagonals; and the intricate architectural details cast dramatic shadows that form abstract designs not visible from farther away.

If you look at a grain elevator from a distance, it is a tall, static tube rising against the sky. From a closer vantage point, its parallel contours recede sharply in vertical perspective; and some of the chutes, wires, and other architectural details provide more unusual patterns than were apparent when you saw it from a distance.

Be discriminating, be inventive, and don't settle for your first impression of the motif until you have explored it from near as well as far—with a horizon and without one.

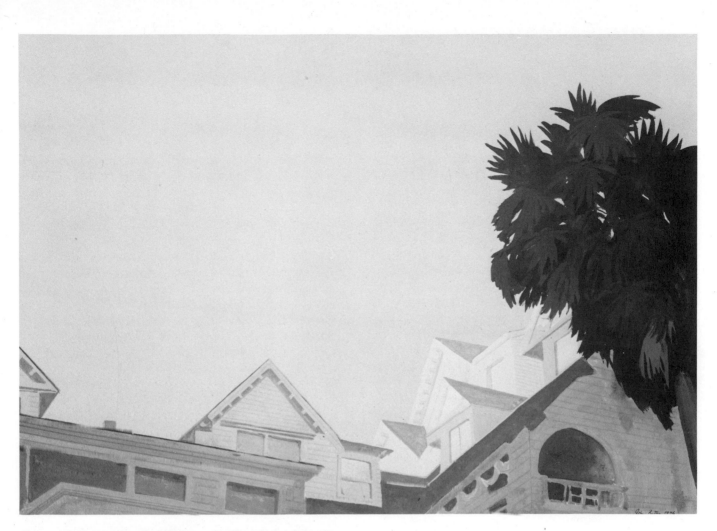

Hotel del Coronado, San Diego, California by John Button, gouache on paper, 14″ x 20″ (36 x 51 cm). Collection of Chase Manhattan Bank, New York City. John Button is a realist who deals in simplified forms and whose work ranges from lonely beach scenes to street scenes and urban skylines. His early training as an abstractionist has had a strong effect on his architectural compositions, which invariably have a firm geometrical structure occasionally reminiscent of Edward Hopper's paintings. Button freely admits that he works from photographs, exploiting the angles, distortions, and cropping possibilities of that medium. The painting reproduced here, one of a series called "Buildings Out West," is typical of his penchant for quirky, chopped-off compositions viewed upward. Here he has taken advantage of this view to focus on a highly complex arrangement of intersecting and overlapping angled planes—offsetting them at the right by the curvilinear forms of the dark palm. Though he is a skilled cloud painter, he has chosen not to fill the sky with distracting forms; instead he uses that area as an extremely simple, flat backdrop in a luminous blue to force the viewer's eye down toward the main area of interest. Photo courtesy of Kornblee Gallery, New York City.

6. DETAILED FOREGROUND

CONCEPT. A compositional device often used by Corot was to leave a rather vague and empty foreground, usually only a loosely brushed mass, and to place his main subject well back in the distance. This sort of placement pulls one right into the painting, dispensing altogether with any foreground interest. In a variation of that approach, many painters throw the entire foreground into very deep shadow (cast by something outside the limits of the picture) and then bathe their subject in strong light. This creates a dramatic effect which minimizes distracting foreground detail and brings out the subject through striking value contrasts.

There is still another variation possible: that is, to purposely introduce foreground detail and keep the picture's principal subject in the middleground or background. This is an intentional suppression of the subject, placing it where it less obviously meets the eye. It is an art of understatement in which the painter refuses to plant the subject in full view for all to see immediately. Instead, he partially hides it behind foreground detail and draws the viewer into the picture at a slower pace. It is a more indirect, more subtle, more artful, more conscious control of what is happening in the picture than simply setting the subject in the middleground with an exclamatory *"There!"*

So, here again we have the quality of unexpectedness. Rather than being directly confronted with the reason for the picture, we are made to look a little more carefully, to discover it discretely moved from the front stage. (Note Robert Vickrey's *Snow Man*, page 13.) Certainly this is more intriguing than having the landscape motif more or less thrust in our faces, and it is a satisfying change from the customary snapshot where the motif fills most of the picture.

Composition aside, the closely observed detail in the foreground helps to create a greater sense of depth and space, and for that reason it has been used by a variety of painters such as Constable, Turner, Homer, Sargent, Hopper, and Burchfield. They found that one way to push the middleground and background back is to bring the foreground as close as possible and reveal the detail in it. The juxtaposition of generalized forms farther away with the more precisely treated foreground elements is a sure way to intensify the feeling of distance within the picture.

This whole concept is allied to the Oriental method of treating the picture's subject as a minor form in relation to all the other forms in the painting. A Chinese master may paint a picture called *The Meeting of Two Poets*, and it takes the average viewer quite a while to locate the two figures and a donkey submerged in a wilderness landscape of craggy mountains, foreground grasses, and twisted trees. But there is something of a thrill in all this that stems from the unusual composition, the surprise of not finding the subject where you expected to see it, and the artist's manipulation of *how* and *what* you look at in the painting. It's almost as if the artist is playing a game of hide-and-seek with you.

PLAN. See if it is possible to get back far enough to allow forms or objects to interpose themselves between you and your main subject. It could be plant forms, shrubbery, a stone wall, or a tree; or the scene could be observed through the tracery of several branches. Or, you can guide the spectator to your subject by having rock masses in the foreground or railroad tracks with semaphores. Anything that is a change of scale from the rest of the picture, whether it is large or small, could furnish you with material for detailed treatment. However, the only danger to avoid is in allowing the foreground to dominate the composition at the expense of the real subject of the painting. If you set up too much competition between the foreground and your motif, you create confusion and divide attention. Make sure the foreground detail stays in its place, either by the use of color, value, or lighting. Your foreground must provide interest and a change of pace, but it should always remain subordinate to the picture's principal subject.

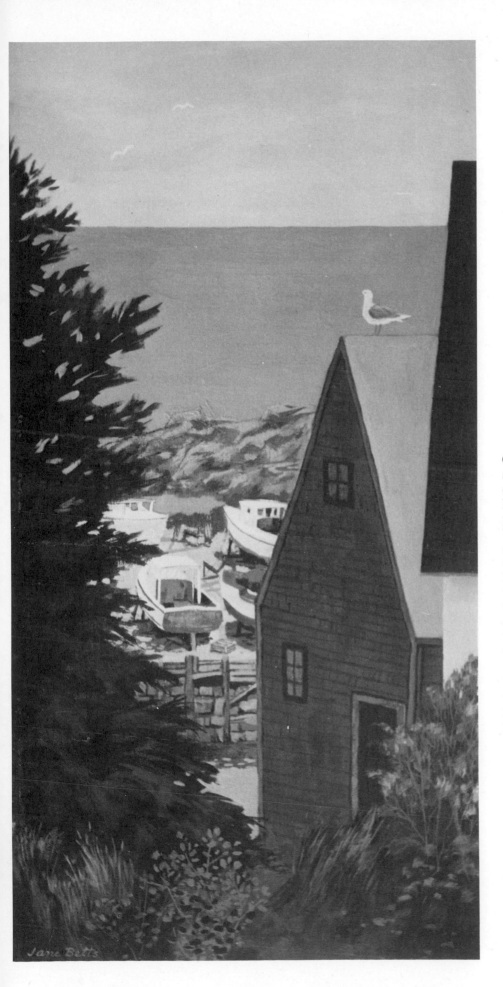

Glimpse of the Sea by Jane Betts, acrylic on Masonite, 24″ x 12″ (61 x 30 cm). Private collection. Jane Betts is known for her Maine coastal scenes, prairiescapes, and flower paintings. This picture is a view of the boatyard at Perkins Cove in Ogunquit, Maine, as seen from her summer studio. Rather than depict the entire boatyard, which many artists have done, she saw the pictorial possibilities in revealing only a portion of it framed between a tall pine tree and a couple of summer cottages. She presents it as if she were sneaking up on the subject, contrasting the glimpsed vertical view with a view of the scene below. She has compressed her main subject into a comparatively small space, surrounding it with a flat expanse of ocean and sky, the pine tree and cottages, and added a change of scale to the composition by the introduction of small-scale detail in the grasses, wildflowers, and shrubbery. The boatyard is seen in strong, warm sunlight, but the foreground elements are subdued in low-key, cooler tones. The viewer's eye is entertained throughout all areas of the picture, but there is a firm control over what is light and what is dark, what is flat and what is simple, and what is active and what is complex. Note, too, how foreground detail helps to strengthen the feeling of pictorial depth.

7. FRAMING WITH FOREGROUND ELEMENTS

CONCEPT. The foreground can be used as an unusual entry into the picture by introducing foreground elements that function as a framing device for the main subject. In this case, the foreground forms and structures are employed not so much for their detail as for the design quality they impart to the picture as a whole. They present the subject more dramatically, setting it off with greater focus and emphasis.

Usually those elements which act as a framing device repeat or reinforce the edges of the painting. Examples of this would be the use of straight-edged verticals such as a doorway in a Wyeth, a viaduct in a Burchfield, or trees in a Cézanne. Other painters, such as Canaletto and Piranesi, have used strongly arched forms as a method of framing their subject. Either way, the artist has created a visual device to draw our attention to the subject. In almost every instance, such landscapes could have been presented *without* foreground framing elements; but by using them, the artist has added his personal viewpoint and a more inventive way of dealing with his motif.

By reaffirming the picture's edges, the framing device tends to concentrate our attention on the center of interest. It directs the spectator's eye into the picture and thereby intensifies his involvement with it.

Finally, the framing of the subject heightens the sense of depth within the painting by contrasting natural or structural forms very close to the picture plane with the forms of the landscape in the middleground or background. In this respect it is very much like the use of detailed foreground, except that here the spatial effect is achieved through large forms functioning as firmly designed masses placed in the foreground, rather than small forms placed at close range to emphasize depth.

PLAN. Since foreground framing was used centuries before the invention of the camera, we cannot say that photographers coined this particular device. At the same time, we can learn a lot by studying the ways in which photographers have taken advantage of this compositional device. Artists of the camera are often more aware of unusual compositional viewpoints than many painters seem to be, and if you want to get a sampling of the subtle or forceful ways of framing the subject, spend an afternoon going through some of the various camera annuals published in the past twenty or thirty years.

Once you have seen how others have used this viewpoint, it is time for you to make you own discoveries. The commonplace landscape can be lifted out of the ordinary by the way you see it; so set yourself the task of finding framing devices for your own favorite subjects. How about painting boats moored in a harbor as viewed, not just out in the open, but from underneath a wharf, with all its ropes and pilings? Try a painting of the same subject as seen from under a bridge or viaduct. Use a doorway or a window to frame the landscape beyond. Porches make excellent foreground settings. Place a building or shack at each side of your canvas and glimpse the subject between and beyond them. Poke about construction sites, elevated train stations, and junkyards. Look about for interesting rocks, cliffs, trees, large branches, gates, fence posts, knotholes in the side of a barn, or farmyard or playground equipment as likely framing devices—the possibilities are virtually unlimited. But you have to keep your eyes open and your mind alert. The foreground probably has the frame you are looking for, but it is up to you to be resourceful enough to find it.

August Morning by Walter Garver, oil on Masonite, 45″ x 36″ (114 x 91 cm). Walter Garver is one of the most design-conscious of our realist painters. He openly admits to using photographic sources, but he uses those sources creatively. His paintings are never made from slides projected onto his panels, but are composites of material gathered from black-and-white photographs and gouache studies to form compositions noted for their thoughtfully designed shapes and patterns. Indeed, his sense of pattern is nowhere more evident than in this painting, with its strong backlighting and its strong interplay of lights and darks. The picture is tightly but sensitively organized. The bridge is skillfully placed asymmetrically, and oppositions of simplicity and complexity have been set up to capitalize on the contrast of static background masses with dynamic foreground diagonals. As usual, Garver has used shadows primarily as shapes, exploiting their design possibilities. Observe, too, the progression in treatment from the highly textured immediate foreground to the flat planes in the distance. Finally, he has contrasted the soft, organic forms of his landscape with the man-made, hard-edge geometric forms in the foreground.

8. LONG HORIZONTAL COMPOSITION

CONCEPT. All serious painters have found it possible to circumvent the stock sizes in canvases and frames by stretching canvases and sawing panels to any measurement they wish. Watercolorists scour the countryside for ever larger papers or paper by the roll, but many students and amateurs, for one reason or another, seem quite content to fall back on stock sizes. Ultimately this hampers these artists—sometimes they become addicted to certain traditional picture sizes and lose the nerve to venture away from these known, safe proportions. An artist can become so accustomed to a certain size and scale that he becomes reluctant or unable to compose pictures that are square, or some other odd proportion not usually found in the stock sizes.

Nevertheless, it is possible to break away from standard proportions and to experiment more freely in a wide range of sizes. A painter should feel equally at ease on a 12″ x 16″ (30 x 41 cm) or a 40″ x 60″ (102 x 152 cm). Some watercolorists, for instance, habitually work only on full sheets (22″ x 30″/56 x 76 cm) or half sheets (15″ x 22″/38 x 56 cm) without realizing that they have fallen into a rut. For the sake of variety, if nothing else, they should occasionally use a double elephant size (26″ x 40″/66 x 102 cm) or try cutting their papers into uncommon sizes. Painters working in oil or acrylic should feel equally free to try out some peculiar or outrageous proportions.

Size is not the issue as much as is *proportion*, the relation of height to width. An unusual proportion offers the painter more challenging compositional problems and provides him with a more visually arresting rectangular form for his subject. The long horizontal format is one of the most interesting to work with, and by this I mean a proportion of 1 to 3 or 1 to 4. I have even done paintings that were a 1 to 5 relationship.

Aside from the exceptionally wide Oriental paintings and drawings with which we are all familiar, there is also a history of horizontals in Western art. I immediately think of some very long horizontal paintings by Constable, Fitz Hugh Lane, and Georgia O'Keeffe, and one watercolor in particular by Winslow Homer that is 3″ (7.6 cm) high and 20″ (51 cm) wide!

There is probably no better way to express a landscape panorama than to use this horizontal format, and it is also good to think of it as a means of revitalizing one's compositions.

PLAN. One way to get started using unusual proportions is to keep those long scraps and strips left over after you have cut canvas or paper or sawed Masonite panels. Those odd pieces which you might ordinarily discard can be used as painting surfaces. Watercolor paper can be cut into long strips—two, three, or four per sheet—rather than cutting it into halves and quarters.

Another way is to determine in advance some outlandishly long proportion and cut your canvas, paper, or panel accordingly. If you are not familiar with long horizontals, it might be advisable to begin with a 1 to 3 relationship of height to width, and later try taking on some of the more extreme proportions.

Your main problems will be subject matter and composition. You should choose some kind of panoramic expanse that fits naturally into the wide horizontal format. Georgia O'Keeffe has done a painting of buildings and factories on both sides of the East River in New York and panoramic cloudscapes as viewed from an airplane. Or, there are always fields, mountains, forests, deserts, industrial landscapes, parks, and prairies that are well suited to this stretched-out proportion.

Compositionally there are also hazards. You must see to it that visual interest is constantly sustained at all points across the picture, or that various areas are emphasized at irregular intervals all the way across. What you do not want to do is divide the surface into two or three obviously distinct sections or permit areas that lack interest altogether. Strive for flow and continuity. Avoid symmetry, centralization, and dead spots where nothing happens. Use all your powers of invention to make the composition read successfully, no matter how eccentric the proportion.

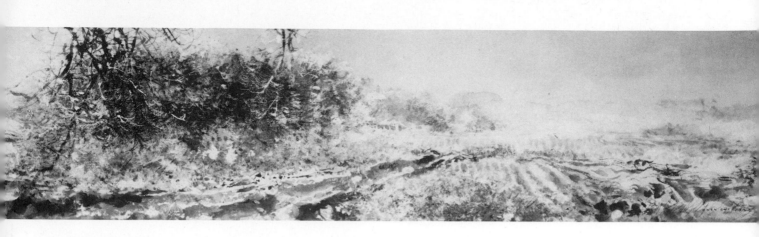

Winter by Chen Chi, N. A., A. W. S., watercolor on rice paper, 13½″ x 53″ (34 x 135 cm). Chen Chi is one of our foremost watercolorists, and since he is a product of two cultures, his work is a refreshing mixture of East and West. He depends strongly upon observation of his subjects, and sketches constantly, but his paintings are never the result of specific drawings. He prefers to absorb the landscape forms inwardly and then later paint improvisationally, allowing his intuitions to take over the development of the picture, intuitions controlled by memory and emotional responses. Here he has used the long horizontal format, often favored by him, to express not just a section of landscape, but a great sweep into and across a space filled with trees, fields, and ground forms. Most of the emphasis is concentrated in the large mass of dark trees at left, accented by deft calligraphic brushstrokes. This carries over toward the middle of the painting, becoming a softer, more subtle, atmospheric treatment. Then toward the extreme right, there is another flurry of calligraphic markings. He activates the total surface by shifts of emphasis, a rich assortment of textures, and a seemingly unlimited range of tonal variations, all tied together by the diversified brushwork. In this way Chen Chi interests the viewer throughout the entire length of the sheet and still maintains overall unity.

9. NARROW VERTICAL COMPOSITION

CONCEPT. The natural counterpart of the long horizontal format is the narrow vertical format. The stock sizes we know so well have been arrived at largely because of their versatility; they are equally adaptable to being hung vertically or horizontally. As in the preceding section, however, I am thinking once again of more unusual proportions of height in relation to width, something like 3 to 1, 5 to 1, or even greater. Possibly this vertically oriented proportion is more striking to the eye, even more eccentric than the long horizontal, because artists have not used it with the same frequency, and the public is not quite so familiar with it.

In some respects it might be said that the very narrow vertical is a more artificial concept, a more self-conscious, almost perverse, rectangular proportion—or at least this is true in the Western tradition. Oriental painters have used it freely for centuries, and certainly it was especially appropriate to their mountain scenes. Whereas the long horizontal expresses distance and a lateral spreading out, the tall vertical is useful mainly to express enormous height, in trees as well as mountains.

Painters in the Western tradition find this proportion less natural to them in terms of its adaptability to landscape motifs, and except for a few scattered artists, it is a proportion generally avoided. Although many abstract painters have found the tall vertical very useful, realist painters have, for the most part, found it fairly difficult to compose landscapes within tall, slim limits. The most recent realist painting I have seen in this format was a Lois Dodd landscape of a house among trees. Actually, it was a vertical triptych, made up of three connected canvases with a total measurement of 168″ x 36″ (427 x 91 cm). It was easily the most striking painting in that exhibition, not for its immense size alone, but for its highly unusual proportions applied to the representational approach.

For some contemporary painters this narrow vertical is a compositional challenge of the first order. It becomes for them a problem-solving situation—how to squeeze, compress, or cajole their subject matter into an extremely vertical rectangle. Even if there is no expressive reason for resorting to such a strong vertical, at least an artist can try it occasionally to test his ingenuity.

PLAN. Some of the vertical panels I have used are 52″ x 24″ (132 x 61 cm), 48″ x 28″ (122 x 71 cm), 44″ x 16″ (112 x 41 cm) and 50″ x 8″ (127 x 20 cm). I offer these only as random suggestions. Different proportions pose different problems compositionally, and some are easier to handle than others.

In some cases the subject matter will dictate the vertical proportion. The design can be worked out in thumbnail sketches or small studies, and from these you can multiply the measurements to arrive at the size you feel is right for you and the picture. In other cases you might haphazardly take a scrap of canvas or Masonite and, considering it as a vertical rectangle, decide what kind of landscape image will best fit into that size and proportion.

You will find that the odd measurements give ample opportunity for large, empty spaces opposed to smaller shapes and divisions. Because of varying degrees of narrowness, the chances for dividing the area vertically are sometimes restricted, and you may find yourself depending on horizontal surface divisions spaced at various intervals. If this is the case, be sure you do not divide the panel at mid-level, breaking the picture into two equal parts. It would be better to have three or four horizontals, placed as judiciously as possible—some far apart, others closer to each other. Or work for some offbeat relation between horizontal and vertical elements or a very off-center focal point.

No matter what your style or approach, the use of a narrow vertical is bound to make you more sensitive to divisions of surface and to the flow and continuity of shapes and areas throughout the painting.

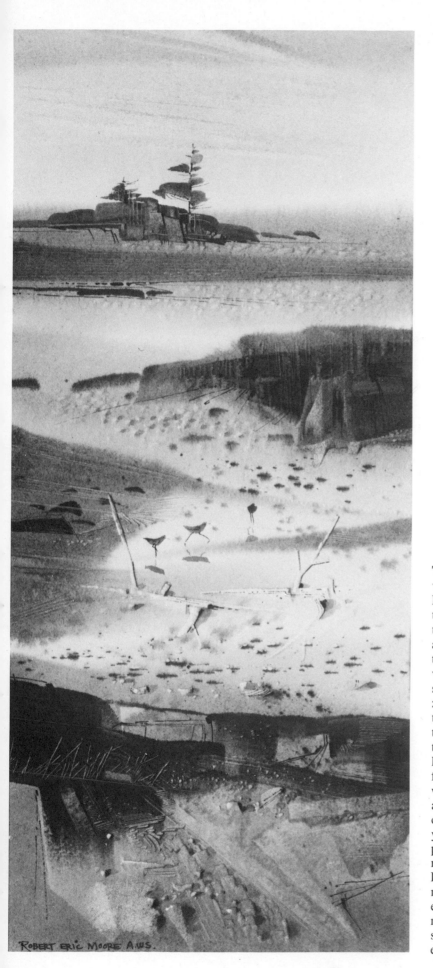

Trio of Windbirds Robert Eric Moore, A. W. S., watercolor on paper, 29½" x 12" (75 x 30 cm). Robert Eric Moore is most adept at bringing out the design qualities of his Maine coast subject matter without losing a sense of realism, synthesizing an abstract structure with a predominantly descriptive treatment. This vertical painting has been divided horizontally into three unequal zones: two smaller zones at top and bottom, and one major zone that occupies the central area. The simplest of the three divisions is the sky and distant land at the top. Most of the detail and interest is to be found in the large area; and as a foil to both of these, the lower area is rich in texture and has the darkest forms. The central area is soft and gentle, with wet-in-wet washes, spattered and mottled textures, and the lightest, broadest passages. All three zones connect and flow easily from one to another, and yet the clearly defined surface divisions keep the picture from being a monotonous, overall treatment in which interest is too equal everywhere. Despite the difficulties of a strongly vertical format, Moore has seen to it that there are no dull or empty stretches. His control of emphasis, focus, mass, line, and abstract textures opposed to descriptive accents is strongly evident throughout the entire painting.

10. IN THE MIDDLE OF A SUBJECT

CONCEPT. If you are not going to look at, up to, or down on your landscape subject, there is something else you can do—get directly into the middle of it. This is distinguishable from a closeup view, because here we are concerned with large-scale subjects which the artist is immersed in or surrounded by.

It is somewhat akin to the device used by authors who begin their stories *in medias res*, plunging the reader right into the middle of things. There is no preamble, no long buildup of situation and character. *In medias res* grabs the reader by the arm and throws him without preparation into the midst of it all, catching him up in the story before he has a chance to become bored.

In painting it can be much the same thing. Instead of a foreground that leads into the picture more or less gradually, the middle-of-the-subject viewpoint eliminates the foreground altogether. The viewer suddenly faces head on—and is completely surrounded by—the subject of the painting.

Similarly, this viewpoint also omits any use of a horizon line, since at this range the viewer is so close to the forms he cannot see much beyond them. He is not permitted the long view that eventually opens out into distant space. It may sound rather claustrophobic, and this viewpoint does indeed severely compress the depth of picture space. As in most contemporary paintings that stress the two-dimensionality of the surface, the subject is contained in a shallow space, and its immediacy might be negated by use of a horizon.

Also, it is obvious that the "normal" scale of things is altered when seen from the middle of the subject. Instead of perceiving the subject as a large-scale mass seen from some distance, the viewer finds himself face to face with it. What otherwise might be small, detailed forms in a panoramic landscape now become larger, major forms occupying a far greater portion of the picture surface. This shift in scale is another intriguing aspect of this viewpoint for both spectator and artist.

The important point to remember is that a subject can be seen from many viewpoints, that the outer view is not the only one, and that the middle-of-the-subject view can offer many exciting possibilities for a heightened experience of the subject.

PLAN. Abandon your traditional ideas of looking *at* landscape, and try a point of view from *within* the subject. For reference, take a look at Monet's lily ponds, some of the garden paintings by Bonnard, Michael Mazur's studies of palmetto groves, or Neil Welliver's forest interiors. In all these the artist's attempt is not to paint the broad view but, rather, to narrow the field to a smaller area within the larger confines of the motif. It is one thing to paint the Everglades from some distance, but quite a different mood is projected when the artist puts his spectator right in the swamp itself, magnifying vegetal forms and patterns or suggesting the ambiguities of flora and fauna which exist in that shadowy world.

You can do much the same thing with other subjects and with their particular expressive possibilities. A garden environment offers many opportunities for playing with color, shape, and design; a forest contains all kinds of linear branch forms intertwined with leaf shapes and patterns; and much the same approach can be taken with cornfields. Instead of the hackneyed surf scene, why not try closing in on the ocean so that sea foam and thrashing waves are experienced at a distance of only a few feet? It may frighten the landlubber, but it affords the artist a chance to engage his audience in a far more intimate involvement with the colors, textures, and movement of a storm-tossed sea. As a change from placid views across ocean or lake, it might be more imaginative to attempt an underwaterscape filled with a multitude of marine shapes, textures, and iridescent colors.

Painting in the middle of the subject may not be for everyone, but it is one possible point of view that should not be overlooked.

Green Passage by Charles Coiner, N. A., oil on canvas, 25″ x 39″ (64 x 99 cm). In this painting Charles Coiner has chosen to paint somewhat impressionistically a forest interior from the vantage point of being surrounded by forest forms. There is no foreground and no horizon, and this allows him to concentrate on what most directly concerns him—the flicker of light among tree trunks, branches, and foliage, and the interplay of lines and textures. The trees are carefully positioned across the picture, and the shifting patterns of lights and darks have been just as consciously organized, an uninsistent design structure that gives order to the loosely painted surface. He has been most careful not to be distracted by literal detail; rather than enumerate all those twigs, branches, and masses of leaves, Coiner has treated his subject suggestively rather than descriptively. As a skilled artist, he has avoided the pitfall of rendering foliage leaf by leaf, and if you look closely, you will note that there are not really any identifiable leaves; instead he has interpreted them in terms of a wide variety of textures—mottled, dappled, dabbed, spattered, glazed, impastoed—to *suggest* leaves without specifically defining them. The viewpoint from the very depths of the forest enabled him to achieve a truly painterly vision of his subject. Photo courtesy of Midtown Galleries, New York City.

11. EXTREME CLOSE-UP—REALISTIC

CONCEPT. A landscape painting usually shows the long view of things, encompassing a broad vista of fields, mountains, trees, and buildings. Even when not painting a panoramic composition that includes vast spaces, the landscape artist customarily situates himself well back from his subject and works with the traditional foreground, middleground, and background. But the mistake that many painters make is to try to include too much in their pictures. Often they put in somewhat more sky that is required in proportion to the rest of the subject matter, or they show more foreground than is really necessary. In most cases, though, it is not wholly a matter of composition; it is more a question of how the artist goes about discovering his landscape material. The common tendency is to look ahead, look around, look outward, and then paint a large segment of nature.

One way to break that habit is to take a tip from the photographers and adopt a close-up view of nature. Instead of looking toward the distance, it can be very refreshing to consider what is closer at hand. Rather than show the entire farmyard, why not concentrate on a corner of a barn with a bucket hanging on a nail and make that the whole subject of a painting? Or select some wooden porch steps as the basis for a composition, studying the patterns of light and shadow falling across those forms.

The point is to be alert to unexpected possibilities for pictorial subject matter, to be aware of material that is nearby, not off in the distance. A painter who deals in close-up views usually seems to make more personal and interesting choices of what to paint, while a painter who habitually takes only the long view tends to paint very much the same sort of thing as too many other painters. The close-up concept can be pushed even further to form a composition from very small details in nature: for example, a tidepool, weathered shingles and some rusty nails, or barnacles on a rock. Such subjects need not be handled in a superrealist technique—which might at first suggest itself—but they lend themselves equally well to very broad, painterly handling or semi-abstract treatment.

The painter Arshile Gorky derived some of his most successful compositions from sitting and looking directly into the grass on a Virginia farm, then doing a series of drawings as a direct response to the forms he had examined at close range. He enlarged, improvised, reorganized, and elaborated constantly, building a personal vocabulary of forms that then became the basis for a series of large abstract paintings.

PLAN. Narrow your viewpoint and generally refrain from looking any further than, say, twenty feet from yourself. You are searching for fragments or sections, rather than for entire buildings or open spaces. Keep an eye out for design possibilities: shape relations; the sharp, slicing diagonal of a slanting shadow; or an interesting interplay of lines, colors, and textures.

It is best to avoid moving in so close that your painting fails to explain itself; show enough of the subject so that people can recognize what it is all about. And do not move in so close that there are too few visual areas in the composition. Try to maintain a balance of a few small areas set off by several large areas, and be sure that the shapes are not too similar in size and scale.

Above all, be surprising in your choices. Train your eye to catch the unexpected—the unusual or offbeat arrangement that might be bypassed by painters looking for more obvious subjects. Swing around suddenly and look behind you to check out a different view of your material. Look directly downward at the areas near your feet. Here are a scattering of tar paper, a rusty metal band, and some rope—a sort of natural three-dimensional collage. Over there are a few dried leaves, some cracked concrete, and a small puddle of oil, iridescent in the sunlight

Your pictures are all around you, waiting to be discovered. Consider all things as possible material for a painting. Keep your eye alert at all times. The seemingly ordinary things you casually overlook *could* become the subject of a major painting by an artist who is unusually sensitive and alert to his surroundings.

Island Lilies II by Joseph Raffael, oil on canvas, 84″ x 132″ (113 x 335 cm). Courtesy Nancy Hoffman Gallery, New York City. Joseph Raffael's paintings are a modern culmination of the tradition of Romanticism and Luminism in American art. His earlier Water Series paintings were such complex and lyrical investigations of fractured light and form that they verged on being almost totally abstract studies of color and light. The newer Water Lily paintings are at first glance more representational in intent. Raffael works from photographs, but transfers his material to a very large scale, and many of his paintings, such as this one, are 7 feet high and 11 feet wide. To view a Raffael painting is to experience two quite different pictures: from a distance, or in reproduction, it looks like a painstakingly exact photorealist painting; a close view, however, reveals a highly spontaneous, impressionistic, painterly handling of impasto combined with calligraphic lines, stains, blots, and dots. The viewer finds himself caught up in an intricate web of varied paint surfaces in which light is somehow given substance. These water lilies, so different from those by Monet, have a seeming clarity which is belied by the almost casual exuberance of the paint surfaces. The distortion of scale applied to lily pads or the colorful glitter of moving water is, for Raffael, only a means to an end, a way of projecting an intensified and very beautiful personal vision.

12. EXTREME CLOSE-UP—ABSTRACT

CONCEPT. Another use of the extreme close-up is as a source for abstract imagery. We have all heard the line about "seeing a world in a grain of sand." There has also been a rising interest in this country in *suiseki*, the collecting of stones with unusual shapes and markings that suggest mountains, waterfalls, and other natural forms and phenomena. It is easily possible to extend that same attitude into the field of painting by searching for abstract landscape compositions in geological matter such as rocks; oil, gasoline, or salt stains on pavement; peeling paint or tattered posters; or various wood tissues and minerals as seen under a microscope. It means reading nature as you would a book, or looking at it with a magnifying glass.

In contrast to the broadest possible view of our planet—photographs taken from outer space—the extreme close-up is an examination of nature in its smallest, most detailed fragments. This is a much closer view of landscape than that discussed in the preceding section, but it is still to be regarded as a form of landscape imagery, no matter how minute the scale.

What the artist is concerned with here is the discovery of shapes, patterns, and textures that reveal the structure and design which exist in even the most casual forms of nature. Some of these could be forms visible only through the microscope. A painter refers to such forms to stimulate his inventive powers, to broaden his repertory of abstract relationships and colors, and to become engaged in a completely new view of his world.

By adopting the close-up view of nature's details, we press beyond the familiar to an intensified awareness of the pictorial possibilities of the less obvious details. Then we rework those relationships into abstract organizations of line, shape, color, and pattern. Quite often not much reworking is necessary, since many of nature's forms, both large and small, are already abstract to begin with.

PLAN. There are two ways to approach this concept. One is by very close observation of nature. Here, as usual, we have a lot to learn from the great contemporary photographers who have concentrated on close-up photography of nature. I refer you particularly to Edward Weston and Aaron Siskind. Of the two, Weston is the most traditionally pictorial, but he favored the extreme close-up in many of his finest photos, especially those negatives made along the California coast at Point Lobos. Siskind is more of a formalist; his work is more purely abstract, and his close-ups are often quite unrecognizable as natural objects or surfaces.

If you choose direct observation of things around you, it means leaving your car behind and doing a lot of walking. Many artists I know are fond of beach-walking, climbing around beach rocks and exploring sea caves, looking closely at small-scale forms and textures—barnacles, stones, shells, seaweed, lichen—keeping an eye out for those lesser forms which might suggest possibilities for abstract paintings.

Walking in the woods or fields offers similar opportunities for finding designs, patterns, and textures. Focus your attention on the very small things, but see a full-scale painting in your mind's eye. The bark of trees, broken slabs of ice at the edge of a pond, a woodpile, the face of an eroded rock—all these could be the starting point for paintings. Don't try to be realistically descriptive; it does not matter if the subject is at all recognizable. Your most important consideration is the orchestration of line and tone, color and texture, to create a picture that exists independently of its origins.

The alternative to direct contact with natural forms is perusal of books of photomicrographs of nature. The best two I know are *Micro Art: Art Images in a Hidden World* by Lewis R. Wolberg (Harry N. Abrams, New York) and *Hidden Art in Nature* by Oscar Forel (Harper & Row, New York, 1972). Though the diversity of such forms and designs is stimulating to the creative imagination, keep in mind that such compositions are never to be copied or simply enlarged onto canvas or paper. You are referring to them only as a general source of design ideas, another kind of landscape world that should be used merely as a point of departure for your paintings. You should enhance them in some way, but never be a slave to them. To copy is to repeat; your job is to *invent*.

Monoliths by Carl Morris, acrylic on canvas, 72″ x 72″ (183 x 183 cm). The clue to many of Carl Morris's paintings lies in their titles: *Core*, *Monolith*, *Geode*, *Yellow Canyon*, *Light and Rock*. They are examples of the extreme close-up presented in monumental terms. They could be called nature abstractions: but, more specifically, they are geological landscapes, internal views of our planet. There are many currents running through Morris's art, but the recurring theme of natural forces, organic forms, fissures, and elemental masses is undoubtedly the result of his intimate association with the coastal landscape of the Pacific Northwest. Rocks are naturally abstract, and to an artist, their markings and striations often seem suggestive or symbolic. In this painting, Morris has adopted a close-up view, and working with monumental forms, weathered textures, and glazes, he has evoked a highly personal geological-abstract landscape so massive and condensed that it is almost a symbol. Morris works in a method of improvisational painting that was common to many of the Abstract-Expressionists of the 1950s, but he uses that method to arrive at images that are a balance between the harsh or ethereal outer world of nature and the poetic, mystical inner world of the artist. The close-up view seen here could be read as no more than a close-up, but his magnification of the subject on a six-foot-square canvas has a stronger visual impact, a sense of awesome, heroic proportions. The painting has transcended its sources. Photo courtesy Kraushaar Gallery, New York City.

13. OVAL OR CIRCULAR FORMAT

CONCEPT. Rectangular paintings have been around for so long that most of us have come to accept the rectangle as the *only* form for paintings. But if we stop to think a bit, circular paintings ("tondi") are found not only in Oriental art but in our Western culture ever since the early Renaissance. Indeed, artists have continued to paint in that format right up to the present. Oval paintings were much in vogue in the 18th and 19th centuries and were occasionally done even by such early modernists as Braque, Picasso, Delaunay, and Mondrian, indicating that the oval is not so completely old-fashioned as it might at first seem.

For the painter temporarily weary of the usual rectangle and looking for a breath of fresh air in his compositions, the circle or the oval format offers a welcome change, a chance to think and design a little differently, to face new problems in terms of how the subject is to be related to the edges of the picture. The main difference, of course, is that the rectangle's customary four edges no longer exist but have been reduced to one edge flowing continuously around the painting.

Actually, I suppose this cutting off the four corners is a boon to those few painters who never quite knew how to deal with those troublesome angles in the first place. A number of beginning painters have either chronic "foreground trouble" or "corner trouble" and don't quite know how to manage these passages successfully. Nevertheless, I would advise them to gain experience and skill in solving these problems first, and then try an oval or tondo later, not as an escape but as an interesting compositional variation.

Contemporary painters have diverse attitudes toward the circle or oval: some consider them excellent foils or containers for paintings consisting primarily of horizontal-vertical relationships; some regard the circle in particular as the perfect shape for symbolic content; others look upon such formats as striking or exciting; and there are those who feel they are the best formats, simply because they are the most natural and appropriate way of presenting certain subjects.

PLAN. My only caution to the painter who is about to undertake an oval or a tondo is that he must be careful that the subject matter does not obviously repeat or follow too easily the curved boundaries of the painting. This would give the picture a soft, sinuous quality, to be sure; but if both subject and edge have such a similar character, there is a risk of monotony or repetitiousness. Generally, firmly designed, hard-edged horizontals, verticals, and diagonals should predominate within this format, and curves should be subordinate elements.

It will probably be necessary to have a good carpenter or cabinetmaker assemble a circular or oval stretcher to your own specifications. It would be easier still to have someone skilled with a band saw cut an oval or circular Masonite panel to whatever contour and size you have in mind. The painting can be done directly on the panel after it has been primed with gesso, or canvas can be mounted on the Masonite panel, using acrylic gel as an adhesive. Frame or glass companies usually can provide framing; or you can use old mirror frames from flea markets and junk shops and cut panels to fit the frames. The situation is somewhat easier in watercolor painting, since the oval or tondo painting in this medium does not necessarily have to be framed right to the edge. Most watercolorists use a standard rectangular mat and frame, but cut only the mat opening to suit the shape and size of the painting. And believe me, it takes a steady hand to cut a curved mat opening! Unless you have a flair for that sort of thing, maybe your framer would do a better job.

Sometimes it is possible to paint on a rectangular sheet of illustration board and then place it in a mat with a circular or oval opening. There is the chance, however, that the shapes in the picture might be awkwardly crowded or cropped. It really is best to plan the circular or oval picture from the beginning as a total organic design fully related to the setting in which it will be shown.

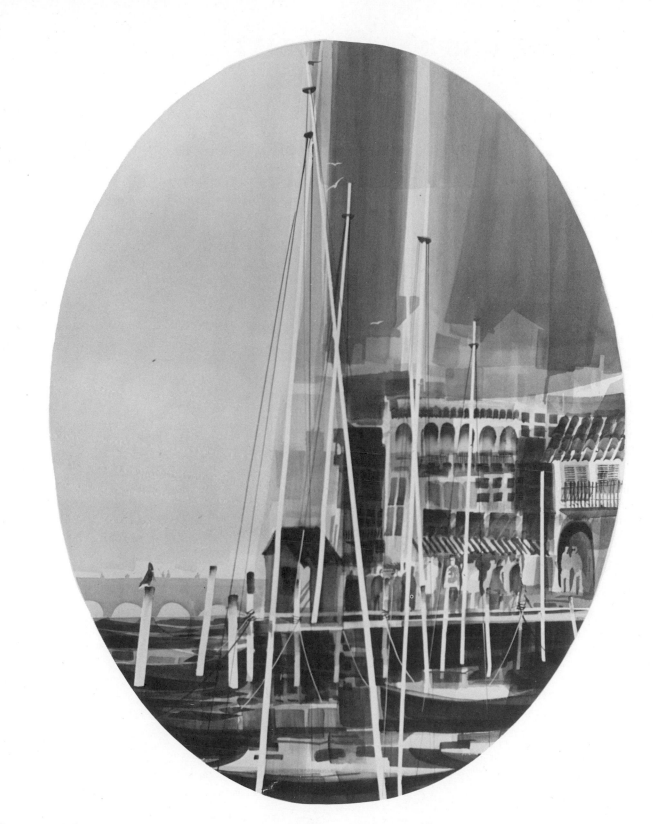

Palm Beach Harbor by Valfred Thelin, A. W. S., water-color on illustration board, 40″ x 30″ (102 x 76 cm). Valfred Thelin is at ease in both the circular and oval format. Here he has chosen to work with a playful design that is built mainly upon a horizontal-vertical structure, relieved by several major tilted masts and some smaller tilted dock pilings. Curves have been kept to a minimum and are to be seen only in the arches of the bridge at left and in the arched forms in the building just to the right of center. The contrasts of lights and darks, the interplay of linear elements with large flat washes, and the oppositions of simple areas to complex patterns have been deftly fitted into a vertical oval composition that strongly emphasizes and reinforces the skyward thrusts of the masts. The painting has been designed so that all lines and shapes take their places naturally within the oval, and there is no feeling that shapes or areas have ended too abruptly. Conceived as an oval composition, this picture uses the oval not simply as an unusual format, but also as a means of heightening the impact of its harbor subject.

14. REFLECTIONS IN A WINDOW

CONCEPT. Painters seem to have always had a fascination with windows, each artist using the window for his own purposes. Some have used windows as a device for echoing the edges of the canvas; others have used them as a frame through which figures and landscape beyond are viewed; still others use windows for their abstract qualities. In modern French painting the window motif appears with some regularity in the work of Bonnard, Vuillard, and Matisse; and in this country we find it as a recurrent motif in the paintings of, among others, Edward Hopper, Andrew Wyeth, Richard Diebenkorn, Lois Dodd, and Richard Estes.

Most artists tend to look *through* the window; but the most recent development is to look *at* the window and see the glass itself as a reflective surface. When you look both through the glass and at it, you see two different things simultaneously: you see whatever is *behind* the glass, and you see whatever is reflected *on* the glass. This makes a far more complex image than if a mirror were used instead of a window. Here what is inside and what is outside the window are inextricably bound together on a single surface. It creates not only complex forms, but also a sense of ambiguity about whether things are actually inside or outside the window. The way in which both deep and shallow space are treated within a window picture is also somewhat ambiguous. The artist becomes a visual juggler, playing with optical, spatial, and even hallucinatory effects.

Photographers, too, have used this concept in which the landscape is viewed indirectly. Sometimes in their work the glass reshapes the landscape into rippling, distorted forms; other times the glass is consciously used for its visual ambiguity and its interpenetration of transparent abstract planes, much as a painter might use these qualities.

All this is not a matter of playing games, but a means of dealing with nature in an unexpected way, of offering the spectator a more fascinating visual experience than just a direct, prosaic view of what is there. It is a viewpoint that is less concerned merely with what is shown than with the more intriguing relation between reality and illusion. It is this metaphysical concern, I think, that underlies widespread use of the window motif in current American painting.

Metaphysics aside, artists enjoy the challenge of tackling the confusion of inside-outside and putting it into some kind of visual order, creating a picture space that sets up both a tension and an equilibrium between real depth in nature and two-dimensional pictorial depth. The successful handling of complicated spatial problems alone would be sufficient justification for an artist to use landscape as reflected in a window for the subject of a painting.

PLAN. First, find a window. It should reflect some sort of landscape subject—a park, a garden, woods, city buildings, a farmyard, a lighthouse, mountains. Possibilities are unlimited. What you are looking for, in essence, is a picture within a picture, a landscape contained by a window frame.

I would recommend that the window glass not be used simply as a mirror. There should also be some suggestion of what lies *behind* the window as well—forms vaguely sensed within the interior, or even a view through a second window on the far wall of that interior. You will be showing what you see through the major window that occupies most of your picture surface. Balanced with that, you will suggest the landscape forms reflected in the glass—a subtle interweaving of what is behind the window with the exterior subject reflected on it. It demands considerable control and a sense of order to make both subjects co-exist on the same canvas. There is always the danger of viewer confusion about what is happening in your painting; but it is your demanding task to make it orderly and readable, while still retaining a touch of the ambiguity that is part of the appeal of this viewpoint.

Another problem lies in resolving the tangled spatial relationships. But the very fact that the glass *reflects a landscape* ensures that the painting as a whole is firmly anchored to the picture plane. No matter how much depth is implied beyond the window, the reflecting glass serves as a constant reminder of the flatness of the picture surface itself.

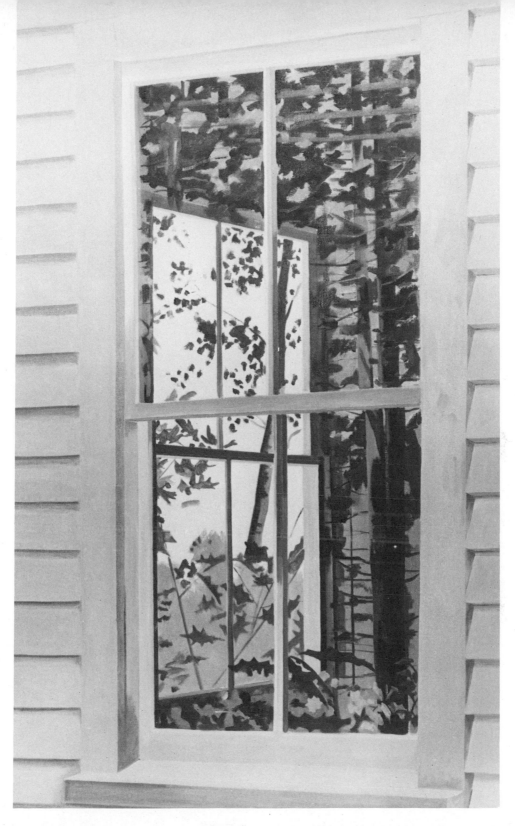

Window Landscape by Lois Dodd, oil on canvas, 60″ x 36″ (152 x 91 cm). Courtesy of Green Mountain Gallery, New York City. Directness, modesty, and understatement are all descriptive of Lois Dodd's carefully structured paintings. She always works directly from nature, solidly and thoughtfully shunning all painterly pyrotechnics. *Window Landscape* has an unusually rich and complex spatial arrangement; actually, there are four distinct planes or spaces in this picture, all highly compressed and occasionally overlapping. First, there are the window and shingles on the picture plane, nearest the viewer. Second, there are the reflected trees in the glass, trees that are really situated outside the window and behind the viewer. Third, there is the interior space behind the window, showing still another window. Finally, there is the space that opens up beyond that inner window to reveal other trees against a sky. Four levels—all contained on one surface and all orchestrated with such logic and control that there is no confusion at all. The viewer knows exactly where he is at all times and is aware of what is real and what is reflected; and there is just enough ambiguity to invite and sustain interest. Note, too, how the window frame and shingles are handled with extreme simplicity and severity as a foil for the intricate spatial activity that takes place within the window area.

15. BACKLIGHTING

CONCEPT. The usual way of lighting a landscape painting is to have a light source coming from the right or left side of the picture. This angle best delineates the forms or volumes and offers the best chances to make use of shadows. It is most effective when the sun is relatively low in the sky, such as early morning or late afternoon, when contrasts are heightened, color is richest, and shadows are deepest.

Frontal lighting, where the light source is in back of the viewer (remember the camera manuals that instruct you to have the sun behind you while taking photographs?), tends to flatten out the subject, minimizing both shadows and description of form. Top lighting is a more stagey device, best used for figure subjects (as in Rembrandt's *Old Woman Paring Her Nails*) rather than for landscape. A diffused light, as on a gray or foggy day, comes from no specific source. Although it provides opportunities to paint rich local colors without distracting lights and shadows, this type of lighting also eliminates shadows and marked tonal contrasts that might enrich the overall pattern.

More than any other, backlighting is perhaps the most striking and dramatic, since it throws the subject into strong silhouette against the sky. In backlighting, the sun does not have to actually be in the picture, as it would be in a late afternoon or sunset painting. There are many pictures in which the viewer faces the glare of sunlight (or moonlight) but the light source itself is outside the limits of the composition.

Backlighting can often be found in the work of Turner, Monet, Degas, and Bonnard. Winslow Homer used it several times, but never with greater strength than in his *The Artist's Studio in an Afternoon Fog*, a view of his studio atop the rocks at Prout's Neck, Maine. This use of lighting can also be found in the paintings of Fitz Hugh Lane, George Inness, George Bellows, Anthony Thieme, Edward Hopper, and Andrew Wyeth. Backlit subjects appear with regularity in Charles Burchfield's hillsides and forest interiors—most tellingly of all, in his magnificent *Ice Glare* in New York's Whitney Museum of American Art.

The effect of light coming from within the picture throws any shadows directly toward the spectator rather than diagonally across or off to one side or the other.

Light itself plays a more important part in the painting than it does for sidelit subjects. This is probably why it had such strong appeal for the so-called American "luminist" painters—and indeed, to all painters who were most deeply concerned with effects of light.

Also, by reducing the main forms to dark silhouettes against a strong light, backlighting condenses all the lesser elements into a more compact composition that stresses the principal masses rather than texture or detail.

PLAN. I personally find backlit subjects the most challenging of all, and backlighting the most dramatic means of presenting certain landscape subjects. Unfortunately, they are not as easy to execute as they look. I do not usually recommend that my students take on a backlighting problem until they have gained both a sharp eye at seeing values accurately and skill in painting subtle tonal differentiations at the darker end of the value scale. Painting against the light is admittedly difficult, just because it does necessitate flattening forms into a silhouette. All you can see is the shadowed side of your subject, but it is up to you to achieve two things: (1) maintain a sense of volume, so that your subject does not resemble a flat cardboard cutout; (2) maintain color and value variations within the general dark masses.

The flat, cardboard cutout effect is a sign of inexperience. Break up the colors and values; do all you can to distinguish the various planes and surfaces in order to suggest a feeling of solidity and volume. Even if it is difficult to discern such fine distinctions, paint them in anyway, so that three-dimensional form is felt even in the very darkest masses.

At all times, relate your dark values to the lighter background with extreme sensitivity and accuracy. To sense how dark your darks really are, don't look into the darks themselves, but look at the light behind them and comprehend those darks in their true relationship to the bright areas. In a backlighting situation, tonal gradations can be very deceptive; but if handled correctly, they can help immeasurably in capturing the brilliance of light and adding to the tonal strength of your painting.

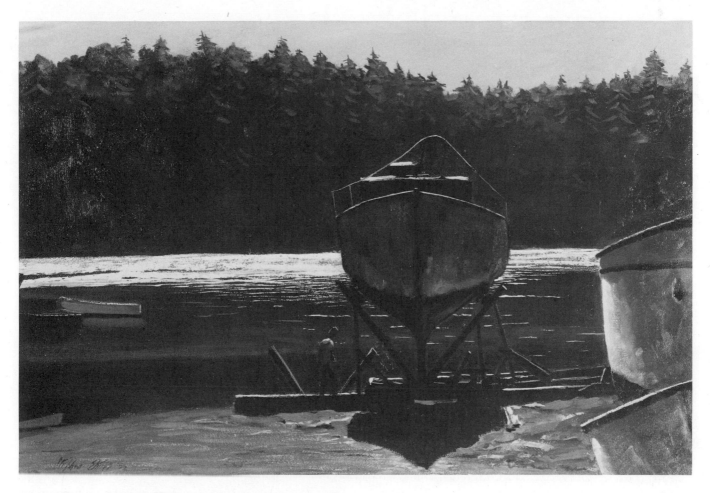

Hauled Out by Stephen Etnier, N A , oil on Masonite, 16″ x
24″ (41 x 61 cm). Courtesy Midtown Galleries, New York
City. Stephen Etnier is a master of backlighting and has prob-
ably made more consistent use of this device than any other
contemporary American painter. In this painting the strong
sun does not show in the picture, but is reflected in the water
as a brilliant strip of white, lighter than anything else in the
composition. Above all, this picture is a lesson in the control
of values: the variations of darks against darks are adroitly
handled so that although most of the areas are in shadow or
very low key, they are sufficiently defined and separated
from each other. Achieving this has required the most deli-
cate adjustments and refinements of values. Accents of light
are used sparingly to define sunlight striking certain edges
and surfaces, and the light reflected upward from the ground
helps to suggest the form of the boat's bow. Trees are seen as
a simple mass against the sky, a simplicity of handling that
serves as a foil for the more detailed forms and structures
elsewhere. The shadow cast by the boat on the immediate
foreground prevents the foreground from being flat and
empty. Although *Hauled Out* is the title of this painting, light
is its real subject.

16. SHADOWS FOR DESIGN INTEREST

CONCEPT. An art student begins his training by learning to draw first in terms of line. Then he progresses from that stage to drawing objects in light and shade, describing form by means of gradations from light to shadow. He also learns to use cast shadows to create a sense of objects resting on surfaces or to show the way one object relates spatially to other objects in the same environment. This is using light for purely descriptive purposes.

Later on, the student will come to think of lights and darks not only as they apply specifically to individual forms, but as a means of achieving a unifying pattern of values throughout the drawing. Thus, manipulation of light and dark is no longer merely descriptive, but becomes an important part of the total design.

The beginning painter follows much the same route, in that his first concern is in learning to depict objects or forms using light and shade, as well as color, *to define and model form* as seen under various lighting conditions. Some artists never feel an urge to go any further than that: they just use color, light, and shadow to express reality convincingly, and let it go at that.

Painters who have a strong coloristic bent, following the discoveries of the Impressionists, use light *to break up forms*. Shadows and tone are minimized, since these artists are less concerned with visual documentation and more interested in how light affects colors in nature.

A third kind of painter looks upon light in still another way, using light and dark contrasts *to reveal geometry in nature*—light and shadow not as description, but as design. Some of the most rigorously constructed paintings in American art are by Edward Hopper, whose pictures often depend almost entirely on the geometrical arrangement of lights and shadows. Hopper himself was amused at comparisons of his starkly structured paintings with those of the nonobjective artist Piet Mondrian. But there is no denying that, in Hopper, there was an abstractionist hidden deep within the great realist. In many cases his subject matter was a deceptively straightforward realism. In actuality, it was conceived and presented as an intellectually formalized design, and such paintings could be enjoyed equally on both levels.

The difference in attitude, where shadows are used for their design interest above all, is that the artist perceives the dark shadows first and foremost as *shapes*, and only secondarily as an absence of light. The ordinary realist painter sees shadow in an ordinary way—to serve as a background mass, to be colorful, or to help project the effect of light on landscape forms—but as little more than that. Charles Hawthorne taught that windows should not be painted as holes in a house, that the student should forget they are windows and make them spots of color in relation to the side of the house. When you are looking for shadows as design elements, you should regard them in somewhat the same way as Hawthorne's windows: not just as shadows, but primarily as shapes. Sophisticated painters see shadows for what they are, but also find in them a way of bridging reality and abstraction.

PLAN. Your first job is to change the way you look at things. Don't think so much about what you are looking at, but concentrate mostly on the shadows. If possible, momentarily forget that the shadow is a shadow, and see it only as a dark shape. It may take some effort, but your objective should be to look first for those shadow-shape relationships and then the subject matter in general, almost as an afterthought.

Choose subjects and lighting that offer you a variety of lights contrasted with strong darks: wharfs, farmyards, alleyways, subway stations, boatyards, highway overpasses. Feel free to alter a shadow in any way that will improve its relationship to the overall design of your painting. Make it more compact, distort it, stretch it out, simplify its contours. You should not think so much of realities as of the drama of light and dark, in which forceful pattern takes precedence over simple description.

You should be dealing with nature primarily in terms of shape and design, utilizing shadow elements for whatever they can do to add another level of interest to your painting. A truly dynamic use of contrasts of lights and shadows can often bring your painting to the verge of abstraction, while still keeping a grip on its realistic aspects. Try for that exquisite balance of nature and geometry that is more satisfying to the eye than either pure realism or pure design.

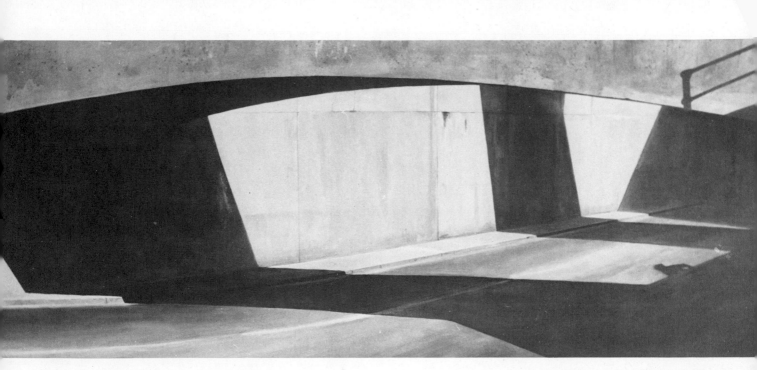

Viaducts by Walter Garver, oil on Masonite, 13″ x 29″ (33 x 74 cm). Private collection. Walter Garver has long been interested in the urban scene in western New York State, but social or environmental commentary are secondary to his use of the city as a rich source of abstract patterns. His paintings have always been notable for their dramatic manipulation of shadow forms that serve a variety of compositional purposes. They break across foregrounds, sidewalks, and walls, dividing and designing the picture surface, but invariably remain within the framework of a realistic style of painting. In this painting the roadway and viaduct forms have been closed in on and stripped to bare essentials, so that the shadow patterns completely dominate the painting. In fact, the abstract shapes of the shadows strike the eye long before one realizes what the actual subject matter is. Garver has seen the shadows primarily as dark shapes with which to design the rectangle of his panel, and he has eliminated every distracting element. (The only implication of human presence is the shadow of a figure at lower right.) All that remains is an austere, condensed design in which the whole interest hinges on the abstract relationship of forceful contrasts of light and dark masses, straight and bent contours, and an occasional linear accent. It is a powerful painting in which reality and abstraction are brought into balance.

17. UNUSUAL CROPPING

CONCEPT. The word "cropping" is usually associated with photography, but the manner in which the camera often happened to cut off subjects abruptly in the early days of photographic art was quickly taken up by late-19th-century painters. It has been suggested, for instance, that certain portraits by Ingres would not have been cropped as they were if he had not been aware of photographic composition; and most certainly, Degas was influenced by photographic images in the intentionally offbeat way he composed various portraits and figure pieces. This quality of unexpectedness has appealed to painters ever since that time, so that today many artists have begun cropping their subjects more radically than ever before.

In the next section I shall discuss corrective cropping, which occurs sometime after completion of a painting but is not a part of its original conception. I am referring here, however, to cropping as a compositional device—a deliberate selection of a viewpoint toward the subject. This kind of cropping, which occurs when the painting is first conceived, involves decisions about just how much or how little of the subject will appear in the picture or how it might be quirkily placed in relation to other areas and spaces within the picture.

The traditional way of situating subject matter within the boundaries of the paper or canvas is to place it where it seems to fit most naturally, with no cramping or wasted space. The motif may be shifted about to a certain extent to avoid obvious symmetry or centralization; but, by and large, the conventional disposition is a straightforward view in which all the main elements of the picture are fully contained within its edges.

The intentionally cropped landscape view is something else again. Unpredictably truncated forms, shapes cut off without warning, cropping that intensifies or exaggerates pictorial relationships to arrive at more interesting shapes—all these are characteristic of planned, unusual cropping. Examples of it are to be found from the Impressionists and Post-Impressionists on down to such more recent painters as Edward Hopper, Andrew Wyeth, Philip Pearlstein, Fairfield Porter, Stephen Etnier, and John Button. These are but a few of the contemporary artists whose paintings frequently include some degree of visual shock achieved by cutting off the subject where least expected. Such skillful use of odd cropping gives their work a more individualistic viewpoint. This element of surprise, of compositional brinksmanship—seeing how drastically the subject can be cropped for effect, without lapsing into mere idiosyncrasy—can take a painting beyond routine composition and offer the spectator a more refreshing view of nature.

PLAN. Here, once again you must rely on your imagination and ingenuity to see your subject in its least obvious terms, to crop the picture as surprisingly as possible. If all goes well, you can mentally crop your composition while first looking at the subject; at other times you may need to draw a complete study of the landscape in your sketchbook and then crop it afterward by marking out new limits for the composition in red or black ink.

Some artists take a piece of cardboard, cut an opening in it the same proportion as their proposed canvas, and then move it around on their preliminary drawing until they discover where it could be cropped to best advantage. The idea here is to find the unusual cutoff point, to avoid trite or conventional placing.

Or, you can also use a camera, framing your subject in the viewfinder, shifting it around until a striking arrangement presents itself. Such photos, taken for purely compositional reference, can spark your creative ideas later on back at the studio.

At all times you must look not just for the asymmetrical design (though that is usually a good part of it), but should keep an eye out for the most daring way to chop off most or part of your subject. This is not always so easy as it might at first seem: if you crop too severely or insensitively, you could be left with a very awkward composition. An arresting design is the ultimate reason for your cropping; shock for its own sake is not enough.

Rooftops: Red Warehouse #8 by John Button, oil on canvas, 38″ x 52″ (97 x 132 cm). Collection Utah Museum of Fine Arts. Purchased by Friends of the Art Museum with the aid of a matching grant from the National Endowment for the Arts. John Button has an eye for eccentric but satisfying compositional arrangements. In this case, the warehouse seems to be attempting to flee the picture by slipping away unobtrusively, but Button has caught it just in the nick of time. In contrast to his painting on page 21, this is not a view looking directly upward; the angles of perspective and the rings around the water tower are not as exaggerated as they would have been in an upward view. Nevertheless, a strong feeling of height and space is achieved by showing only the rooftops and not the entire warehouse. By concentrating on that upper portion of the building and the expanse of cloud and sky above it, Button has created the unsettling feeling that, as critic-historian Robert Rosenblum put it, "There's no place to put your feet." The sky dominates the picture surface in terms of square inches, yet the warehouse forms are by far the most positive elements; it is this juxtaposition of a compact area of strong, hard-edge geometric forms with the larger, soft sky forms that gives this picture its special quality, a quality made possible only through its offbeat compositional cropping.

18. CORRECTIVE CROPPING

CONCEPT. Corrective cropping is used to revise and improve the composition after a picture has been completed. In most instances, corrective cropping will seem necessary only when it is apparent that there are areas of wasted space. There may be areas either too empty or in some way not contributing fully to the total composition; the most direct way to get rid of these is simply to cut or saw them off. Usually an artist will make every effort to revise the composition in terms of repainting and redesigning, but if it is obvious that will not work, perhaps it is best to take a more blunt approach and try outright amputation.

There are two main reasons for cropping. One is to condense the picture into a smaller size, to make it more compact and less rambling, with a minimum of unraveled ends. This ensures that small or not particularly interesting elements are eliminated in favor of a taut composition concentrating on a few crucial forms. The other reason is to elicit a more interesting design, to close in on shapes to arrive at more striking relationships. A painting that has been composed rather conventionally can be improved by stressing offbeat design which is more engaging to the eye than it was in its earlier state. If the artist sees possibilities for redesigning the painting by radical cropping, knowing that a much finer painting will result, then he has every right to chop off the deadwood.

Ideally, of course, the artist should plan and control his composition right from the start, thus having no need to rely on afterthoughts involving such drastic measures as cutting off whole strips from one or more edges of a painting. On the other hand, sometimes there has been a serious miscalculation as to how to make best use of the picture area; what looked promising in the sketch or in the blocking-in stage may not turn out as successfully as the artist had hoped. Obviously, the first step is to try to solve the problem by painting revisions; but if the fault is so basic that repainting and re-

designing are ineffectual, then cropping, right or wrong, is probably the only workable solution.

To *depend* on revision by cropping is quite another matter. Every effort should be made to design within the limits set by the paper or canvas, and no true professional would have it any other way. Corrective cropping should be reserved as a last-ditch measure. If such cropping becomes a regular habit rather than an exceptional technique, it should most certainly be a danger sign to any responsible painter.

It is worth noting that Charles Burchfield frequently used what might be termed "reverse cropping" to revise his compositions. If he found he needed more room to extend an image or add on other forms, he carefully attached extra strips of paper or illustration board to the edge of his watercolor, thereby enlarging its surface rather than diminishing it. This form of compositional correction was handled so skillfully by Burchfield that the viewer ordinarily does not notice it unless he looks for it.

PLAN. Try to avoid cropping completed paintings, but if you are faced with a considerable amount of wasted space that can be filled in no reasonable way, then do not hesitate to cut your canvas or paper, or saw the Masonite panel. And do it in good conscience, knowing it is for the good of the picture and is more important than concern over what people will say. As far as I am concerned, you can walk all over your picture, tear it, spit on it, crop it—whatever helps the painting is in the best possible cause, and no need for apologies.

Aside from wasted space or awkwardly designed areas, if you find you can really tighten the formal relationships by cutting in closer, that you can accentuate the design qualities and fill the surface with shapes that mold a more powerful, coherent composition, get out your razor blade or saw and perform the necessary surgery!

Ash Cove (top) by Stephen Etnier, N. A., oil on Masonite, 16″ x 24″ (41 x 61 cm). **Ash Cove** (above), 22″ x 36″ (56 x 91 cm) (before cropping). Courtesy Midtown Galleries, New York City. Stephen Etnier is one of our most design-conscious realists. Long after his paintings have been completed, and even exhibited, he continues to examine them critically for ways to improve them, usually by cropping and thereby tightening up the composition. In the case of *Ash Cove*, the lower illustration shows the painting in its original state before cropping. The picture is composed conventionally, complete with sailboat, dock, gear, reflections in the water, and a foreground which acts as a support for the strong vertical forms of the wharf. But Etnier has a flair for taking pictorial risks, for trying the unusual, for trimming nonessentials, for dramatizing his subjects. *Ash Cove* in its final form, top illustration, shows the artist concentrating interest instead of scattering it; filling the rectangle more fully; removing details in order to emphasize major shapes; and changing the emphasis from a panoramic view to a close-up. With all that, he has still managed to retain the feeling of a stretch of open space across the water, an important part of the picture in both versions.

19. WHITE AS A MAJOR AREA

CONCEPT. The use of very large areas of white (i.e., blank) paper has long been a common practice among watercolorists and printmakers, but this trait can also be applied to paintings in oils or acrylics. The white of the paper or canvas can, of course, be used as a background or field on which the painter places lines or shapes that do not fill the rectangle out to the edges. Such paintings have very much the effect of a drawing in which large portions of the surface have been left untouched. Here, however, I am referring to white as a flat area occupying a major part of the picture surface but acting as a large shape or form within the painting, not as an overall background.

Leaving an extensive amount of flat white can be an audacious way of patterning the surface, whether in representational or abstract painting, and it takes considerable nerve as well as compositional skill to bring it off successfully. It has a tremendous impact on the eye, but control has to be exercised so that, despite its shock value, it is well integrated with the rest of the picture. It must look as if it belongs there harmoniously, but it should also be in startling or dramatic contrast to the other picture areas.

Many people know that the black leading in stained-glass designs is a highly effective means of setting off the rich brilliance of the colored glass, but not many also realize that white is just as effective for the same purpose, if not more so. A stroke of almost any color against the white of paper or canvas is bound to look rich and strong, and it is only as other colors are placed around it that it begins to lose its original power. Although most painters feel a compulsion to cover the entire paper or canvas with color—keeping whites to a minimum—white can sometimes be used to bring out the richness of colors in other parts of the painting.

In representational landscapes, white as a major area would logically be found only in snow scenes, perhaps the white walls of buildings, or an occasional sky. There are not many other opportunities for a large mass of pure white to function logically without seeming raw, unnatural, or artificial.

In abstract landscapes, white is more suited to major shapes and masses, since it appears simply as one color related to other colors, and it does not necessarily have to be linked closely to associations with the natural world. In abstract art, white affects other colors in a relation based predominantly on design and pattern, and to a lesser extent upon realistic references. Thus the artist is able to use it more freely if he feels the picture needs it, or if it leads to a more unusual composition.

PLAN. If you are painting representationally, choose a subject that gives you a chance to use a substantial amount of white. (A snow scene is the most obvious choice, but other ideas might occur to you.) Design the composition so that the white takes up the greater part of your picture. Keep the white as blank and uneventful as possible; use its emptiness as a foil for detail elsewhere in the painting, and its intense white or off-white as a foil for the deep, rich colors throughout the rest of the picture. Don't feel you have to insert a rock here or blades of grass there. Insist on absolute simplicity and reticence, for once you start adding a stroke here and a mark there, you will probably end up by adding too many little touches, and the starkness of the white will be totally lost.

Watch, too, for transitional elements and edges that connect the white to the other areas; it must not look too sharply cut off or separate from the rest of the surface. Above all, the white should appear planned and intentional, not as if you had simply never gotten around to dealing with it. Any textures or variations of color or tone within the white should be as subtle, discreet, and imperceptible as possible.

If you are painting abstractly, use white as a powerful shape, not as mere background. Though some abstractionists leave large parts of the canvas wholly unpainted, that is not a recommended practice. Such surfaces are easily soiled or damaged but less easily cleaned or retouched. White paint or off-white mixtures are much to be preferred. Remember, the daring relation of an expanse of white to a smaller area of resonant color is what the picture is all about. See if you can shake up the spectator visually and still control orchestration of the formal relations of color, space, and pattern.

Wolf's Neck by Thomas Crotty, acrylic on Masonite, 24″ x 44″ (61 x 112 cm). The white foreground extending into the distance occupies fully two-thirds of the picture surface. The gray sky has been kept as simple and unvaried as the white snow, with the result that all interest and detail have been concentrated in the thin strip of distant forest and the two masses of trees and shrubbery at either side of the picture. These two masses are unequal in size and weight and placed so that the open space between them is not in the very middle of the composition. In spite of the realistic rendering here, Crotty has not lost sight of design: the dominant white area has a strong shape above all else. In lesser hands it might have looked too contrasted or separate, but he has connected it to the dark masses in the picture by varied hard and soft transitions—the severe edge of the snow at left juxtaposed with the blur of grass and underbrush at right. Crotty successfully resisted the impulse to put something in that empty white foreground, and the painting's strength has been increased by that reluctance to overburden the composition with unimportant distractions. This is a poetic picture in which the daring use of white as the major area was not simply a compositional device, but contributed actively to the sense of space and mood.

20. DISTORTION OF SCALE

CONCEPT. The artist looks to nature mostly for its pictorial possibilities—for the ways in which landscape can be used as a starting point for an arrangement of forms on paper or canvas. The customary ways for dealing with subject matter are in terms of shape, color, pattern, lighting, and design. But another interesting and challenging element that appeals to some painters is *scale*.

Scale is a matter of relative size and proportions. In a painting, a human figure can be made to seem very large or very small, depending on how it is related to small or large landscape forms. Contrarily, a landscape panorama can be made to seem more monumental or majestic by the introduction of tiny figures or animals.

Scale can also be purposely changed about so that various forms are presented in an unfamiliar context: a gigantic sun or moon dominating the landscape below it; a looping stage curtain framing a desert landscape; a giant teddy bear in a real forest. Some of this borders on surrealism, in which the unreal is made as convincingly real as possible by photographically descriptive rendering. Everything is absolutely "real" except the unexpected use of scale: therein lies the jolt to the spectator's sensibilities.

Still another way to manipulate scale is to select a relatively small-scale subject and place it on a very large-scale canvas that runs to seven, eight, or nine feet. To be sure, this is a variation of the close-up. The main difference is that it is not simply a matter of viewpoint but is primarily an extreme contrast or opposition of scale within the picture: very small-scale subject matter blown up to exaggerated size on an enormous canvas.

Incidentally, a very large canvas can add a great deal to the impressiveness of a painting. There is a considerable difference in the way a subject will look on a 24" x 36" (61 x 91 cm) scale and on a 6' x 9' (183 x 274 cm) scale. In the smaller size, it lacks presence; it has a "So what?" quality. But painted on a 6' x 9' canvas, it has an inescapable impact, a larter-than-life scale that envelops the viewer and intensifies his entire visual experience of it. The artist, while working on a large scale, also experiences a feeling of expansion and release far more exciting than what he feels when working on an average-size canvas or panel. It is important to remember, though, that a very large canvas does require a major statement of some sort on the part of the painter. Trivial ideas or subjects remain trivial, no matter how huge the surface on which they are painted.

Distortion of scale is one of the first things an artist can do to break away from conventional images and begin to involve himself with concerns on a higher creative level than mere description.

PLAN. Get in the habit of looking at things around you with an eye toward scale relationships. What effect would it have if something were painted much larger or smaller that it really is, while neighboring forms remain in their true size or scale?

If you enlarged the scale of natural forms and then added very tiny human figures, how would that affect your landscape? For instance, a small piece of driftwood and a couple of rocks picked up from a beach could be the start of a painting in which those forms become heroic in size as contrasted with figures. Human figures are of known scale, and their presence as small-scale forms in the picture will automatically give a feeling of large scale to the gnarled driftwood, and the beach rocks will begin to take on the aspect of cliffs at oceanside. Seeing such possibilities in nature's forms will broaden your way of perceiving the world about you. It will also suggest new pictorial situations that can be handled quite realistically in every respect, except for the distortion of scale.

Also, observe small things and see what they suggest to you in terms of great enlargement. The smaller the original forms, the more their enlargement will yank them out of context, often beyond recognition. A couple of twigs next to a rock could be so simplified or stylized that, when blown up on a large canvas, they are completely out of scale and no longer identifiable; they are really nearer abstract design. Or, you can paint small-scale material on a very large surface. Since your brush is not restricted to a small area, you can handle the forms freely, in a loose, thoroughly painterly technique. Yet, when viewed at a distance, these large loose forms may give an impression of detailed realism.

Scale distortion has many pictorial possibilities, and it is up to each artist to discover those possibilities in the environment most familiar to him.

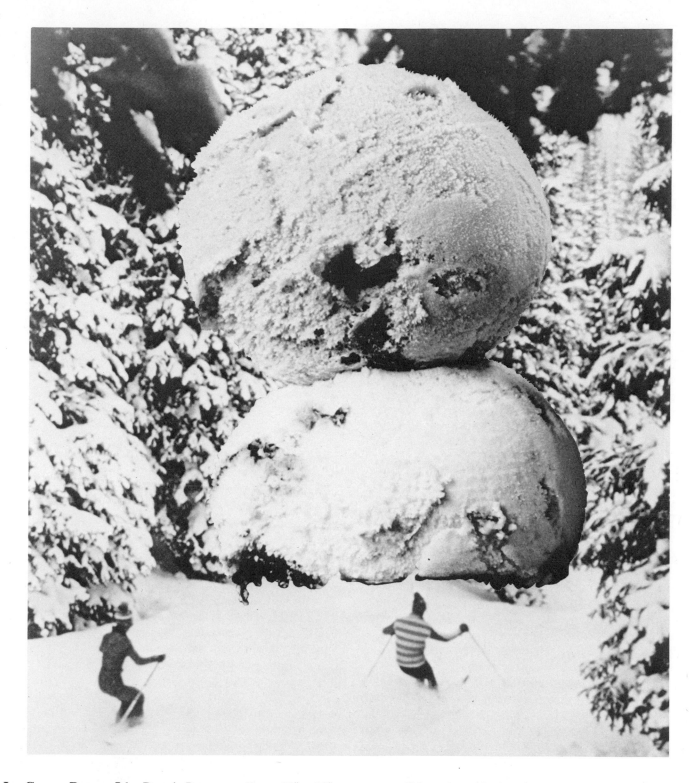

Ice Cream Dream I by Dennis Rowan, collage, 18″ x 20″ (46 x 51 cm). Dennis Rowan's recent series of collages are based on a surrealist juxtaposition of various scales within a single picture. In this case, the double scoops of ice cream dwarf both the pair of skiers and the snowy pine trees; or, seen in another way, the tiny scale of the skiers causes the ice cream scoops to take on gigantic proportions. Either way, there is a conscious manipulation of scale—a distortion of the expected scale relation between man and ice cream within a winter landscape—that gives the viewer a visual jolt. This surprise is further heightened by the fact that since these are photographic images combined in a collage, they are even more credible and convincing than if they had been rendered in paint. Rowan has used a wide variety of photographic sources, including large travel posters, for his basic landscape environments, but it is the careful choice of images which he inserts as a surreal counterpoint to those landscapes which make his collage landscapes very much his own. This brings up the question of humor, since many of Rowan's compositions are not meant to be haunting, disturbing, or mystical, but are clearly meant to evoke a slow smile. With so much of our landscape art being in such deadly earnest, it is a relief to see an artist willing to deal with it in a more playful mood.

21. SKY AS LANDSCAPE

CONCEPT. The sky in a landscape painting can be little more than a simple background for the main subject, or it can take a more prominent part in the composition by acting as a light source, reinforcing the mood of the picture, providing a sense of great open space, or acting as the environment for active cloud formations. In pictures such as these, skies are only a secondary consideration in the total composition.

Nevertheless, skies have always fascinated landscapists for their dramatic effects; for their color, light, and atmospheric effects; or simply for their abstract shapes and space. One immediately thinks of Constable's stormy skies and windswept clouds or of Turner's skies, ranging from tumultuous forms to pearly mists. In fact, Constable isolated skies as a specific subject for study in many of his outdoor sketches, both in oil and in watercolor. Capturing transitory sky effects became the entire reason for painting, and trees and land were only the most minor elements, if present at all.

The same attitude toward skies as the sole subject of paintings reappears in the work of three contemporary Americans: Jon Schueler, Hyde Solomon, and William Allan. There are some large sky paintings by both Schueler and Allan in which all land elements have been completely eliminated, and the sky itself occupies the entire surface. Hyde Solomon usually hints at just a bit of land, or sometimes, as in his superb series of paintings *The Skies of Monhegan*, he uses dark granite cliffs at the very bottom of the picture as a foil for the sky forms overhead.

These painters approach the sky as landscape in differing but sometimes overlapping ways. Allan works in a limited range of blues and grays and is most attracted to the soft, shifting shapes and subtle patterns of cloudy skies. He works on a very large scale to suggest the breadth and spacious feeling so necessary to his subject.

Jon Schueler has continuously explored the sky motif, first in the form of a brushy expressionism. Most recently he has adopted a more Turneresque attitude in which color, light, and atmosphere are the main aspects that concern him. His paintings are frankly romantic, sometimes almost mystical; he has, in fact, referred to the sky as "a simplicity impossible to understand." Schueler works in a variety of sizes, starting at 4″ x 6″ (10 x 25 cm) for watercolors and going up to 6′ x 6′ (183 cm) for oils.

Hyde Solomon is not so interested in atmospheric effects or light as he is in using explosive brushwork as an equivalent for dramatic, swiftly-moving sky forms. His are extremely painterly versions of skies, with cloud movement being referred to principally as a source for his energetic, but often highly poetic, paint handling. Solomon does not customarily work on an unusually large scale, and most of his canvases are in the 50″ (127 cm) and 60″ (152 cm) range.

PLAN. Forget the landscape at ground level and look to the sky for your subject. Since observation of reality and a response to it are the first steps in the creative act, I would recommend your doing a number of studies directly from nature in oil, acrylic, or watercolor, in order to familiarize yourself with this new material before you tackle skies as full-fledged paintings. Photographs of skies, no matter how accurate, are a poor substitute for direct experience and will tempt you to copy rather than respond.

Although it is possible to paint a skyscape very realistically, you are bound to discover that, on a purely documentary level, photography does a superior job of recording the light and color of a sky in all its varied transitions and gradations. So, instead of attempting to copy a sky and coming off a poor second to the camera, try to approach the sky in more painterly terms—translate it into brushstrokes, dramatize it, evoke a sensation of airy space—but don't settle for rendering only what you see. You should be using sky forms as a means of composing the surface of your picture interestingly, and if you don't succeed on that score, the painting will fail.

Work on a fairly large scale as much as possible—the larger, the better. A skyscape painted on a 24″ x 30″ (61 x 76 cm) canvas lacks breadth, and you are going to need all the space you can get.

You must, as in any other form of landscape painting, have a definite attitude toward your subject and must make that attitude clear to your audience. Your skyscape should transcend those preparatory sketches and studies; it should be an organized, fully developed painting, a sustained exploration or evocation of light, color, air, movement, pattern, or mood—any, or all, of these effects.

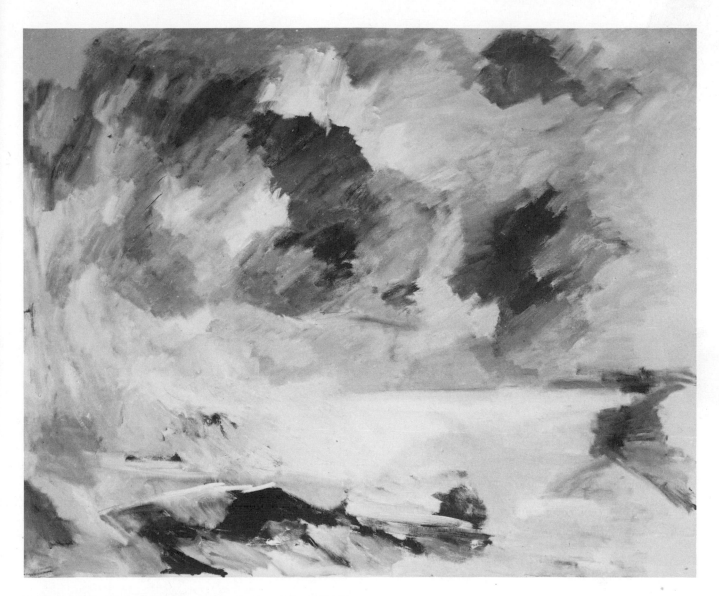

Red Cloud by Hyde Solomon, oil on canvas, 54″ x 60″ (137 x 152 cm). Courtesy Poindexter Gallery, New York City. The painted image is more important to Hyde Solomon than the situation which provoked it. The sense of surface and paint manipulation takes precedence over nature's manifestations, so that, although a sky is what triggered his creativity here, this painting is by no means an attempt to grasp reality in literal terms. The gestural, agitated brushstrokes relate to the movement of clouds, expressing turbulence, but not describing it. The structure of the painting is based on a single horizontal division of the picture surface, with the major activity in the sky area. The looseness and softness of the clouds is effected mainly by contrasting them with the stability of the horizon and the sharp form of the implied land mass in the lower part of the composition. Sky and land are brought together by a loose passage at middle left, but in general, the vigor of the brushwork dispenses with any atmospheric blending of tones; intermediate values are a series of separate paint mixtures applied directly and left unsoftened. Solomon's emotional identification with his subject, together with his sensuous use of a varied range of paint textures, results in a skyscape in which paint is handled as an equivalent of nature's form and movement; it evokes the sky, it does not imitate it.

22. ATMOSPHERIC TREATMENT

CONCEPT. Landscape forms are best revealed in a clear, strong light, and unless painted by an artist who is a colorist above all else, most pictures require a sense of pattern and a full range of tonal values. Sunlight, of course, is the usual source of light in the great majority of landscape paintings, but moonlight has been effectively used by some painters; in either case, contrasts of light and dark are a vital part of the composition. The strong, single light source is a help, not only in description of form and volumes but also in bringing out clearly defined edges.

An alternative to that kind of lighting is the diffused light of a gray day, when there is no single light source. This is not too popular with artists for a number of reasons. The range of values is quite limited, which means there is less contrast and it is more difficult to differentiate values in order to describe form. Edges are not as clearly seen; it reduces opportunities for strong patterns; and, last but not least, it is a rather glum and cheerless light. It may lend a somber mood, but that is about all.

There is another alternative, however, which has attracted painters with some regularity, and that is the atmospheric effect of landscape enveloped in fog, mist, or haze. Remember Turner's swirling mists, Whistler's foggy London scenes, or the blurred winterscapes of Twachtman. And among contemporary American artists who have repeatedly used soft-focus effects are Jon Schueler, Albert Christ-Janer, John Hartell, and Richard Bogart.

Atmospheric treatment serves several purposes. First, it describes various weather conditions such as fog, drizzle, rain, mist, falling snow, and, unfortunately, smog. Second, it can be used to produce an Impressionist effect of hazy, shimmering light. Finally, it helps to create mood through a poetic softening of natural forms, with delicate nuances that bring to the picture a sense of mystery, of landscape suggested rather than revealed.

Paintings in which landscape is only faintly visible through a blur of atmosphere quite often seem to lack the compositional firmness of the more conventional sunlit painting. This is why artists such as Monet and Twachtman were in some disfavor for a number of years. Their use of softness and suggestiveness was not fashionable, and their paintings seemed too loose and formless compared with the structured forms of Cézanne and the Cubists, or even such solid realists as Rockwell Kent and George Bellows. But by placing less emphasis on pictorial organization, many painters whose pictures are most concerned with atmospheric effects invest their work with a deeply lyrical quality that is for them more important than structured composition.

PLAN. To begin with, you must allow yourself a good deal of time for observing how landscape is affected by fog, rain, or snowfall. This means you must study values: how they relate to each other as they fade into space and what kinds of grays there are—how light or dark, how warm or cool. And you must pay special attention to the variety of edges—how hard or soft, how close up or far, and how atmosphere blurs them. Make yourself especially sensitive to all the subtle variations of muted color.

If you are an oil painter, do atmospheric studies in the *alla prima* technique, finishing the painting in one session while the paint is still wet and blending is most easily accomplished. If you are more at home with watercolor, do a number of wet-in-wet paintings, seeing how much can be said through the art of suggestion, using only the barest minimum of sharp edges or accents. In acrylic you'll have to work very quickly or use an acrylic retarder, but it can be done. By all means, study Chinese and Japanese ink paintings of landscape—still the greatest examples of lyrical atmospheric painting.

You may dissolve your motif in atmosphere, but try not to lose a sense of composition altogether; a structure must be faintly evident underneath the paint. Such pictures should be painted tenderly, with delicacy and finesse, working for a manner of painting in which the most exquisite adjustments of edge, tone, and color count for more than anything else.

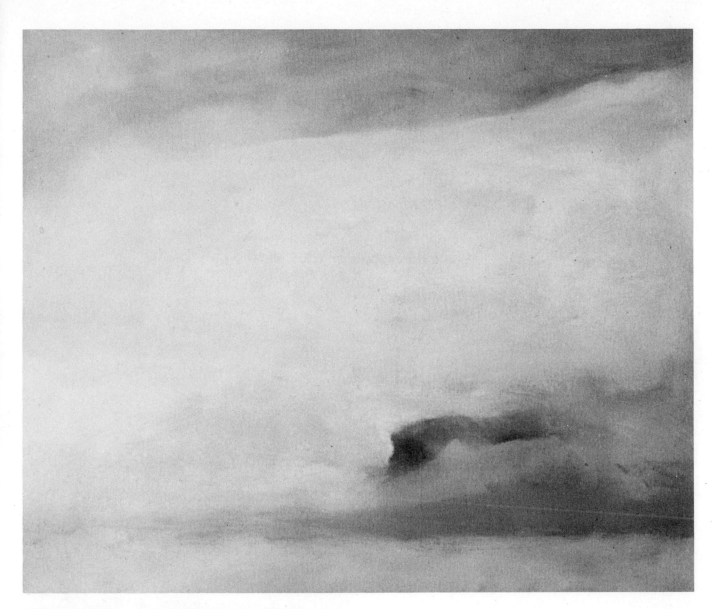

Reflection: Light and Sound by Jon Schueler, oil on canvas, 40″ x 48″ (102 x 122 cm). For many years Jon Schueler has been painting skies, pictures which reached a high point in a series he painted at Mallaig, overlooking the Sound of Sleat off the coast of Scotland. That lonely shore was a perfect vantage point from which to observe the drama of the skies in their many changing moods. Snow clouds, the glare of coastal haze, shores shrouded in mist—all became material for Schueler's brush, and soft, atmospheric treatment was the only appropriate way in which to deal with such intangible, and fleeting effects. This painting presents a world suspended in air and space, in which there is an implication of a headland glimpsed momentarily between clouds above and fog below, and a suggestion of ocean and mist at the base of the picture. The loosely formed composition is generally based on several unequally spaced horizontal divisions; the single dark accent (and the nearest thing to a hard edge) is the small mass of the headland, which provides a point of emphasis and helps to indicate the scale of the other areas in the picture. The pleasure to be derived from this painting lies in its poetry, simplicity, restraint, its light and atmosphere, and the artist's embracing of nature and natural forces on a far more personal and profound level than seen in a standard landscape painting.

23. PAINTING FROM MEMORY

CONCEPT. When a friend, laden with his painting gear, arrived to pick up Pierre Bonnard to go out with him on a day's sketching expedition, Bonnard came out to the car without so much as a sketchbook in hand. When asked where his sketching materials were, he just settled in comfortably and said, "*Moi, j'observe*." He was going along just to look.

An artist's memory is one of his most invaluable pieces of equipment, and most art teachers stress the importance of developing a vivid, accurate memory as a major creative tool. Robert Henri, for instance, envisioned an art school where the model was posed in one room but the students painted in an adjoining studio. They could make as many notes, sketches and studies from the model as they wished, but none of these could be carried back to the studio—they had to rely on memory to do their painting. Kimon Nicolaides, one of the great teachers of New York's Art Students League, insisted on constant memory exercises in his life drawing classes. He recommended that whatever subject the students drew, it should be drawn over again later from memory.

An artist's memory is principally a repository of innumerable visual experiences. A landscape painter should ideally spend several years working directly from nature in all seasons and all lighting conditions in order to build up a vast store of firsthand knowledge, an intimate acquaintance with natural forms, and an awareness of how nature looks in every conceivable situation. There are many times when a painter has to fill in from memory or improvise to some extent, using what he has remembered to give his treatment the ring of authenticity. Beginning painters who have not spent enough time intensely observing nature tend to produce pictures that—being based on a shaky or shallow memory—are quite unconvincing. Worse yet, they often have the look of being faked. On the other hand, an experienced professional painter with a well-trained, well-stocked memory can invent landscapes that are combinations of various remembered scenes, lighting, and weather conditions and make them absolutely convincing in every respect.

Equally valuable to the artist is the fact that, while a sketch, drawing, or photograph may contain *all* the material that was there, memory usually acts as a sifting-out process for eliminating nonessentials. It selects and retains only those elements that are of genuine importance to the artist; all details that do not contribute to the essential quality of the original subject are screened out and dropped altogether.

In improvisational abstract painting, memory is used to evoke associations that will enable the artist to bring meaning and recognition to the forms and colors that appear spontaneously during the painting process. Memory can re-create both the particular and the general—those little observations which lend conviction to the picture or the larger intangibles such as space, light, weather, and seasons. Memory is one way of transcending the specific and the momentary in order to endow landscape subjects with a sense of universality.

PLAN. Work from memory as much as you can. For example, work from nature in one version and then repeat the painting as a memory exercise. In many cases you will find the second version is better. It will be simpler and more to the point, with fewer distracting elements. Less time and less paint will have been spent on trivia that may have appeared in the first version, when you included everything just because it happened to be there.

Look at the landscape as hard as you can, storing it all away in your mind. Leave your sketchbook at home every once in a while to force yourself to rely on remembering what you see. When you get back to the studio, rush to the nearest sketchbook and rapidly draw the major impressions gathered on your "mental sketching trip." At first you may find that you will return with only one or two really vivid visual experiences worth recording, but as you acquire more skill at absorbing what you see, you may come up with as many as half a dozen sketches that are complete enough in lighting, composition, and detail to serve as material for a similar number of paintings.

One warning: except for memory exercises, do not paint habitually from memory until you are ready for it. When looking at my students' work, I can immediately detect which areas were painted on the spot and which were completed later in the comfort of the studio. Aside from a lack of conviction, those areas done from memory are painted in a spirit not consistent with those done outside.

Painting from memory is not the same as faking it, and if you can't fake it convincingly, don't fake at all.

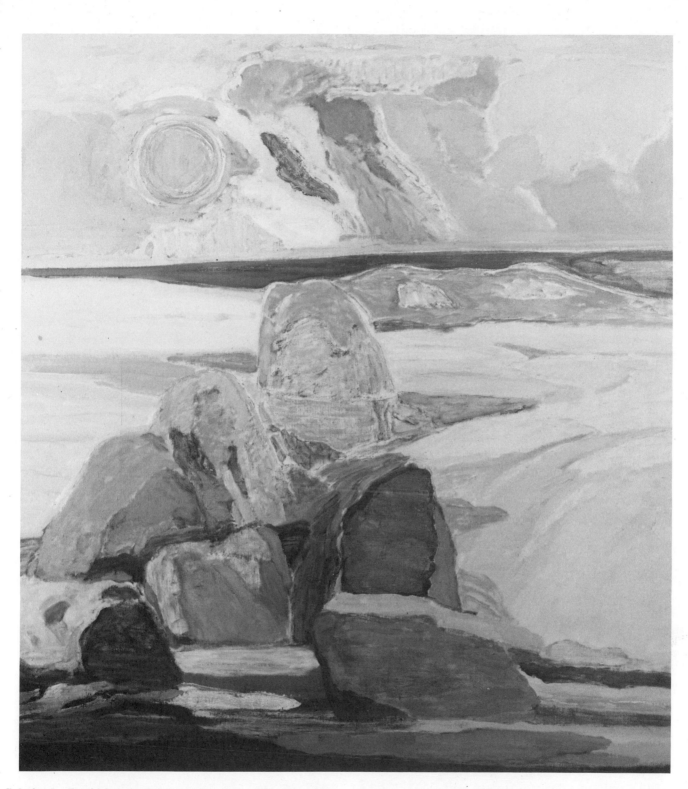

Solstice by David Lund, oil on canvas, 54″ x 48″ (137 x 122 cm). Courtesy Grace Borgenicht Gallery, New York City. Like many painters, David Lund is a confirmed beach-walker. Walking—and the observation and study which accompany it—is his means of storing up a repertory of forms, textures, and colors to which he can refer later when he is at his easel. His usual procedure is to start out with a period of observation and contemplation and then follow that with drawings in charcoal or pastel done from nature; but the creative act itself takes place at a distance from the subject. The paintings, such as *Solstice*, are all done in the studio, from memory. When beginning a picture, he establishes a general structure with charcoal and then takes it through numberless changes which revise shape, space, and color until, as he puts it, "the forms take on a specific light, space, and gravity. As the work progresses, often over several months, decisions become more critical, more acute." Lund is far more concerned with initial impressions and experiences in front of nature, and with the transformations of nature that occur within his mind's eye, than he is with factual description of appearances. Lund's memory, together with an improvisational approach and a passion for rigorous structure, combine to produce paintings that push well beyond nature described to nature recreated.

24. IMAGINATION AND FANTASY

CONCEPT. Most painters are content either to paint landscape as they see it or to distort and reorganize it into abstract patterns or symbols. Some artists, however, are not content with outward appearances. They reject nature as we know it and are more interested in inventing their own worlds. While most artists have occasionally made brief excursions into imagination and fantasy, the majority are not really to be classified as visionaries in the sense that some are: Redon, Moreau, Ryder, A. B. Davies, Eilshemius, Tobey, Graves—painters whose output was almost exclusively private and introverted.

Morris Graves has called himself a painter of the "inner eye," saying, "I paint to rest from the phenomena of the external world." The California painter Walter Snelgrove wrote, "From my studio I try to paint places where I've never been but would like to be." John Hultberg has referred to his paintings as an imaginary reality, adding that as an artist he "has not followed or even distorted nature, but rather duplicated it on another level." Such statements sum up the viewpoint taken by painters whose strongest drive is to exteriorize an inner vision, who prefer to create a *new*, not a known, world.

Certainly, interior landscapes are just as valid a form of painting as any other, and even the freely followed imaginative impulses of such an hallucinatory painter as Redon had a firm basis in years of observation and experience. A thorough acquaintance with nature had preceded his turning inward to discover his enigmatic fantasies. In all instances where painters have resorted to the unconscious as sources for their imagery, their paintings constitute a release from reality but are, at the same time, related to it. Nature, in abstract art, is used as a point of departure; but in art of imagination or fantasy the visionary painter, instead of reorganizing nature, uses it to give credibility to his private dream-world, to make the unreal real.

Invented landscapes are not necessarily escapist in character. Some project anger or protest; others are vehicles for poetic or metaphysical imagery; still others are simply an artist's personal vision of another world. Of course, there are indeed a few artists who create an ideal world preferable to the one they already know.

The use of invention, imagination, and fantasy is obviously not for all artists, but it should be noted that in the proper hands it has produced some of the world's masterpieces. Witness Bosch, Piranesi, Goya, Blake, Redon, Ensor, Ryder, de Chirico, Bacon—the list could go on and on.

PLAN. As in working from memory, the use of imaginary subject matter requires considerable preparatory background in drawing and painting and prolonged direct experience with nature. So before you begin inventing your own landscapes, make sure you have sufficient experience in art and in observation of nature's forms. It also would not hurt to be a naturally visionary sort of person.

Assuming you have all the necessary background and equipment, be willing to put everyday reality behind you and give full expression to your inner experiences and visions. If you actually have sensed interior landscape forms or compositions or have dreamed them, these would of course be your most natural source and starting point.

Otherwise, stimulate your imagination by looking at newspaper photographs upside down and see what strange landscapes they suggest to you. Or put down colors randomly and play with them improvisationally until landscape forms begin to emerge. It's what *you* see that counts. Combining disparate collage images can also call up inner visions. You might not necessarily copy the collages in paint, but the juxtaposed images might suggest to you a landscape that is more fantastic than logical, and you can take it from there.

Do anything that stimulates your imaginative powers—reading, listening to music, studying the formations of rocks, clouds, or textured walls. The main thing is to flow naturally with your impulses and intuitions, letting the imagined landscape reveal itself with as little possible rational interference, especially in the early stages. Be unselfconscious, be totally receptive, be brave enough to try anything that occurs to you, no matter how illogical it may seem at the time. The final result—the work of art—is what counts.

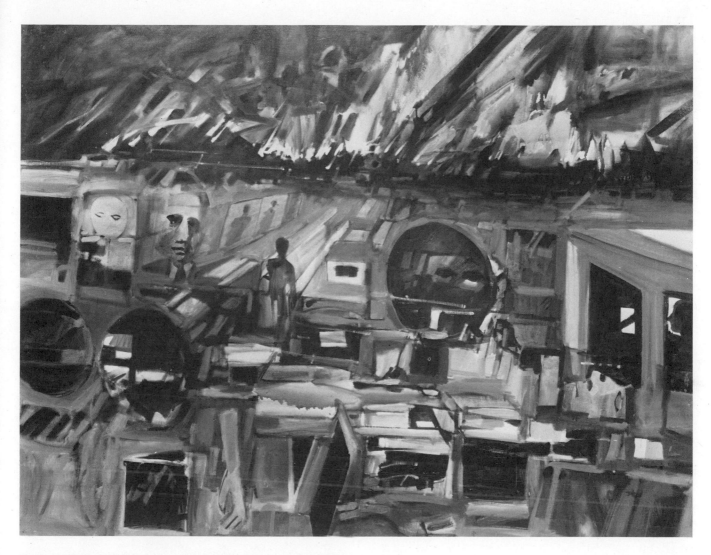

Spring's Slow Explosion by John Hultberg, oil on canvas, 36″ x 48″ (91 x 122 cm). Courtesy Martha Jackson Gallery, New York City. John Hultberg's earliest paintings were in a nonobjective Abstract-Expressionist style, which he soon repudiated in favor of very individual personal visions that are romantic, haunting, threatening, or simply mysterious, set in environments that sweep back into deep perspective. This painting is a dramatic construction of rooms, compartments, portholes, and boxes in a state of partial ruin. In the far distance is a conflagration shooting skyward, and scattered here and there through the composition are faces and figures in several different scales. It is a painting that, despite its possible social or environmental implications, makes no overt commentary and has no clear message; rather, it is a painting concerned above all else with structure and space, an exploitation of the artist's imagination in painterly terms. We are constantly reminded by the authoritative, spirited brushwork that this is to be regarded as primarily a powerful experience in paint, ranging from stains to impastos, from broad masses and patterns to swift linear accents. Hultberg has merged reality with fantasy in a delicate balance which produces an image more compelling than a literal illustration would be.

25. CLOSE-UP FRONTAL VIEW—REALISTIC

CONCEPT. Compositionally, the head-on or frontal view of an architectural subject would seem to be static and uninteresting; yet it is a favorite with many painters. The idea here is to close in on a subject, such as a row of storefronts, a barn, or a wharf, and view it frontally, facing it directly so that all windows, doorways, and lines are parallel to the edges of the picture. This means there is no perspective to speak of; by viewing the subject head-on, there is no two-point perspective, and thus no converging of lines toward vanishing points. It's as if the viewer were facing a wall, looking directly at it.

This viewpoint accomplishes two things. First, by getting rid of any major diagonals or converging perspective lines, it creates an arrangement of purely horizontal-vertical surface divisions, lines, and shapes that give a representational painting more the look of an abstraction. This is a little like eating your cake and having it too, since the painting can be enjoyed on two levels simultaneously: as realistic depiction and as abstract design. It can be fully appreciated as being only one or the other, depending on one's tastes; but ideally, it could be appreciated as a satisfying blend of descriptive painting and geometric structure.

Second, the frontal view, in which the subject is completely parallel to the picture plane (or picture surface), creates the sense of very limited depth within the picture. It has a two-dimensionality that is in accord with modern concepts regarding translation of three-dimensional subjects onto two-dimensional surfaces such as paper or canvas. These concepts will be examined in somewhat more detail later. Briefly, however, late-19th-century painters and muralists realized that illusionistic painting, using both linear and aerial perspective, was in effect violating the flatness of the canvas (or the wall of a building) by creating a "hole," or a suggestion of very deep space, on that flat surface. It was

pretending to be something it wasn't. They felt the integrity of the picture plane should be retained, even insisted upon; so they began altering natural forms slightly, treating them as flat shapes and patterns parallel to the picture plane and perceptibly contained within a controlled or limited depth. This is exactly what the frontal view accomplishes even in the most photographically detailed representational painting; it is a traditional treatment, but is presented in terms of modern picture space concepts.

PLAN. The subject matter for a frontal view is virtually unlimited: the face of a rock or cliff, a wall with tattered posters, a barn, a fishing shack, a stable, a storefront or a warehouse, the side of a building that remains when an adjoining building has been razed, a wharf with pilings, poles, ropes, and ladders. It is best to let the subject fill the picture as much as possible, in order to eliminate any other buildings or subjects that might be distracting.

As you compose the subject, do it with an eye to unusual design, to the patterning of lights and darks, the relation of small shapes and large ones, and oppositions of detail and emptiness, of flat and textured elements, of line and mass. In other words, select your subject because it already has a certain degree of abstract design in it, a design you can bring out or emphasize by careful rearrangement and a certain amount of selectivity. If necessary, an occasional shadow within the picture or from outside it can be used as a diagonal relief to all the horizontals and verticals. Stress the design as much as you wish, but paint the picture as realistically as you care to. A first impression of the finished painting would be that it is a purely representational picture. This impression would be followed quickly by the realization that it is also a very handsome, satisfying abstraction. This way you can give the spectator the best of both possible worlds.

Shed #1 by Larry Webster, A. N. A., A. W. S., watercolor and acrylic on smooth illustration board, 30″ x 40″ (76 x 102 cm). Although this is a completely representational painting which faithfully depicts the weathered textures and peeling paint on the side of a shed, it is also a beautifully designed abstraction that reads as a handsome arrangement of rectangles, whether it is viewed upside down or right side up. Shadows have been used not only to show the effect of sunlight on the building's various surfaces, but also as dark shapes and masses which form a strong pattern in a rich range of values. By closing in on his subject and looking at it directly head-on, Webster has arrived at a composition that essentially relies on horizontals and verticals and verges on the nonobjective purity of a painting by Piet Mondrian. To prevent that strictly horizontal-vertical structure from becoming too stiff and static, Webster has introduced two slightly tilted diagonals in the form of the boards stacked against the shed at the left edge and the deep shadows under the steps. Despite the two very strong darks beneath the door, this picture is primarily a two-dimensional composition in which divisions of the surface and the overall pattern of values are of greater interest than any implication of depth or space within the picture.

26. DISTANT FRONTAL VIEW—ABSTRACT

CONCEPT. The frontal view can be applied not only to the close-up view but also to more distant or panoramic landscape views. The same principle still applies—the landscape forms and architectural elements are seen head on, with all planes parallel to the picture edges. (A plane is any flat shape or surface that is connected to the picture surface or moves into space within the painting.) Again, perspective is minimized or eliminated, and all forms are reduced to flat, rectangular shapes.

Because the artist is dealing with planes rather than volumes, seeing only frontal surfaces and not the sides, buildings or similar forms are handled as if they were so many sheets of cardboard. The sky area is conceived as one plane; the foreground is another plane; and any smaller landscape forms within that environment are conceived as a grouping of planes placed in front of or behind each other in the space defined by the foreground plane at front and the distant sky plane at rear. Since the painter has chosen to work with two-dimensional planes instead of three-dimensional volumes, the space thus created in the picture is very shallow compared with the illusionistic deep space of the traditional realist landscape.

This controlled depth makes no attempt at an illusion of recession into deep space, so it is already a departure from realistic appearances, and the picture begins to take on a more abstract look, in which nature is treated more as a conscious, formal arrangement and less as a literal transcription of what the eye sees. This frontal view is a most convenient way of perceiving the geometric structure in the world around us. An Italian hill town, for instance, observed more or less head on, looks very much like a Cubist abstraction. In fact, many of the distant buildings, towns, and castles in the backgrounds of early Renaissance paintings are painted from a sort of frontal viewpoint and look strikingly modern in terms of their abstract qualities.

Contemporary painters have used the frontal view of large-scale landscape forms to design their picture surfaces in terms of horizontal and vertical divisions, a patterned mosaic of flat shapes or planes that join and overlap to create a fundamentally abstract structure. If the treatment leans a little toward realism, the painting comes out as a form of designed realism. If it leans toward the abstract, it comes out as a kind of semiabstraction in which design dominates the realistic content. The important point to remember is that depth is not created in this frontal view by the Renaissance method of linear or aerial perspective. It is created by an overlapping of planes that gives a feeling of recession into space (like a stage set) or by planes that are staggered, overlapped, and stacked vertically in the Oriental method. This suggests depth because the bottom edge of the picture is considered to be nearest the viewer and the top edge is considered to be farthest away.

PLAN. Here again, the choice of subjects for a frontal view is almost limitless: skyscraper construction; harbors, with boats and docks; cityscapes, farmscapes, Indian pueblos, industrial areas, and so on. In order to take maximum advantage of the geometric structure, choose at first those subjects that include some kind of architectural forms—houses, sheds, shacks, barns—all of which provide a ready source of rectangular planes that could fill all, or the major part, of the painting. Later on, perhaps, you will find this same frontal view can be applied to other subjects that are less specifically rectangular, such as cliffs, mesas, hills, valleys, forests, mountains, or prairies.

Study the Tunisian watercolors of Paul Klee or his mosaiclike architectural fantasies; the drawings of barns and the paintings of industrial subjects by Charles Sheeler; the early Parisian street compositions by Stuart Davis; and the cityscapes of Niles Spencer. You will find these works excellent examples of the various ways in which the frontal view can be utilized.

Don't make any attempt to show perspective, even where it is present. Treat all forms as being only rectangular. Sides of buildings may be shown as you flatten out the plane to a purely rectangular shape that does not converge in linear perspective. For the moment, forget the reality of things and try to bring out the design possibilities in your subject, integrating reality and design so that they become truly inseparable. The design gives form to the chaos of reality, and reality gives reason for the design, so that it does not lapse into sterility.

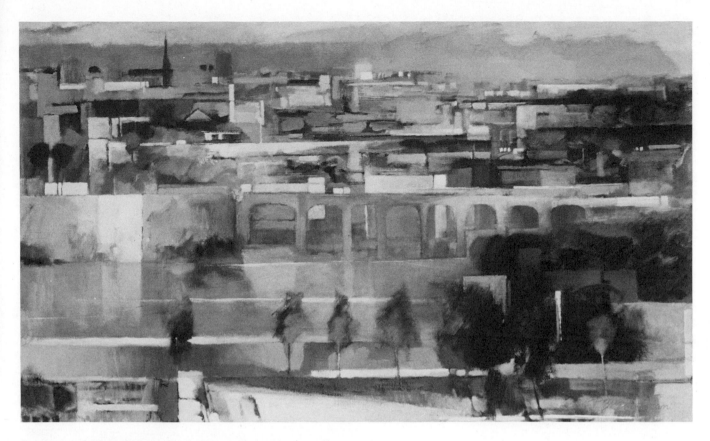

Shadows of Morning by Paul Zimmerman, N. A., oil on canvas, 30″ x 50″ (76 x 127 cm). Private collection. Paul Zimmerman's paintings do not usually start out with a specific motif, but rather build from a rapid development of abstract forms and color relationships that gradually become more specific until the picture eventually finds a definite subject. Since his compositions are abstract structures from the very beginning, the subject matter arrives through the back door, so to speak, and is then adjusted to already existing abstract shapes and patterns. In *Shadows of Morning* he has evolved an intricate, firmly designed structure of horizontal and vertical planes that evoke the idea of a frontal view of a city and river. Buildings are barely suggested rather than rendered; in fact, they are not buildings as much as they are generalized blocks of tone and color. With the biggest, simplest areas in the lower part of the picture nearest the viewer, recession into depth is achieved by an overlapping of the planes and by the way in which the architectural forms become much smaller as they near the top of the painting. The predominance of horizontals and verticals is relieved by the arches in the bridge, the sloping diagonal in the immediate foreground, an occasional indication of a triangular roofline, and the soft-edged trees. Edges throughout are sensitively varied in a range from sharp to blurred, which avoids monotony and prevents the picture from looking hard and artificial.

27. SIMPLIFICATION—REALISTIC

CONCEPT. One of the first things we learn as beginning art students is to simplify—to select and put into a drawing or painting only what counts most. We gradually realize that there is no necessity to record everything the eye sees. We retain some things because they are important to the picture; we leave out others altogether because they are not essential.

The ability to simplify is an advantage the visual artist has over the photographer. The camera records everything, and there is not much the photographer can do to simplify. Unless simplification is achieved in the darkroom, the final photographic print contains every element that was present when the shutter was released. The draftsman or painter has more options. If he has the time and the energy, he can choose to include every last detail, just as a camera would, selecting only a viewpoint. Most artists, however, welcome the chance to leave out things that don't interest them, that seem distracting, or that fail to reinforce the idea or expression they are trying to achieve.

The sign of the novice is his determination to include everything just because it is in front of him. The sign of the experienced painter is his ability to pare away the nonessential, to select skillfully only as much as he needs, and to purify the subject, depending on it and what he is trying to express about it.

Giotto and Masaccio were among the first painters to subordinate or eliminate detail in favor of simpler, more massive, generalized forms. I also think of John Sell Cotman's watercolors as being "essences"; his pictures, more than those by other artists of his time, demonstrate the use of conscious selection and simplification of natural forms into basic shapes and patterns. Everything in his paintings is there for a purpose. In the 20th century Henri Matisse was the grand master of simplification, distilling subject matter to the fewest possible elements, to a minimum number of flat shapes related to each other with the greatest economy and directness. Two Americans noted for their command of extreme simplicity are Georgia O'Keeffe and Milton Avery, who refined, flattened, and condensed their images until only the bare essentials remained.

As an intellectual process of evaluation, selection, and consolidation, simplification is one of the first stages in departing from the copying of outward appearances and moving toward a more purely pictorial viewpoint characterized by purification, economy, and reticence.

PLAN. Simplification in realistic painting can be approached in two ways: by addition and by subtraction. Usually this takes place in the studio rather than on location outdoors. The first step, of course, is to gather your reference material, in the form of on-the-spot sketches or photographs, and then begin a series of studies exploring the subject matter to uncover its simplest, most basic relationships.

In the additive process of simplification you begin with a blank sheet of paper and set down what you consider the most important line, such as a horizon or a rooftop, and then add the next most important lines, one at a time, slowly and thoughtfully, until the landscape develops in its most fundamental aspects. See how few lines, shapes, and values you can use to express the character of your subject. If you are convinced you need just one more line to project the image more clearly or to improve the composition, go ahead and add it. When you are just about finished, ask yourself objectively if every line is really necessary, if something can be eliminated without losing the sense of the subject or weakening the design. If so, go ahead and remove it. Once the linear arrangement has been established, develop the tonal pattern in pencil, watercolor wash, or gouache, making sure that no two adjacent values are the same. The final stage is to translate these values into color. Once that has been satisfactorily worked out, start the final painting.

In the subtractive process of simplification, you can put tracing paper over your sketches or studies and trace only those lines that seem most important. Some degree of simplification will already have taken place in the on-location drawings, but now you are refining it further. Now take the traced drawing and see if it can be pared down into even simpler shapes on still another sheet of tracing paper. Once you have arrived at an image and composition, develop the tonal pattern and color scheme.

The more experienced you become at simplifying, the more the process can take place in your head and less through preliminary studies.

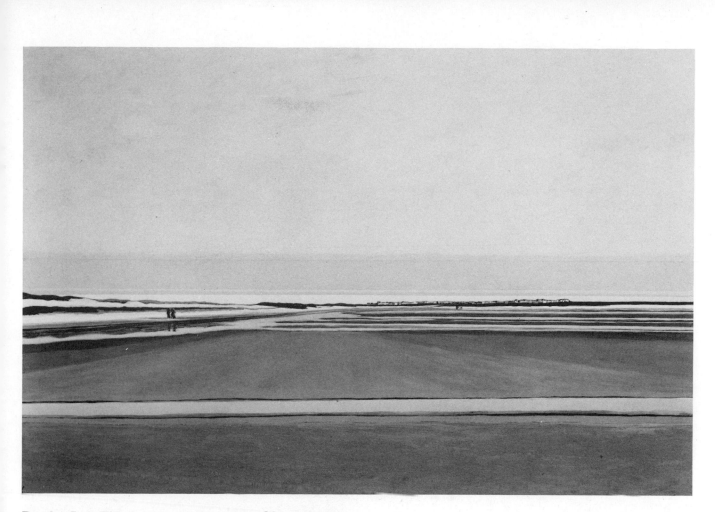

Beach— Low Tide by John Laurent, oil on Masonite, 32″ x 48″ (81 x 122 cm). All of John Laurent's paintings originate in observed reality—meadows, farms, rivers, beaches. One can always sense his deep respect and affection for nature beneath the severity and detachment of his paintings. The degree of simplification often results in a kind of formal lyricism that is very appealing. The painting reproduced here is of Ogunquit Beach, not far from the artist's home in southern Maine. The lower part of the picture is a carefully divided area of horizontal strips of water and wet sand at dead low tide. This same horizontal emphasis is repeated in the bands at the lower edge of the sky, a repetition which links the sky to the foreground and keeps it from becoming too separate. Everything has been done to express vast space, both on land and in the sky—the expanse of beach receding toward tiny beach houses in the distance, the emptiness of the sky, the scale of the sand dunes, and the lonely, small figures. This beach scene has been conceived solely in terms of its biggest, flattest planes, its simplest shapes and masses, and Laurent has managed to reconcile what is predominantly a surface design with a feeling of deep space. Nothing here is extraneous, everything has a visual function. Above all, it is the utter starkness and simplicity which give the painting its greatest impact.

28. SIMPLIFICATION—ABSTRACT

CONCEPT. Simplification contains the seeds of abstraction. As an object or motif is simplified and condensed, it begins to look more and more abstract. When the realistic, detailed aspects are stripped away, as texture is removed and as any accidental or transitory effects are taken out, the motif becomes less specific and real and becomes more generalized and abstract. The mountain, then, is not a *particular* mountain—it has become simply *a* mountain, and the image that remains is something nearer to a symbol or design than to the original motif. The drawing or painting per se has become more important than its origins.

Simplification in realistic painting lends the picture a partially abstract quality. However, it is still not an abstraction, although it may indeed have some abstract elements in it. This is especially true of the work of Milton Avery, who simplified and distorted, but whose paintings nevertheless can be regarded as basically realistic in attitude and treatment.

If, however, an artist wishes to push simplification further toward pure design, to arrive at an extreme simplicity in which the subject has given way to an arrangement of forms that are so spare and so reduced that it is barely recognizable, then his picture is to be considered primarily an abstraction, regardless of the fact that it may contain a few identifiable elements. An example of this is a painting by Georgia O'Keeffe, which is composed of only four elements: a band across the top of the picture, a large field of white, a vertical red rectangle in the center, and a horizontal row of twelve small rectangles close to the bottom edge of the painting. It is called *White Patio with Red Door*. When the title is known the picture makes perfect sense; without the title, it is just a striking design—minimal, austere, somewhat antiseptic. It is a simplification suggested by a definite subject, but a simplification so total that it has become entirely self-sufficient, standing on its own as a design, independent of its origins.

The difference between simplicity in realism and simplicity that has "crossed the border" into abstraction is merely a matter of degree. When more realistic elements are retained, the picture is likely to be seen as a modified form of realism. With fewer realistic elements retained and the image reduced to formal relationships of shape, pattern, and color, the picture is likely to be considered an abstract design. The painter has the choice of selecting the degree of simplification he feels is most congenial to his thinking and most expressive of his subject.

PLAN. Push the simplification of your subject further than you did in the preceding exercise. Here again, I recommend doing several preliminary studies in pencil, wash, or gouache to reduce the motif to its barest essentials. It is a help if your subject already has a built-in abstract quality, such as a Cubistic relation between a group of farm buildings, or the planes and linear elements at a construction site. Bring out those abstract qualities as much as you can by stressing the most important horizontal, vertical, and diagonal relationships and thinking more about the design you are creating than about the reality of the subject itself. Look for continuities in which an edge is established, is lost for a moment, then is picked up and continued again somewhere else at the other side of the picture. Lining up of such edges makes it possible to achieve greater readability or visual coherence throughout the composition.

Allow planes to interpenetrate each other occasionally, so an effect of transparency results as one plane is seen through or behind another. Some painters prefer to do their preliminary studies in the form of collages in a range of white, black, and three grays. The advantage of collage is that you can hold an actual shape in your hand and move it around on the illustration board until you find where it fits best, in the most precise relation to other shapes. Later, this monochromatic collage study can be translated into color. Or if you are fairly experienced, you might well analyze your subject in a full-color collage right from the start. Your main object in doing this should be to arrive at the essential design aspects of your subject through severe simplification.

If you want to reduce the number of areas in your simplified design, close in on your subject so that all extraneous elements are removed from consideration. Keep in mind this one point, however: the fewer the elements you choose to work with, the more beautifully and sensitively they must be related to each other. Minute, subtle adjustments make all the difference when you are dealing with very exact relations between a minimal number of areas.

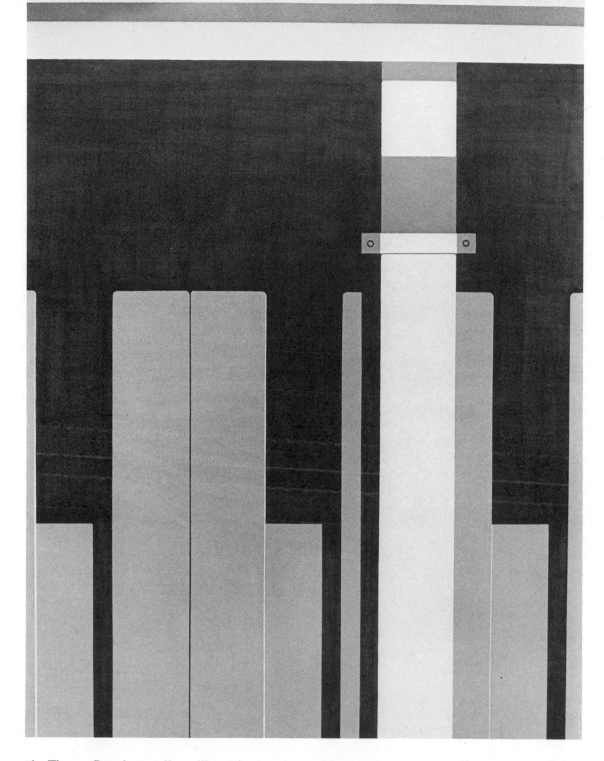

Downspout by Thomas Pressly, acrylic on illustration board, 40″ x 30″ (102 x 76 cm). Perhaps because of his background as an architect, Thomas Pressly's paintings are characterized by firm structure, bold pattern, and vivid color. In *Downspout* he has concentrated on an architectural detail from a frontal closeup view, but actually the downspout is nothing more than an excuse for a flat color pattern, a convenient vehicle for his strict simplifications. The design is uncompromising—a rigid set of horizontal-vertical relationships that entail an offbeat composition of major vertical forms set against a large, dark mass, varied by subordinate horizontal elements. Note that in addition to the flat principal shapes, which have been thoughtfully varied in width, Pressly has introduced three or four delicate linear accents as a foil for the large masses. The picture has been designed with clarity, crispness, and economy, and one of its satisfactions is the artist's unerring instinct for meticulously spaced intervals between the various shapes. It might appear to be a simple design, but the more you look at it, the more its complexity reveals itself. This is an abstraction that has been arrived at through simplification rather than distortion or reorganization.

29. STYLIZATION—DECORATIVE

CONCEPT. When stylization is mentioned, it brings to mind much of the art of the twenties and thirties; but, of course, the decorative tradition goes back much further than that. Almost all pre-Renaissance art had a strong element of stylization, and it is certainly a very important part of most Oriental painting. In Western painting, stylization vigorously surfaced again toward the end of the 19th century, mostly in book and magazine illustration and in other works related to the Art Nouveau movement.

Generally speaking, to stylize is to conventionalize nature's forms, usually for such decorative purposes as murals, tapestries, and illustrations; as we shall see, however, it has its legitimate uses in easel painting as well. Stylization is a conscious designing of nature—taking some liberties with nature for artistic purposes—not only by simplifying but also by emphasizing rhythmic repetitions and graceful, linear arabesques.

Although some people regard stylization as being synonymous with decoration, that is only partly true, and as I have mentioned previously, decorative art has a long and honorable tradition. For example, such a distinguished modernist as Henri Matisse once said, "What I dream of is an art of balance, of purity and serenity devoid of troubling or depressing subject matter: an art which might be fit for every mental worker, be he businessman or writer, like an appeasing influence, like a mental soother, something like a good armchair in which to rest from physical fatigue." Obviously, this notion would not appeal to those who consider art as an emotional catharsis, an expression of the agonies of the artist and his times, but Matisse's words do in fact describe one of the many functions of painting.

The stylized, decorative approach to landscape is only one of several ways to search out the order in nature, to comprehend the design that is present in all aspects of nature, and to explore landscape motifs as sources for inventions whose ultimate aim is to be elegant and gratifying. It is a matter of removing all accidents and trivial details and interpreting the subject in its most generalized, even idealized, terms. In stylized decoration the subject is minor compared to what it elicits from the artist in the way of harmonious relationships of line, shape, texture, and pattern. Stylization is nature generalized rather than individualized. It is "artificial" in the best sense of the word: made with human skill.

PLAN. Instead of being attentive to the irregularities and particulars of your subject, begin the stylizing process with a phase of strict simplification to establish the most basic outlines and masses. Generalize the forms as much as you can, but always with an eye to the design inherent in those forms. In the next stage, stylize the shapes of trees, the flowing contours of the land, the winding of roads, the patterns in rocks and cliffs, the intertwining of branches. Treat clouds, not realistically, but as definite, handsomely designed shapes. Any shadows in the picture should be just as carefully designed as the principal shapes. Look for visual echoes, for repetitions that will help relate various areas throughout the picture.

You should not be as conscious of the reality of things as of their design potential, and once you are in touch with that design quality, push it to the utmost. Search for details that give you the opportunity to introduce ornamental embellishments here and there. Consider it your job to reveal and celebrate nature's innate sense of design.

When it comes to color, don't be afraid to take some liberties with that, too. There is little to be gained by developing an excellent decorative design and then handling it in terms of ordinary, humdrum color. Use color for its own sake as another decorative tool; have some fun with it. Don't put down the first color that occurs to you—perhaps it is too obvious. Why not try for unexpected color combinations instead of the colors that exist in nature? After all, if you can stylize nature's forms to suit yourself, you can stylize color, too, and create a personal color scheme to reinforce and enhance the world of forms you have just created.

Looking Down by Betty Bryden-Wills, ink and watercolor on rice paper, 32″ x 30″ (81 x 76 cm). Betty Bryden-Wills lives close to the seacoast, and her work reflects her association with a world of cliffs, coves, surf, seaweed, shells, and beach stones. Her paintings are the result of a process of purification and simplification toward decorative rather than expressive ends. She is most concerned with spacing, arresting contours, refinement, delicacy, line quality, and subtle patterns. All this gives her pictures an almost Oriental serenity and elegance, a quality supported by the rice paper she paints on. The elements in *Looking Down*, an imaginative under-waterscape, are conventionalized—the worn, rounded stones, the rolling contours of the wave, the shells and seaweed, the intricate tracery in the seafoam—all handled with an eye to their qualities as graceful lines and shapes. Her frankly two-dimensional treatment is entirely consistent with her interest in flat, decorative arrangement, and there is no attempt to suggest volumes or any sense of light and shadow. This is a most personal view of nature as filtered through an exquisite and lyrical sense of design.

30. STYLIZATION—REALISTIC

CONCEPT. Besides being used for decorative art, stylization also has a place in realistic paintings in which nature is modified or abstracted by means of stylization. For a painter taking the first tentative steps away from traditional, realistic landscape painting, stylization offers the chance to take some liberties with nature, to stress design without getting involved in too radical a departure from the look of things, and to work in a way that is more two-dimensional than three-dimensional.

Rockwell Kent, for instance, found that his personal method of formalizing nature in his designs and illustrations was also adaptable to some of his landscape compositions of Maine and upper New York State. Regionalist painters such as Thomas Hart Benton and Grant Wood both relied on a stylized treatment. In the case of Benton, the active rhythms and convoluted forms in his murals carried over easily and naturally into his easel paintings. The early work of Charles Burchfield was far more stylized than his later, more naturalistic paintings; when he used stylization, it was to give visual form to the sounds of katydids, the whistle of wind through a forest, or heat waves vibrating above corn fields. Georgia O'Keeffe has always had a strong pull toward stylization and has used it consistently through most of her career. And Morris Kantor, a confirmed experimenter with the forms of nature, used stylization during various periods in his work—but never more powerfully than in his series of compositions based on the cliffs and surf of Monhegan Island, off the coast of Maine.

Stylization is the imposition of man-made conventions on natural forms and, as such, is a deliberate ordering of things that are not usually so clearly ordered. Painters who are reluctant to go all the way into abstract reorganization of their subjects tend to use stylization as a halfway measure: it is not entirely real, nor is it very abstract. But it does give them an opportunity to alter or interpret what they see and to express a personal vision without committing themselves to the extremes of realism or formalism. Within the range of stylized treatments variety is possible—anything from fastidious refinement to rugged, painterly handling.

PLAN. If it is possible to identify precisely the various stages from realism to semiabstraction to abstraction, then the stylization I am referring to here lies somewhere between realism and semiabstraction. For painting of this sort, it is best to restrict your subjects to forms that are clearly distinguishable—positive forms such as buildings, quarries, rocks, mountains, boats, surf, grain elevators, and the like. For the time being, avoid elements such as trees and shrubbery, whose forms are too vague, cluttered, or amorphous. If you cannot analyze it clearly, then it will be all the more difficult for you to get a grasp of the form, to understand its basic structure, and to separate and define its planes in your painting.

Here once again the subject should be generalized rather than particularized. You are still looking for pattern and design, for swinging movements and repetitions, but with somewhat less decorative intent than is suggested in the discussion of decorative stylization. Keep the linear composition simplified and the descriptive drawing fairly realistic. At the same time, stress the two-dimensionality of the subject and emphasize its flat planes rather than volumes.

Tighten your pattern into clearly defined shapes of light, middle, and dark values, and make sure your handling of the design is consistent. If some areas are too representational, while others are more overtly stylized, the total picture will lack the necessary coherence of idea and style. In other words, if you stylize one element, you must stylize them all to a similar extent or run the risk of presenting a conglomeration of attitudes that will create confusion in the eye and mind of the viewer.

Remember, you are working for an effect of slightly abstract realism, a stylized blend of nature's outward appearance with its inner structure.

Tide In by Robert Eric Moore, A. W. S., watercolor on cold-pressed paper, $20\frac{3}{4}'' \times 28\frac{1}{4}''$ (53 x 72 cm). The paintings of Robert Eric Moore are excellent examples of stylized abstract realism. Without ever abandoning recognizable subject matter, he works within his own repertory of gently abstracted forms clearly based on nature but frankly nonrealistic. With a keen sensitivity to pictorial structure and the interplay of hard and soft edges, Moore extracts whatever design qualities he finds inherent in his subject, whether it be the plunging rhythms of waves, rocks and reefs, the splash of surf, or the patterns of snow. We are constantly reminded that this is a painted wave or a painted rock, and that it is not an attempt to copy it illusionistically. In *Tide In*, rocks are reduced to stylized shapes and planes, with just a suggestion of texture here and there. The wave is treated as a gracefully flowing mass, accented by linear strokes that emphasize the movement in the surging water. The splash of foam is less strictly stylized, but it is still controlled and shaped enough so that it is consistent with the spirit of the rest of the picture. Such a painting captures the action and drama of coastal waters in terms of artifice and design rather than descriptive realism.

31. MULTIPLE VIEW OF A SINGLE SUBJECT

CONCEPT. When painters discover a motif that attracts them from more than one point of view, they often explore that motif in a series of paintings. It takes more than one painting to say everything an artist knows and feels about a particular subject—different vantage points and different lights and seasons bring out different aspects. This leads him to paint a subject repeatedly, even obsessively, until he feels he has finally grasped it or exhausted its possibilities (which may be never). Examples of this kind of repeated exploration are Monet's water lily paintings, his sequences of sunlit effects on haystacks, and his Rouen Cathedral series and Cézanne's series of Mont Saint-Victoire. More recently, Reuben Tam's evocative views of Monhegan Island and Andrew Wyeth's numberless watercolors and temperas of the Olsen farm in Maine and the Kuerner farm in Pennsylvania also display the repeated attraction a subject often holds for an artist.

In the mid-19th century, Edgar Degas began similar explorations of figure subjects, but instead of doing separate paintings of a specific pose, he showed one pose from several different angles in one painting. His *Frieze of Dancers* in the Cleveland Museum of Art and his *Women Combing Their Hair* in the Phillips Collection, Washington, D.C., are cases in point. Degas wanted to express movement in his art (he had seen various experimental photo sequences of figures in action by early photographers such as Muybridge), so he chose the device of multiple views of a single pose repeated in one painting.

Later, the Cubists became fascinated with the idea of simultaneity—seeing figures or still-life subjects from several angles at the same time, combined into a single image. In a still life, for instance, a bottle might be shown simultaneously in profile, from the view looking downward into the mouth of the bottle, and from the view looking up at it from below.

This concept probably reached its culmination in Marcel Duchamp's *Nude Descending a Staircase*, the famous or infamous shocker at the Armory Show of 1913. The main point of the picture was that a single composition suggested movement by overlapping and shifting the changing aspects of a figure in motion.

This kind of superimposition of images in one painting leads to a rather abstract design, just as if two color slides of different views of a landscape were superimposed one over the other. This produces a very complex image, full of transparent overlays, repetitions, and interpenetrations, which is far more intricate and interesting in its relationships than those existing in either slide individually.

The multiple view of a single subject requires considerable skill in selection and organization. If the artist does not impose an overriding sense of order, such a multiple view could become so busy and confusing that it would be unreadable.

PLAN. There are several ways to approach the composition of multiple views of a single subject. One would be that suggested above, in which you select two slides that show different views of the same subject. You then superimpose one slide on the other and view the combined images as the source for an abstract landscape.

Another way would be to do a series of two or three ink line drawings from different viewpoints on tracing paper; then superimpose the drawings on each other and see what kind of abstract composition results. The tonal pattern can be developed as a separate phase. After line and tone have been integrated, you then have a basic structure on which to build a painting.

Still another method would be to make a drawing of the motif from one viewpoint, then move around it and do a second drawing of that motif on the same sheet of paper. You will find that certain elements may coincide, while others may combine into interesting shapes, planes, and structural relationships. You can either do the second drawing while ignoring the earlier one upon which you are working, or you can adapt or alter the second drawing as you work, so that it is consciously related to areas in the first drawing.

Whichever method you use, you will have to spend some time afterward in sorting out, eliminating, simplifying, moving lines about, until you have a composition that is highly complicated but readable, and whose main appeal lies in its abstract interweaving of line, shape, pattern, and color.

Coming and Going Over the Footbridge by Corinne Trippetti, watercolor on paper, 20½″ x 14½″ (52 x 37 cm). The famous footbridge in the harbor at Perkins Cove in Ogunquit, Maine, has long been a favorite subject for both amateur and professional artists. Most have painted standard versions of it, showing it very much the way it looks; but Corinne Trippetti chose to treat it more playfully and imaginatively. Here she has combined several views of the bridge as seen from both sides of the channel leading into the harbor, even including the fishing shacks and summer cottages that are on opposite banks of that channel. Vertical elements of the bridge have been extended schematically into the sky, breaking up the sky into a series of adjoining planes that tie in closely with the forms of the bridge itself. The first impression of this painting is one of designed realism, yet it is more an intricate, abstract linear design than a credible structure, a personal fantasy rather than an actuality. It is a most satisfying and entertaining use of the multiple view, one that can be enjoyed for both the games it plays with reality, and the beautifully organized abstract interplay of line and pattern.

32. USE OF LARGE EMPTY SPACE

CONCEPT. There will always be some painters who have a horror of a vacuum, who feel that every inch of a picture surface has to have something happening in it. The idea of flatness, emptiness, or simplicity is to them something to be avoided, so they go out of their way to think of ways to fill the picture to the utmost. Quite often this only leads to a sense of clutter, bursting at the seams, and a feeling that the painter must have lost his ability to select and simplify.

This overcrowded quality can occasionally be used to good purpose—sometimes for a certain design or expression—but in the majority of cases, it can be detrimental to the total effect of the painting. Depending on the subject, the artist should look for areas in his composition where nothing at all will be happening, where large, empty spaces can serve a specific function.

There are advantages to using empty space. First, we have already seen in the discussions of Low Horizon and Sky as Landscape, how a large, simple sky can suggest openness and vast space, especially when set off against small landforms in the lower part of the picture.

Second, large uneventful areas can be used in a design sense as counterpoint for more active areas: setting extremely simple areas off against extremely complex ones. If all areas are more or less equal—active to about the same degree—we sometimes don't know where to look. But large spaces tend to throw our eyes toward major centers of interest. The artist can use these empty areas to direct his spectator's attention by consciously varying the degree of surface activity. The eye is attracted to the busier or more intricate passages, since there is not enough happening in the empty areas to engage it for very long.

As a corollary of this effect, empty spaces give the picture greater visual variety than if all areas are actively filled to the same degree. They offer the viewer a change of pace, a noticeable shift from one kind of surface treatment to another. If the separate areas of the picture become too similar in terms of size, scale, texture, or color, monotony is bound to result. Thus large empty areas can provide the necessary spice to maintain the viewer's interest and attention.

Finally, empty spaces can be used as the Oriental masters used them, as rest areas for the viewer's eye. This is partially a question of design and partially one of variety. It takes a good deal of reticence on the artist's part to restrain the urge to add something more, to occupy the composition more fully, but it is worth it to exert self-control, to select rest areas in at least one or two sections. The viewer will appreciate it.

PLAN. If you find that your pictures generally tend to be overly busy, begin a new painting in which you promise yourself to exercise some restraint. Limit the quantity of forms with which you usually fill the composition. Select one or two major areas and keep these relatively simple and uneventful, no matter how strong the urge to insert "just a few" more shapes. Think of the reasons for preserving that large emptiness: to express space, for design or emphasis, for variety, or as a rest area for the eye. If you have a genuine reason for not cluttering the painting, it will become more of a compositional necessity and less of a noble resolution that lacks conviction or purpose.

This plan can also be used retroactively. That is, you can go back to old paintings of yours that are too crowded and confusing and now rigorously flatten or simplify some passages, creating large empty spaces that change the composition for the better. The idea is to cause a shift of interest or surface emphasis, to rid the picture of any confusion, and to provide that needed change of pace from area to area within the picture. Ask yourself what parts of the picture are most important to you in terms of design or expressiveness; leave those alone and, by all means, retain them. It is the lesser areas that are natural choices for elimination, consolidation, and simplification. See how daring you can be in your use of large empty spaces while still maintaining compositional balance.

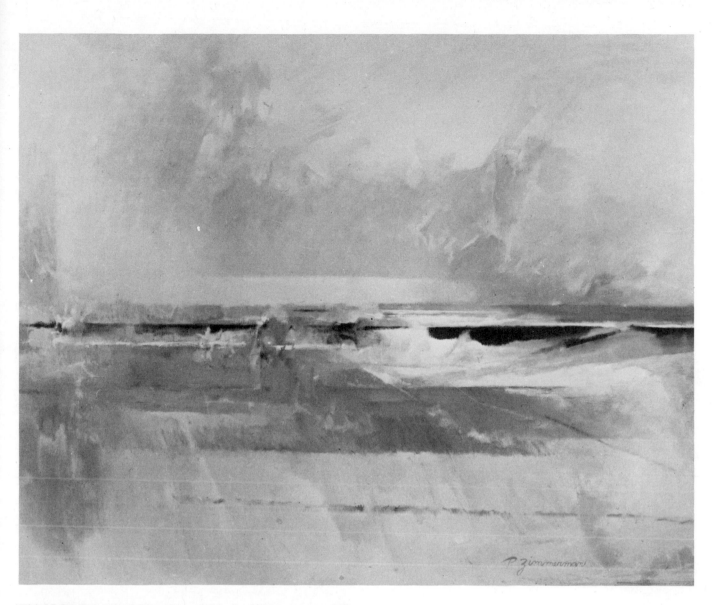

Tidal Marsh by Paul Zimmerman, N. A., oil on canvas, 40″ x 50″ (102 x 127 cm). Compared to Paul Zimmerman's other painting on page 63, there seems to be very little happening in this almost subjectless picture. It is a very simple, open composition, divided into two basic units: sky and marsh. The marsh itself has several horizontal subdivisions spaced at various intervals: these provide an entry into the picture and create a feeling of recession. These horizontal lines and planes are occasionally interrupted or cut across by diagonals of varying degrees, and the principal dark horizontal band is broken into at middle and left by a few minor vertical brushings. The strongest contrasts of light and dark come together just to the right of center, giving the picture more emphasis at that point than anywhere else on the surface. The sky is not as obviously structured, the tones are very close in value, and the brushstrokes are more relaxed and casual. Yet under that casual openness, a firm vertical and horizontal band—a sort of inverted L-shape—can be sensed just beneath the surface at the left side of the painting. This constitutes an almost architectonic hard-edge mass that acts as a subliminal foil for the loose treatment elsewhere in the sky. The whole painting is a lyrical evocation of space and light; the paint seems only breathed on, and the artist has made the most subtle use of large empty spaces, expressing the maximum with a minimum of means.

33. LANDSCAPE AS STRATA

CONCEPT. Because of the basic relationship of land and sky in nature, many landscape compositions can be conceived of as layers, horizontal bands, or a series of stratified zones.

In representational painting, pictures are sometimes simply divided into an upper and a lower section, sky above and land below. (For examples of this type, refer to B. M. Jackson's painting on page 15, the Chen Chi on page 27, or the Hyde Solomon on page 133.) In many paintings, however, the picture is composed of several horizontal bands, as in the Crotty on page 49, the Laurent on page 65, and the Zimmerman on page 63.

Seeing nature as strata is clearly evident at the seashore, where one is acutely conscious of nature being stacked in layers that read from top to bottom: blue sky, white clouds, blue ocean, white surf, dark wet sand, and bright dry beach. Or in the mountains, where the strata might read: sky, clouds, mountains, forest, distant shore, lake, reflections, and foreground shore. On the prairie it might be: sky and clouds, a distant stand of trees, sunlit distant fields, shadowed fields in middle distance, sunlit field in foreground, and a country road—all traversing the picture in horizontal strata.

In abstract landscape compositions, undersea or underground, there are even greater opportunities to express the stratified structure of nature. Simultaneous views of landscape can be shown in the same picture by designing the composition into lateral zones that refer to sky, land, and water, and below these, a series of geological strata—combining what is visible with what is known or felt—all in the same composition.

The layered composition is perhaps the most condensed or simplified view of the world that surrounds us; and limited though it may seem, it is subject to a wide variety of interpretations. These depend, as usual, on who the artist is, his unique experience of landscape, and the personal vision and style with which he manipulates that landscape. Paintings that employ repeated horizontals as their fundamental structure have been executed since the early days of painting, and—like many of the concepts presented in this book—the fact that it has been done before by masters of the past and present should not deter other painters from exploring its many possibilities. The important thing is to add something of your own to this well-established concept.

PLAN. One of the common compositional mistakes made by beginners in landscape painting is the division of a picture surface into three equal layers of (1) sky, (2) trees and/or buildings, and (3) foreground. An effort must be made to push the contours of some of the foliage higher into the sky in some places than in others, and at the same time to observe that the baseline of the buildings or trees is somewhat varied, creating an irregular interpenetration of foreground and middleground.

Some of this same attention to breaking out of one band into another has to be observed in paintings based on the concept of landscape as strata, but there are two main differences between that concept and the novice's compositional errors. First, the stratified composition is frankly just that—a frontal view of the landscape that openly insists on repetitions of horizontality. It *emphasizes* that quality rather than disguises it. Second, there are many horizontal divisions into not just three bands, but five, six, seven, or more, which vary considerably from thin to thick and from light to dark values. Some passages are barely more than thin lines or ribbons, while others are very large, solid masses. But they all traverse the picture surface in horizontal planes. This means the subject matter must be selected with some care to make sure it contains as much intrinsic interest and variety as possible.

Similarly, in the abstract use of stratified elements, an attempt should be made to make the horizontal strips irregular and varied and to think of them as a *design* of layered units. This can be done with either a hard-edge or a painterly treatment. Also, it is well to remember that because of the vertical stacking of the strata, the painting minimizes recession into deep space and is viewed as a predominantly two-dimensional painting, reading up and down. To keep the painting from becoming too nonobjective, try to give the strata a reason for existence—by composing and adjusting those bands in such a way that they make implied or direct references to landscape situations, whether real or imagined.

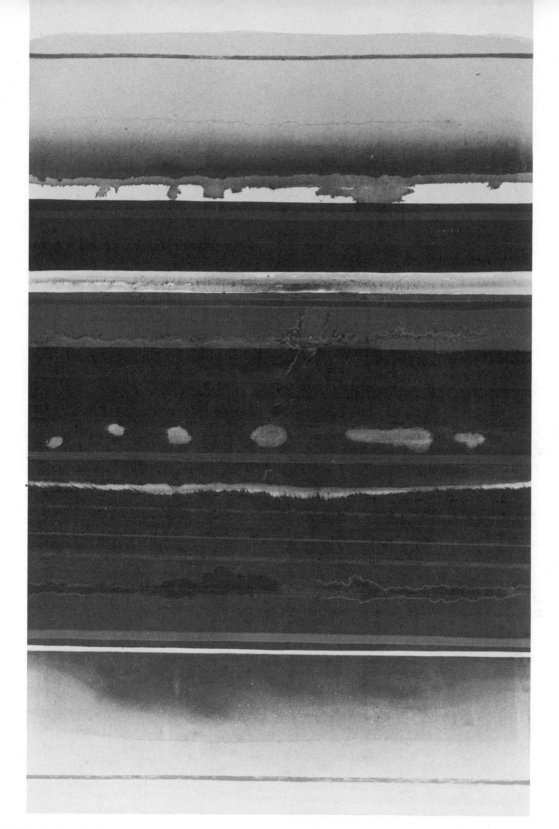

Blue and Red Latitudes by David Simpson, oil on canvas, 85½″ x 52½″ (217 x 133 cm). Collection Oakland Art Museum, Oakland, California. David Simpson is a West Coast painter who was involved for a time in a series of paintings composed entirely of horizontal stripes and bands. Many of those paintings were clearly references to nature—beaches, tides, lake reflections, strata of sky, water, and land—whereas other paintings in the same vein were more nearly pure painting, to be enjoyed exclusively for their internal relationships. *Blue and Red Latitudes* is a combination of consciously applied stripes and ribbons of color offset by loose, accidental bands and edges that have been allowed to drip, run, or blur. Grainy textures are opposed to flat paint, and both are used in opposition to filmy stains of color. Some edges are subtle, their presence barely sensed; other edges are firm and hard. This is a frankly beautiful painting (especially in color). Though it is landscape by inference or implication, it is essentially a painterly experience in which everything depends not only on the painted and stained surfaces but also on the sensitive arrangements of the various strata to which the artist limited himself.

34. ALLOVER TREATMENT IN SMALL UNITS

CONCEPT. As a complete change from paintings in which the composition consciously plays off large simple shapes against areas of complexity, there is another kind of pictorial composition that is concerned more with assembling small units of color that cover all or most of the picture surface. This is a sort of mosaic effect which breaks up the surface into hundreds, possibly even thousands, of small color patches of approximately equal weight and emphasis throughout, without any attempt to introduce flat, simple rest areas.

Pictures of this sort often have somewhat the effect of an enlarged detail of an Impressionist painting by Sisley, Monet, or Seurat. Everything is handled in terms of clusters of color, small-scale shapes that flow across the surface in scarcely perceptible groups or movements.

Many of Pierre Bonnard's paintings were done in this manner—pictures of the view from his studio or of his garden that are complex interweavings of color strokes applied in a restless, allover treatment. Similar effects appear in some of the tree and garden paintings by Gustav Klimt, in which small patches of color are massed two-dimensionally, all over the surface—like a frontally viewed wall of color cells filling the picture to its edges. Also, the American painter Mark Tobey was known for his very personal conception of abstract landscape as essentially a clustered patterning of tiny strokes, marks, and linear symbols that cover the surface more or less uniformly, with only subtle shifts of emphasis here and there. Recently, there seems to have been a resurgence of paintings done in this manner as a quite distinct category of current landscape painting. I refer here to the work of such artists as Gabor Peterdi, Gyorgy Kepes, Morton Kaish, Joseph Raffael, and Virginia Dehn, as well as some of the earlier paintings of Hyde Solomon and Alan Gussow.

Pictures by these artists working in the allover style vary from semirealistic to abstract. Most reflect the kinship and interdependence of art and technology that is examined in Gyorgy Kepes' book *The New Landscape* (Chicago: Paul Theobald and Co., 1956), a book I recommend highly to all landscapists interested in pushing forward the frontiers of that branch of painting or, indeed, of art in general.

PLAN. As preparation for painting in an allover treatment, there are two sources you might refer to. Look at original examples or reproductions of the works of the painters listed above. Also, study detailed sections of the work of French Impressionist and Post-Impressionist painters such as Monet, Sisley, Pissarro, Seurat, Bonnard, and Vuillard, as well as the Austrian painter Klimt. If originals are not easily available to you, there are excellent books on these artists that will give you a good idea of the various ways of handling multiple color units as an allover surface.

Second, you can refer to such books as *Micro-Art: Art Images in a Hidden World* by Lewis R. Wolberg (New York: Harry N. Abrams) or *Hidden Art in Nature* by Oscar Forel (New York: Harper & Row). Look especially at the photomicrographs that seem to relate most closely to the concepts discussed above, images composed of organic color patterns that are very frequently suggestive of landscape forms or natural forces. Quite obviously, such photographs are definitely *not* to be copied or enlarged by you, but could provide a viewpoint to be applied to your own abstract landscapes—a means of translating or interpreting natural forms, light, weather, and seasons as densely arranged allover patterns filling the picture space.

Since this method of creating a good-sized painting by amassing small color spots can become a time-consuming one, I would suggest, as a beginning phase, an undercoat of one or more colors, on top of which you can arrange your myriad touches of color. To produce a little extra color vibration in the early stages, you might use an undercolor that is generally the complement of the colors you plan to use on top of it—underpainting with a bright green for the reds that will follow, or underpainting with violet as preparation for spots of orange-red. It will take considerable time to apply the necessary hundreds of patches of color, but some time can be saved at the beginning by having the canvas or panel covered with three or four or more broad color masses on which you can then place your color units.

As the painting progresses, be sure there is some underlying sense of order, either in the masses over which the colors are applied, or in the design of the color clusters themselves. Keep the surface from looking disorganized. This general sense of order does not have to be too apparent, but it must be present.

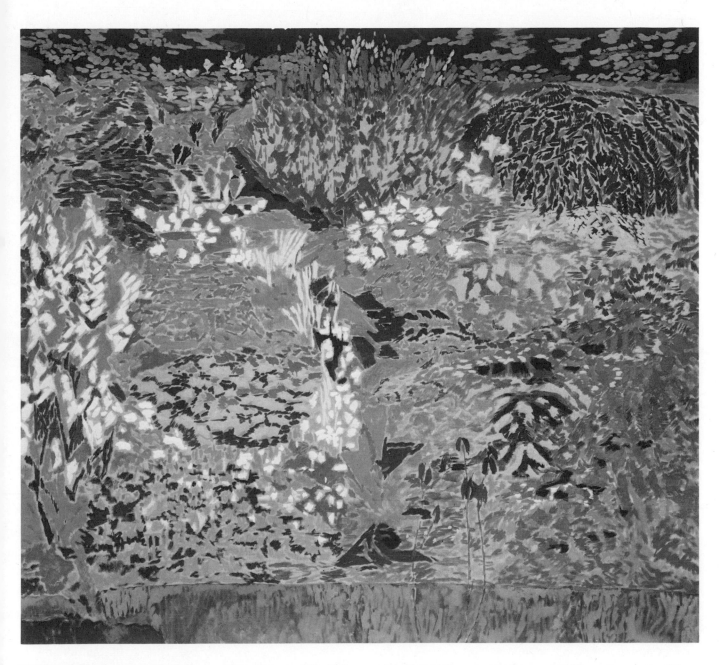

The Rock Garden by Alan Gussow, oil on canvas, 60″ x 70″ (152 x 178 cm). Courtesy Washburn Gallery, New York City. Alan Gussow combines his career as a painter with his activities as an ardent environmentalist. His paintings have always centered on nature, and in many instances, they reflect the world he knows best, the areas close to his home and garden upriver from New York City. *The Rock Garden* is undoubtedly a motif familiar to Gussow, and he has interpreted it as a kind of decorative Impressionism, a complex, all over pattern that candidly emphasizes the flatness of the picture's surface. A careful examination of this painting shows a general structure of unobtrusive, underlying shapes that group and unite the small, colored shapes that form the composition. These units that cover the surface are not the casual brushmarks and scumblings of the Impressionist style; they are mostly dabs, strokes, and bars of color that are very consciously shaped, almost designed. This variety of shape, character, density, and direction of color is what gives visual interest to a picture field that otherwise might have been too uniform. In some respects this is an intimate kind of painting that does not depend on an impact as seen from a distance; rather, it invites the viewer to contemplate it at close range, to relish the detail of its parts as well as the orchestration of the whole.

35. DISTORTION FOR DESIGN

CONCEPT. In the discussions of stylization, we saw how painters gradually depart from appearances and begin to exploit the design qualities inherent in a subject. Stylization is the first step toward making intentional distortions that have more to do with pictorial considerations than with fidelity to the subject. There are many degrees of distortion, depending on how much an artist needs to change the motif to suit his pictorial or expressive requirements and his stylistic preferences. Some distortions, remaining on the side of realism, consist of relatively minor adjustments to make the subject conform in some way to the compositional demand. Other distortions are quite extreme and may take the motif to the brink of unrecognizability. Nevertheless, distortion in paintings is always a conscious act on the part of the artist to alter reality to suit pictorial purposes.

What are the reasons for distorting a landscape in the first place? The principal and most cogent reason is that the artist is creating a work of art. He is expressing *his* experience of reality. He is not copying reality; he is not repeating reality; he is not even documenting reality. If that were his only objective, he would be wiser to acquire a first-rate camera and do the job right. Even the most brilliant draftsman and technician can't successfully compete with a camera when it comes to capturing accurately light, colors, blendings, and the infinitely complex detail that exists in nature. The artist is limited at the very start by the range of pigments available, which are a poor match for the range provided by color film.

The painter, because he is first and foremost a picturemaker, concentrates on making a painting. What exists in nature is nowhere near as important to him as how *he* interprets it in terms of color and design.

The point is that subject matter is something on which to base a painting. Nature only provides suggestions for the artist's creative faculties; it does not set forth ironclad rules on how the final painting must look. For example, if the artist knows that a green roof will suit his picture better than the red roof that was really there, then he distorts reality to the point of using the green required by that picture.

With this in mind, it can be seen that distortions of the visual facts of landscape are not only an option, but a necessity, if the artist is to transcend appearances and create a work of art. This means that in order to produce a picture which satisfies its internal design requirements, technical considerations, and the artist's expressive intentions, the artist is obliged to make various changes in the design or color organization, or both. (Color distortions are discussed in the section "Notes on Color," page 138.)

Design includes the composition of the picture, its spatial qualities—surface divisions and recession into picture space—and the rendition of shapes, lines, colors, and patterns. The artist who takes a creative approach to landscape looks for design elements already present in his subject and then intensifies them. At the same time, being responsible for structure and order in his painting, he alters the look of things to arrive at a higher order of reality—nature reorganized in terms of design.

PLAN. Get rid of the notion that what is in the existing landscape must be repeated, just as it is, in your painting. Feel completely free to enlarge certain elements, stretch them out, shorten them, change colors into more interesting relationships—whatever distortions you feel are necessary to improve your picture. Don't distort aimlessly or without purpose, though; any changes you make should perform a specific function in the painting, especially in terms of composition and design.

Search for the design qualities of your subject—is it line, shape, color, pattern, rhythm? Play down the realistic aspects of the motif and make more out of its possibilities for design interest. Use your subject as a means of designing your picture surface, just as if you were dividing up a field of some sort, getting your ideas about just where to divide it by looking at the various forms in your landscape subject. Another way to approach the composition is to develop a nonobjective design of horizontals and verticals on your canvas and then see if you can somehow fit your landscape subject into it—with a slight change here and a few distortions there. Coordinate your own design ideas with the design ideas suggested by your subject. Your final painting should look as if a sense of design, of order, is much higher on your list of priorities than mere faithfulness to what your eye sees.

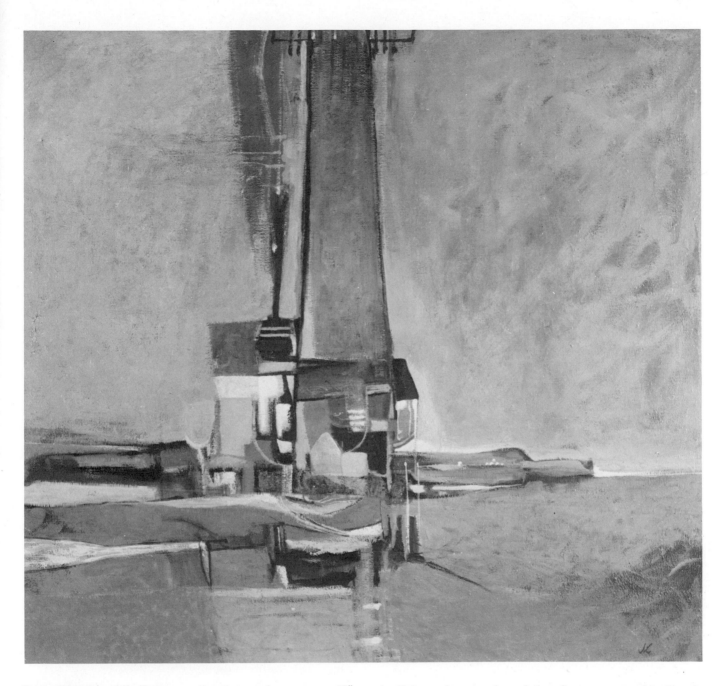

Boon Island by John Laurent, oil and enamel on canvas, 48″ x 48″ (122 x 122 cm). Private collection. Artists have always been attracted to lighthouses. In fact, their picturesque qualities seem to be almost irresistible, except that they present the risk of painting a cliché. They are subjects that have been painted so often, and sometimes so badly, that many painters avoid them as a matter of course, even when they remain impressed by their pictorial possibilities. Boon Island is off the coast of Maine and New Hampshire, subject of a well-known novel by Kenneth Roberts, and the light itself is a stark, dramatic pinnacle rising sharply from bare rock. John Laurent has shunned the obvious treatment. In his painting it is not a lonely column standing romantically against the sky and sea. He has chosen to interpret it as a semiabstract design. The subject is still recognizable, though he has daringly cropped the light at the top edge of the picture, suggesting that the light was not as important to him as what it meant in terms of its abstract relationships of line, shape, color, and pattern. To begin with, he designed his canvas by using the ground plane and the light as the most basic horizontal and vertical division of the picture surface. Then he has added painterly interest by introducing a variety of both flat and scumbled areas, as well as a variety of linear elements that function not only descriptively, but also as pure lines—thin and thick, rough or delicate, straight and curved—that weave in and out among the abstract forms. Finally, Laurent has freely altered shapes and sizes to suit the needs of the pictorial structure, and all realistic detail has been subordinated to the overall design—a distortion of nature in the interests of art.

36. DISTORTION FOR EXPRESSION

CONCEPT. Broadly speaking, artists fall into one of two categories: they are either rational or emotional; objective or subjective; Classic or Romantic. Whereas one painter is most concerned with patterns and structure in nature, another painter might be concerned more with his personal responses to nature, with expression rather than design. The latter, when he distorts nature, does so not to bring out the hidden order in nature but to intensify its expressive qualities, or to project more forcefully his own feelings toward the subject.

This is a more Romantic view of landscape, one that stresses mood, drama, mystery, or excitement. Although even the most emotional paintings must be contained within some kind of order, their design qualities are bound to be less significant just because of that insistence on expressive form and color at the expense of almost everything else. Let us see how two major painters have made use of expressive distortion.

One of the most subjective of all modern landscape painters was Chaim Soutine, who early in his career painted turbulent pictures in which houses were twisted out of shape as if made of rubber. Trees and roads seemed agonized and were contorted, and the whole canvas was painted in a burst of strong emotion. The violent distortions that occur in an early Soutine are meant to evoke in the spectator the same frenzied response the artist felt as he painted it.

John Marin was less concerned with his emotions and more concerned with transcribing the essence of his favorite subject, coastal Maine. His object was to "make a paint wave breaking on a paint shore," translating the world of the real into the world of paint. His obsession was to communicate an experience of nature in the most direct and spontaneous way possible. There were some distortions related to abstract design, but his basic urge was to celebrate nature. That's why his distortions usually emphasized the flow of the ocean, the hardness of the granite, the bend of trees in the wind, and the sinuous movement of white foam washing over beach pebbles.

With Soutine, painting was a matter of distorting na-
ture to express his deepest personal feelings, but always based on direct contact with the landscape motif. Marin also always painted his watercolors in front of nature, but he was more involved with understanding nature itself than he was with his own feelings. The original response had to be there, of course, but he preferred to recreate nature rather than dwell too much on personal reactions.

The subject itself and the qualities which most move the artist will suggest the kind of distortions to make. Aside from an intensely emotional involvement with the subject that demands distortions of drawing and perspective, and aside from more energetic brushwork, taking liberties with color is another most effective way to reinforce the expressive impact of a painting. Some painters, while retaining fairly conventional drawing, depend solely on color distortion as a means of heightening the emotional effect of their pictures. Each painter must define for himself just what he is trying to express in any given painting.

PLAN. Your response to your subject is all-important here. Keep in mind that your are going beyond telling how the subject looks; you are seeking a highly charged, intensified image that either expresses something about the subject itself or expresses your inner feelings about it. In this instance, calmness and deliberation are out of order; what you should be aiming for is a sense of excitement and a depth of response you wish to communicate as vividly and forcefully as possible. Arouse the spectator in whatever way you can: try to feel a oneness with your subject, distort the drawing, force the perspective, intensify the color, or paint at white heat, wielding the brush freely, even violently.

Don't lose sight of what first struck or excited you. Don't get bogged down in technical details, but go straight to the heart of your subject. Avoid all distractions. It doesn't matter if the composition is not worked out as neatly and precisely as you would like—the main consideration is immediacy and expressiveness. If your image is sufficiently powerful, no one will miss the niceties of design.

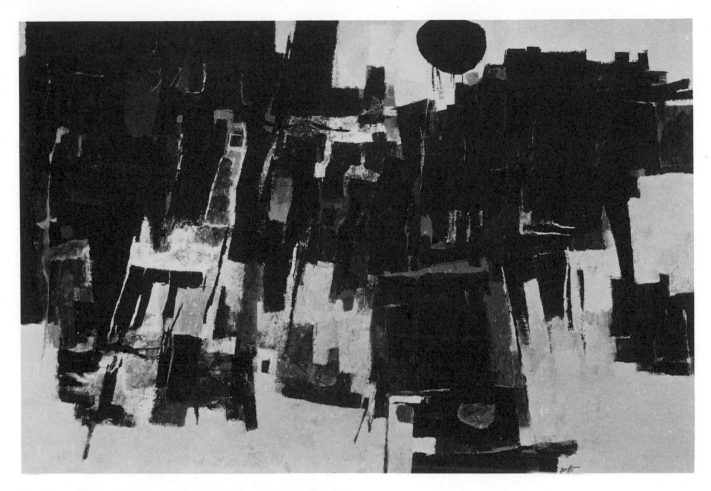

Northern Spaces by Edward Betts, N. A., A. W. S., lacquer on Masonite, 48″ x 72″ (122 x 183 cm). Courtesy of Midtown Galleries, New York City. This painting was done a number of years ago after one of my visits to Monhegan Island, following an occasion when I climbed from the rocky base to the top of the cliffs on the ocean side of that island. What I most wanted to express was the sense of towering height and the harsh, rough quality of the granite cliff. To paint such a scene realistically would have been too tame to communicate my feelings about that face of the dark cliff rising up against the bright sky, so I felt free to distort natural appearances. Rather than treat the gray rocks literally, I interpreted them as a series of vertical or tilted strips and blocks of deep blues and purples and jet black, some reaching almost to the top of the painting, others continuing upward beyond the edges of the composition. The sun, toward which everything seemed to move, was painted a very dark red. My whole concern was the evocation of unyielding rocky structures building upward—a dramatic, forbidding wall of granite. I distorted nature here to project the immensity, starkness, and strength of a sea cliff silhouetted against the sky. I handled it in the most painterly terms possible so that it could be enjoyed not only as an intensified expression of a coastal environment, but also as a rich, sensual experience in paint, color, and texture.

37. SEMIABSTRACTION

CONCEPT. Semiabstract painting is a rather broad area that lies between the two extremes of designed realism and nonobjective design—somewhere about halfway between Andrew Wyeth and Piet Mondrian. Ideally, semiabstract painting is a balance of nature and design in approximately equal amounts; but, of course, few pictures have such a precise balance. Each painter has his own preference as to the ratio of realism to abstraction; so the middle zone between realism and abstraction is actually far broader than one might at first realize, and it allows the painter considerable leeway in where he stands in relation to the two extremes.

To get an idea of the wide variety possible within the limits of the semiabstract approach, here are some American painters whose works in general could be classified as semiabstract: Lyonel Feininger, John Marin, Charles Sheeler, Milton Avery, Niles Spencer, Preston Dickinson, Lamarr Dodd, Everett Spruce, Keith Crown, Morris Kantor, and Balcomb Greene. And illustrated in this book: William Palmer, Jason Schoener, Paul Zimmerman, Ethel Magafan, Hans Moller, Reuben Tam, John Laurent, Betty M. Bowes, Margit Beck, Robert Eric Moore, Richard Phipps, Morris Blackburn, and David Lund. Such a range of styles and individual approaches should indicate that semiabstract painting seems to offer the artist almost more freedom of viewpoint or attitude than either pure realism or pure abstraction.

It has long been my feeling that either photographic realism or pure abstract design are really easier to master than semiabstraction. If a painter has solid training and plenty of time and patience, he can paint thoroughly convincing realistic landscapes; or, a painter with taste and a solid foundation in the principles of design and color can create very handsome nonobjective paintings. But to achieve that subtle blending, that interplay between nature and design, is the most difficult and challenging of all. In the long run, it demands much more of the artist as synthesizer than either simple descriptive delineation or pure abstract design.

Semiabstraction is not a style; it is a viewpoint toward nature that results in paintings which integrate identifiable subject matter and formal design structure. This integration establishes an interdependent equilibrium between nature and design in which neither dominates the other.

PLAN. Your aim here is to find that middle ground between nature and design where you feel most at ease. You can begin by pushing beyond simplification, stylization, and design distortions toward an even more abstract approach to your subject. Treat your landscape as a series of *shape relationships* in which you actively explore the shape possibilities inherent in your subject. Too many painters are insufficiently aware of the power and importance of shapes in their paintings; they tend to use flabby, indecisive shapes that resemble half-deflated balloons. Look for shapes that have a certain energy or vitality to them—strong shapes that relate beautifully or excitingly to each other. If a shape is unclear or uninteresting, redesign it, improve on it. Make a painting that appeals purely on the level of shape and pattern relationships.

You can also analyze your subject in terms of planes. First identify the planes; then separate or disengage them from one another and reassemble them, shifting and overlapping them in new or unexpected positions and combinations that are more interesting to you. Tilt some of the planes so they seem to move in and out of the picture space, exploiting the tensions between them—tensions that exist between the flatness of the picture surface and its implied, but limited, depth and the tensions between the planes that come forward and the planes that recede. Analyze the planes and then manipulate them. Play with them as inventively as possible, but always within a controlled space that allows neither deep holes in the painting nor projecting elements that seem to jump too far out of the picture.

At all times you should be working toward a synthesis of visual reality with those design elements forming your picture. If your painting seems to be edging too close to realism, strengthen its design aspects; if it becomes too abstract, find a way of reintroducing your subject so that it becomes more recognizable—perhaps with a cloud form, a roof, a ladder, a sign, a figure, a texture, or other details that will give a clearer idea of what the picture is all about.

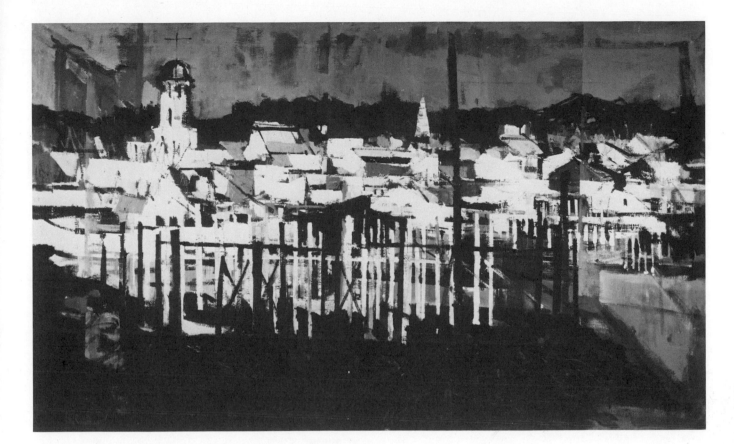

View of Kennebunkport by Alfred Chadbourn, N. A., oil
on canvas, 24″ x 48″ (61 x 122 cm). This view of a seacoast
village can be read in two ways: as a composition of white
houses and wharf structures, and as an abstract arrangement
of angular shapes, planes, and linear elements bound together
in a dramatic pattern of strong lights and darks. To some, it
might be seen as a rather dashing, realistic harbor view,
while to others it might seem nearer to pure abstraction. Ac-
tually, it falls somewhere between those two poles, in the
area called semiabstraction. The buildings are very loosely
defined, without any attempt at architectural exactitude; roofs
and sides of buildings are treated as a complex organization
of planes, something like sheets of glass that have been bro-
ken and then reassembled into new forms and combinations.
With the pilings of the docks we are less aware of what they
really are, but are more aware of their design as a procession
of light and dark lines across the picture. Essentially, there is
no light and shadow, only light and dark shapes. Sky and
foreground have been kept relatively simple and subdued in
order to concentrate interest on the interaction of forms and
patterns in the painting's major areas. This is a very skillful,
painterly version of a scene in which the motif has suggested
the design treatment, but the design does not obliterate the
subject—a fine example of the delicate balance of nature and
design you can achieve in a semiabstract painting.

38. INTENTIONAL AMBIGUITY

CONCEPT. There are two kinds of ambiguity in painting: intentional and unintentional. Many paintings by students and amateurs are unintentionally ambiguous, either because they lack a clear understanding of what the picture is all about, or they fail to identify the various forms or areas within the picture or the spatial relationships that exist between different areas. If the artist is unsure of what his forms refer to, these will be equally unclear to the spectator; and if he is not clear in his own mind whether a particular form is in front of or behind another form, that also can cause serious confusion in the spectator's mind. The artist first must define for himself *what* and *where* things are in the picture space before he can communicate it to his audience. Unintentional ambiguity is a failure to organize the components of the picture so they communicate successfully.

On the other hand, there are times when an artist purposely seeks a certain degree of obscurity of ambiguity. This trait is to be found frequently in literature, most particularly in poetry, where the writer is deliberately vague about just what is going on. His intention may be to draw a veil of mystery over the subject or actions, to appeal more directly to the reader's imagination, to enrich language and content, or to suggest possible multiple meanings and interpretations. This usually results in a somewhat higher level of art than that which comes out directly and "tells it" just as it is.

Painters have similar impulses to avoid the obvious and leave a little to the imagination. Painters have poetic instincts, too: they feel that not everything has to be explained with clarity and logic, that certain areas or forms might well be read in more than one way. Arthur Dove's paintings are often ambiguous in that the origins of his nature symbols are not always easily identified, and more than one interpretation is possible. Morris Kantor, in certain late paintings, played with a now-you-see-it, now-you-don't approach to nature, a sort of visual teasing in which the spectator would feel on the verge of recognizing forms but was never quite sure he was right. William Brice did a series of paintings involving a metamorphosis of figures and rocks, but he made it difficult for the viewer to discern just where figures left off and rocks began. A melting together of forms exploited ambiguity as part of the esthetic satis-faction to be derived from those paintings. And Balcomb Greene has done some paintings in which rocks, surf, and sky are strangely and ambiguously intermixed, and others where landscape briefly seems to become a figure, which then slips back into being landscape.

Intentional ambiguity is one way for an artist to demand more from the spectator, to persuade the viewer to participate more actively in the painting. It means, however, that at all times the artist must be in control of those ambiguities, which should be intentionally employed toward some pictorial purpose.

PLAN. If you find your paintings are becoming to literal, that you tend to spell out everything, leaving little to the viewer's imagination, try some paintings that are less factual, less detailed—pictures in which landscape forms are occasionally suggested rather than clearly rendered. Think of your painting as being an example of peripheral vision, with some areas being seen more sharply than others. Deliberately throw some forms a bit out of focus, or treat several forms purely as color areas or shapes that have no specific meaning or reference.

Don't feel, for instance, that every part of your picture has to be explained. If you sense that the painting needs a green smudge here or a bright red accent there, put it in, whether or not it has a logical counterpart in nature. If you are working freely and improvisationally and end up with a painting in which some areas are less easily understood than others, don't worry about it; as long as you are convinced they work well pictorially, there is no need to rationalize them. Your painting is ultimately more important than the facts.

Also try doing pictures in which you purposely blend and transmute natural forms, one into another, to arrive at curious, intriguing new forms and relationships or situations in which a form subtly becomes something else right before the viewer's eyes. True, this is not easily accomplished, but it is worth trying if only to stimulate your imaginative faculties.

Finally, don't talk down to your audience. Consider the idea of making your viewers put forth a little more effort to get the most out of what your pictures have to offer.

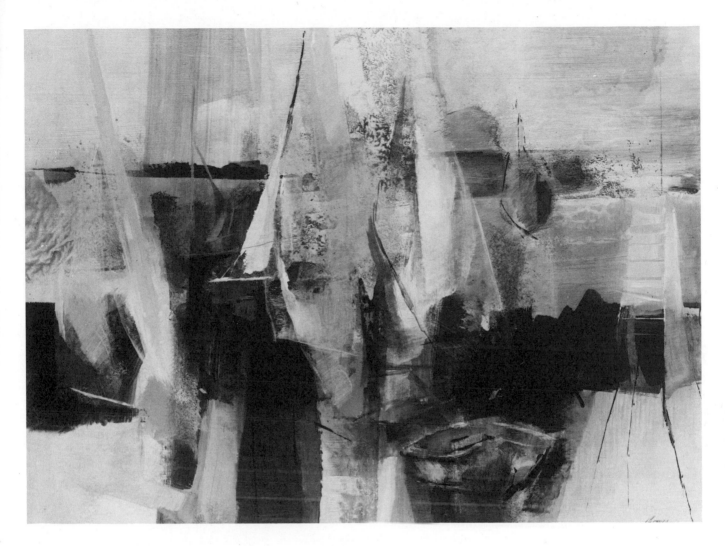

Corinthian Sails by Betty M. Bowes, A. W. S., acrylic on Masonite, 24″ x 32″ (61 x 81 cm). Betty M. Bowes has mentioned that this painting is, "a composite of many seasons of sailing and racing at the Corinthian Yacht Club on the Delaware River in Pennsylvania." Sails, sailboats, docks, river, and sky are all referred to in her composition, yet she has treated this picturesque material primarily as an exercise in the relationship of shape, color, pattern, and texture. Her subject is sensed rather than described; instead of a literal rendition of an actual dockside with sailboats, she has interwoven her vigorous forms within a firm but loosely handled semiabstract structure, resulting in a painting that in no way specifically pins down realistic details. It is a picture based on inference, implication, and suggestion, with just enough clues (a boat in the foreground, flapping sails, the planking of a dock) to provide a hint as to the picture's subject. Some areas, in fact, have little direct reference to anything in nature; they are mainly handsome textures or broad sweeps of color. The ambiguity here has been consciously controlled by the artist—she knows enough about boats and sailing to have added all the authentic detail she cared to—and the picture is better for the fact that she has not chosen to tell too much about her subject.

39. TEXTURE IN LANDSCAPE

CONCEPT. Watercolor relies on the sparkle of thin transparent washes over white paper, so it is not the medium for those artists to whom impasto textures are important or necessary for the full expressiveness of their art. Toward the end of the 1950s, exaggeratedly heavy impastos were favored by a number of painters, exemplified by Antoni Tàpies in Spain, Bram Bogaert and Jaap Wagemaker in the Netherlands, and in this country, the early work of Jules Olitski. Many artists in those days, dissatisfied with the ordinary impastos possible in oil, began adding various fillers to the paint in an effort to arrive at even thicker, massive mountains of paint. They added not only sand (already used much earlier by Braque and Picasso), but went so far as to add sawdust, birdseed, pine needles, coffee grounds or tobacco, none of which can be considered good risks for a stable and permanent paint film. The resulting surfaces were more like sculptural relief than even the heaviest oil impastos.

With the development of acrylic polymers, artists could indulge their tastes for such sculptural surfaces to an even greater extent, and much more safely, by using acrylic gel, modeling paste (finely ground marble dust), wood flour, mica talc, or other fillers mixed in with acrylic medium or gel. The binding properties of the acrylic polymer medium are quite extraordinary. I recall a student of mine who, using a hammer and chisel, tried to chip off some unwanted impasto from a Masonite panel. The impasto area did indeed finally come off, but it took a good amount of the Masonite along with it—the Masonite gave way before the acrylic did. The lesson to be learned here is that painters who must deal in heavily textured surfaces would be safer to use acrylic as their binder rather than oils.

The sense of substance and tactility obtained through exaggerated impasto aids the painter in expressing or suggesting earth and rock surfaces, elemental forms and textures that have been created by hundreds of centuries of geological forces. In fact, a relief painting of this sort often is a kind of metaphor of the very terrain to which it refers: it is not *like* a landscape, it *is* a landscape— with hills, valleys, chasms, fissures, and encrustations. The heavily textured painting then has become a landscape in its own right. It forcefully projects a sense of nature that is a more direct, firsthand experience of various landscape configurations and of eroded, pitted, weathered surfaces than is possible in paintings that go

no further than describing the subject. For those who want to immerse themselves in landscape rather than paint references to it, an exaggerated impasto technique will have a visual impact that can be quite overwhelming. The viewer not only looks *at* the painting; he is almost pulled *into* it.

PLAN. In using texture that not only refers to landscape but also, in a sense, creates its own landscape surface, I would recommend working on a fairly large scale—certainly no smaller than about 36″ x 48″ (91 x 122 cm) or 48″ x 60″ (122 x 152 cm). This gives a feeling of breadth and weight, with a scale closer to nature than is feasible in a very small format. It is one that, by its very size, gives the painter more room in which to maneuver his rich textural buildup.

Also, as indicated previously, avoid oil as your medium for such purposes: model your forms and surfaces using acrylic gel or modeling paste in conjunction with inert fillers such as sand or mica talc. Modeling paste, if used alone in lavish amounts, will sometimes crack. (The usual rule is that if it doesn't crack in twenty-four hours, it won't crack at all.) It is advisable to mix the modeling paste about half-and-half with gel in order to avoid such cracking. Sand does not have to be mixed directly with acrylic medium or gel, but can be sifted over an area that has been painted with a 50:50 solution of acrylic medium and water. The sand will adhere only to those wet areas, and any excess sand can easily be brushed off the surface after the wet sand has dried in place. This operation can be repeated at will until an extremely sculptural surface is achieved, projecting an inch or more from the panel's surface. A Masonite panel, by the way, is safer than canvas simply because it is a less flexible support, so that blows from the front or rear are not likely to damage or loosen the impasto areas.

The textured substances can be applied with knives, spatulas, putty knives, or fingers and can be further enriched by carving, scoring, scraping, or combing. These surfaces can then be painted opaquely or can be glazed and wiped to effect a wide range of color textures.

It is best to have some idea of a general composition or distribution of shapes and areas before beginning to paint and to vary the surfaces so the heavily textured masses are contrasted with simpler, flatter, less textured areas.

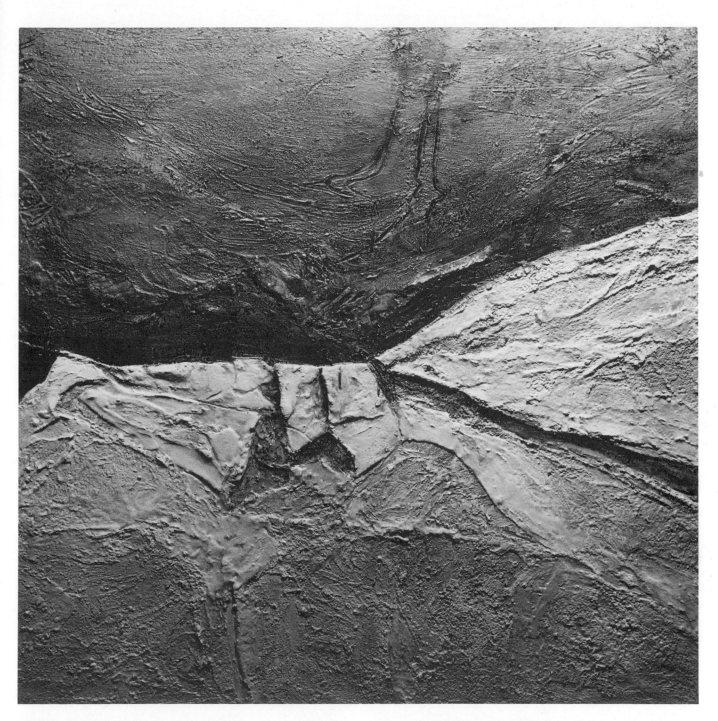

Cleft by Beverly Hallam, acrylic and mica talc on Belgian canvas, 48″ x 48″ (122 x 122 cm). Compositionally this painting is relatively uncomplicated and easily assimilated. Its power and visual interest lie in the richness of its textural surfaces—a recreation of a rock cleft seen in closeup view. While it has its origins in the artist's observations of coastal rock forms, it is also like a relief map, deeply concerned with the solidity of rock, with primordial forms, and the action of elemental forces. Although the painting represents such things, it is itself a rugged, monumental landscape of cut, carved, incised, scraped areas, an equivalent to what occurs in nature itself. The mica talc and acrylic were mixed with an electric eggbeater, then applied with a trowel, painting knife, whitewash brush, and basting tube. After the painting had dried, it was glazed with both acrylic colors and finely ground dry pigments mixed with a wetting agent called Methocel. This picture has as much to do with geology as it does with art, a personal response to nature arrived at through the dialogue between the artist's intuitions and her materials. The manipulation of the medium has determined to a large extent the forms and textures that appear in the completed painting.

40. GESTURAL LANDSCAPE—SEMIABSTRACT

CONCEPT. Almost any mark or brushstroke an artist puts down is, in a sense, the result of a gesture. The hand that holds the brush jabs forward, moves this way or that; the wrist turns or twists; the whole arm swings the brush across paper or canvas in a sweeping stroke—all these are the painter's gestures. In very realistic painting styles, such gestures are almost nonexistent or are firmly subdued. In more painterly, brushy techniques, however, the approach is looser, and gesture can be brought into play more frequently. When the entire picture is formed of combinations and clusters of swiftly executed brushstrokes very freely applied, then the painting can be called *gestural* both in concept and in the application of paint.

We think of Andrew Wyeth as a master of controlled, precise detail in his egg tempera paintings, but we should not forget that, at the same time, he is also a master of gestural sweep in his transparent watercolor paintings and studies. Close inspection of any of John Singer Sargent's figure or landscape sketches, whether in oil or watercolor, discloses the touch of a born gestural painter; details of many of his paintings are as totally gestural and abstract as any painting by De Kooning or Hofmann. Constable, Turner, Bonnard, Bellows, Kokoschka, Marin, Gorky, and Motherwell are all gestural painters, in contrast to Seurat, Cézanne, Eakins, Demuth, Hopper, O'Keeffe, and Burchfield, who are decidedly nongestural in approach.

Outside our own culture, the ink painters of China and Japan were highly adept at the use of gesture in landscape painting, producing possibly the most expressive gestures in all art history. In terms of delicacy and sensitivity, breadth and strength, variety, lyricism, nuance, complexity, and finesse, they remain unequaled. They were specially skillful at adding an extra ingredient, that of closely identifying the gesture (and the brushstroke) with the thing to which it referred: the cragginess of a mountainside, the twisting of a branch, the wispiness of clouds and mists, the spikiness of pine needles, or the downward rush of a waterfall.

Perhaps the finest of our semiabstract watercolorists was John Marin, who literally attacked the paper while feeling at one with nature—sheets of rain slanting from the sky, the smack of white surf on granite, the surging motion of the sea, jagged coastal rocks and the mountains of New Mexico and New Hampshire, sharp dark firs and spruce silhouetted against the sky—his brush seemed to become the subject as he painted it. This was felt gestural painting on the very highest level of art.

Gestural semiabstract landscape implies having a strong empathy with the subject; it means energetic paint handling that translates nature into vigorous form and motion; and it means that loose brushwork takes precedence over the detailed view of things, that the gestures relate as much to the principles of abstract design as they do to the character of the subject depicted.

PLAN. Feel out your landscape first in a series of drawings in either pencil or brush. Keep your hand moving restlessly, thinking all the while about what the subject is like, what is happening, and letting it come out on the paper freely and instinctively. You are not making a factual drawing or a map; you are seeking essential forms and movements. You should respond as directly as possible to what you see—drawing not a cloud, but the movement or bulk of a cloud; drawing not a branch, but the way it grows, reaches out, and moves in space. You draw forms more as you *feel* them than as you *see* them.

Once you have done many drawings to explore your subject, you can move into painting. But work for the same spirit of immediacy as in your drawings. Follow your impulses, working quickly so you won't have time to get bogged down in stiffly rendered description. Capture the upward thrust of a rock formation, not just its outward appearance; show the fluidity of ocean swells and the force of wind against trees.

Finally, begin to combine your painter's gestures with an attempt to emphasize the design aspects of your subject. You can still paint as freely as you wish, but keep a sense of design at the back of your mind as you work. Since gestural landscape is more a matter of felt responses to the subject than study and rational analysis, it is important to cast the subject into some kind of formal order that will underlie the gestures and give them coherence. The more you work along these lines, the more easily you will be able to blend instantly what you see and feel with a semiabstract compositional control.

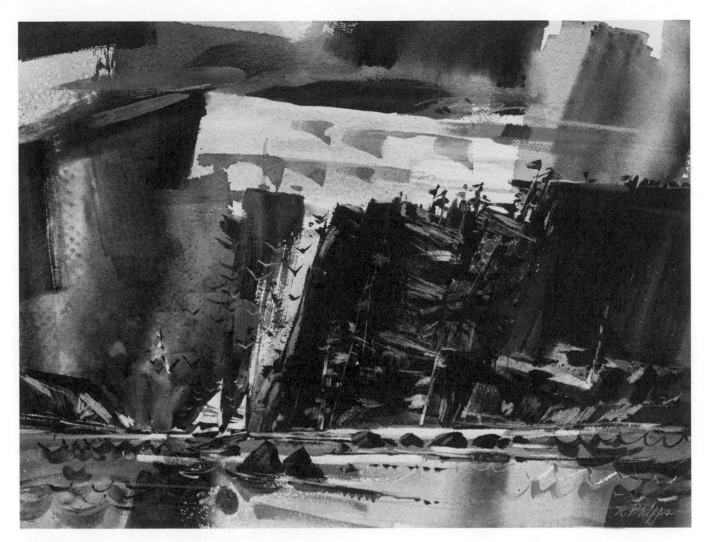

Rounding Point Loma by Richard Phipps, watercolor on paper, 18″ x 24″ (46 x 61 cm). Private collection. This watercolor painting is a dramatic composition that exploits the dynamic aspects of nature, and the artist's gestures are an essential part of projecting those dynamics. We can feel the movement of his brush as it traverses the surface in broad, vigorous strokes and fluid washes, creating massive slabs of rock, and contrasting patterns and intersecting planes in the sky and the choppy water in the foreground. Trees are not so much trees as they are brushstrokes, and at every point we are invited to share in Phipps's own excitement and enthusiasm as he zips the brush forcefully downward, digs lines into the moist paint, and slashes quick strokes here and there to suggest sharp, rocky forms or gulls in flight. His gestural brushstrokes give the picture unity, and his firm grip on semi-abstract two-dimensional structure keeps the picture from falling into a raw emotional response that is scattered and unformed. There is a great zest and freshness here, a delight in the grandeur of nature that is projected primarily by the artist's casual, gestural approach, and his unerring instinct for relaxed yet controlled design.

41. GESTURAL LANDSCAPE—ABSTRACT

CONCEPT. The principles of abstract and semi-abstract gestural painting are the same, except that in the former the landscape is treated as gestures that carry the motif further toward pure abstraction. Recognizability is less in evidence, and the purely formal qualities of line, shape, pattern, color, space, gesture, and touch are stressed more openly. This results in paintings that tend to be landscapes more by suggestion or implication rather than by description or reorganization of planes.

There are a substantial number of contemporary American painters who choose to paint landscape in a gestural abstract manner. Very likely, though, the first practitioner of this approach was Claude Monet, whose series of water lilies was a pioneering effort to interpret nature not by faithful rendering but by translating landscape motifs into pure color, paint surfaces, and complex interweavings of strokes, dabs and scumbles. In these pictures Monet often eliminated skies altogether, so that the viewer looked directly into the depths of a seemingly shoreless pond. Unable to orient himself in the background, middleground, and foreground, the viewer found himself confronted with a painted surface on which the relationships of colored pigment and physical gestures were paramount. Nature was used merely as an excuse for indulging in the most ravishing and delicious color sensations. Indeed, only a few feet away from the canvas, the effect was that of total abstraction.

Some of today's painters have adapted this view of nature to their own personalities and perceptions of landscape. Joan Mitchell, for instance, is one of the foremost of our gestural landscapists; her compositions are arrived at intuitively and improvisationally. Although at first her approach seems to have strong allegiances to the Abstract Expressionist school of painting, one eventually realizes it is really nature—airy, spacious, vibrant—that preoccupies her most. It is her slashing, hooked, relaxed, or explosive gestures that produce an inescapable feeling of a painter digging inward to form a landscape-related image.

Other Americans who share a love for expressive gestures that evoke a sense of landscape are Syd Solomon, William Kienbusch, Glenn Bradshaw, Hyde Solomon, Carl Morris, and Lawrence Calcagno. Even a number of painters usually associated with nonobjective painting, such as Helen Frankenthaler, Willem De Kooning, and Adolph Gottlieb, have at various times done pictures with very strong landscape implications.

In all their work the gesture is the fundamental method of arriving at landscape forms. Although the severe abstraction usually minimizes easily recognizable references, the gestures that originate such images are basically rooted in an intimate contact with nature.

PLAN. Carry your gestural landscapes a few steps further toward more rigorous abstraction. Simplify radically; search out essences. A horizontal slash of yellow paint could be a riverbank, some scribbly lines are beach stones, and above a mass of deep yellow-green might be a brushy area of dark black-green that alludes to pines or mountains. Allow yourself a much looser form of design here, and don't work too hard for naturalistic references. If some passages are a little ambiguous, don't give it a second thought—at least not yet.

These are studio paintings, after all, and should not be attempted on location, though Oskar Kokoschka was able to do it now and then. Always get your ideas from something you have observed firsthand. Refer to your sketches, studies, and notes; then put them away and attack the painting. Rely on your memory for the important things, but forget details. Assemble strokes, colors, stains, and patterns that suggest landscape forms without being in the least specific. Develop your own system of shorthand gestures. Get it down quickly, then later sit down and calmly contemplate what you have done. Wild or energetic as the picture may be, it should still have a sense of overriding order, however indefinable.

If the picture needs any changes, figure out what it is you want to do, mix the exact color, get the correct amount of paint on your brush, and then hit the canvas, doing it in one stroke if possible. Revisions and additions should not look different or more studied than the rest of the paint surfaces, but should be handled in the same spirit. If the work starts to show, you have probably already lost the spontaneity inherent in the gestural approach. Rather than beat one painting into submission, do a series of four or five, until you arrive at what appears to be an inevitable combination of gestures, colors, and shapes that vividly express your feelings about the landscape.

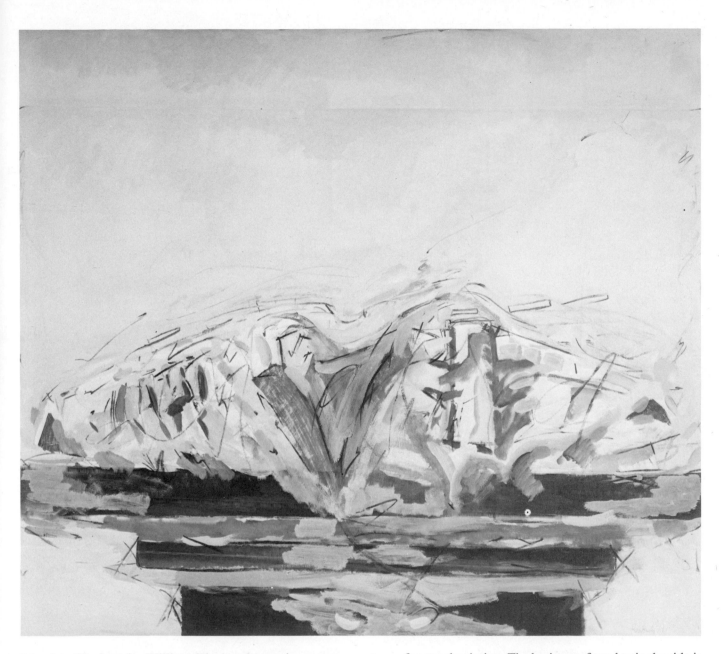

Island to Horizon by William Kienbusch, casein on paper mounted on board, 37″ x 41½″ (91 x 105 cm). Courtesy Kraushaar Galleries, New York City. William Kienbusch is well-known for his very personal, lyrical abstractions that are based on his long familiarity with coastal Maine. His subject matter is varied—barns, walls, fences, buoys, rocks, island beaches, pastures, quarries—and his pictures, however abstruse or abstract, are invariably based on specific material he has seen, sketched, or photographed. It is immediately apparent that his paintings are translations or transformations, not copies. They are always done in the studio, but only after he has fully absorbed his subject mentally and emotionally in nature, and explored the material in several preliminary studies. *Island to Horizon* is a typical example of his muscular type of gestural painting. The horizon referred to in the title is barely visible, as though seen through sea-mist toward the top of the painting. The major activity is his treatment of the island itself, which is reduced to freewheeling, emphatic brushstrokes and swiftly whirling calligraphic charcoal lines that are merged with the thin and thick casein paint. The picture is intensely expressive rather than analytical, using Kienbusch's own vocabulary of symbolic forms, strokes, and touches that evoke rocks, trees, beach, and ocean. It may be difficult to attach specific meanings to specific marks and arabesques, yet the sense of it all manages to come through. As freely abstract as it is, this picture would not have been painted without the artist's deep and powerful response to nature.

42. GEOMETRY IN LANDSCAPE—REALISTIC

CONCEPT. Artists through the ages have often noted and explored the geometric aspects of landscape, not only in architectural subject matter such as barns, churches, wharves, fishing shacks, and industrial and urban scenes, but also in natural formations such as trees, cliffs, mountains, and cataracts. Land patterns such as fields freshly ploughed to reveal geometric designs, or lightly covered with drifting snow, or intersected by elaborate highways have also lent themselves to geometric treatment.

Nature viewed in terms of geometry was first articulated by Paul Cézanne, who, though he was fundamentally a realist painter, regarded landscape largely as a problem of forms in space. He personally felt these forms could be reduced to a basic three: the cube, the cone, and the sphere. Even the French classical master before him, Nicolas Poussin, was also fully aware of compositional geometry. His paintings, realistic as they are, are solidly constructed with infinite care, both in terms of spatial relationships and horizontal-vertical relationships. Furthermore, an analysis of just the straight-line horizontal and vertical elements in Seurat's masterpiece *A Sunday Afternoon on the Island of "La Grande Jatte"* will demonstrate that its basic design structure is astonishingly intricate and abstract. (See Daniel Catton Rich, *Seurat and the Evolution of La Grande Jatte,* University of Chicago Press, Chicago, 1935.) Edward Hopper was another artist deeply aware of geometry in his paintings of landscapes, urban street scenes, and rooftops. He composed his paintings not only by capitalizing on the geometric forms of his subjects themselves, but also by using the diagonals that resulted from the effects of severe light and shadow.

As we have seen earlier in the sections on painting from a frontal view (pages 60-63), it is possible for a completely realistic painter to treat his subject descriptively, yet at the same time do so within a compositional framework that is quite geometrical or abstract in its linear and planar relationships. It is just this insistence on, or revelation of, geometric structure that keeps some realistic pictures from looking unnecessarily casual and formless. There is always a sense of the artist's eye having perceived the geometric qualities and then consciously having adjusted and controlled the arrangement of lines, shapes, and patterns throughout the painting. So, the fact that an artist works in an extremely realistic mode does not preclude the fact that his paintings can contain an interplay of geometric relationships offering deep esthetic satisfaction above and beyond the subject's simple compositional placement within the picture's rectangle.

PLAN. Your aim here is to paint a picture absolutely realistic in every respect, but built on a firm geometric structure that is unobtrusive but nevertheless strongly felt. The design aspects of the painting should play an important part but should be skillfully blended so they do not immediately strike the viewer. With this in mind, give thoughtful consideration to what you will paint. The subject itself should possess some geometric qualities—internal relationships of line, shape, and mass that create a pleasing abstract arrangement.

Once you have decided on an appropriate subject, compose it carefully in terms of line only within the rectangle of your paper or canvas so as to make the very most of its design properties as they relate to those four edges. Generally, closing in on the subject to some extent will permit you to design your surface more successfully than if you surround the main subject with too much distracting empty space. A painting of two barns, a silo, a shed, and a rail fence would capitalize best on the geometric relationships if the architectural forms were allowed to occupy the major part of the picture surface, introducing only as much sky and foreground as is absolutely necessary.

After the composition has been established as linear divisions of your picture surface, plan the patterning of values clearly, either in your mind or in thumbnail sketches. Make sure the composition reads logically, both in its fidelity to nature and also as a purely abstract arrangement of light, middle, and dark values.

You are now free to paint as realistically as you please, including all the details and textures that interest you, provided they stay in their place within the overall scheme. This treatment of nature based on geometrical scaffolding makes for a more esthetically rewarding painting than does conventional, direct realism.

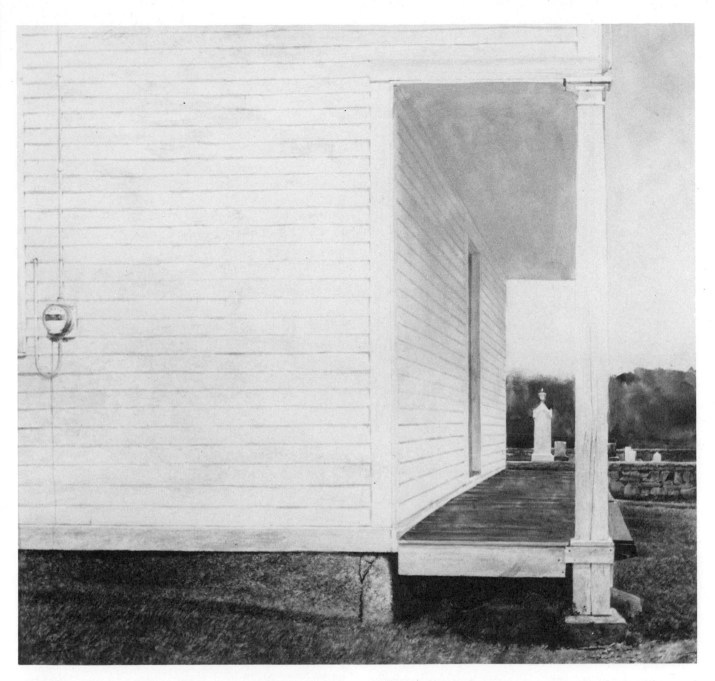

Auburn, by Thomas Crotty, A. W. S., watercolor on paper, 22″ x 23″ (56 x 58 cm). Courtesy Frost Gully Gallery, Portland, Maine. This watercolor is realistically painted, but its unusual appeal, beyond the subject and the technical handling, lies in the way Crotty has seen and composed his subject; he has treated realism in terms of austere design. For one thing, he closed in on his subject to take better advantage of the major horizontal-vertical relationships and to make more concentrated use of a single large shape opposed to smaller units and linear accents. He has presented his subject primarily as an arrangement of several flat, high-keyed planes set off by darker masses from foreground to distance. He has seen it also as a group of flat planes accented by linear elements: the wiring of the electric meter, the clapboarding, and small cracks in the foundation and the weathered wood of the supporting post at right. There are only a few diagonals, such as the converging perspective in the planes of the porch ceiling and flooring and the gentle upward slope of the grass against the foundation. Note, too, how the window frame at the very left edge of the picture, and the wiring next to it, keep all the horizontal lines contained within the composition so that they do not shoot out of the picture. If *Auburn* were analyzed purely in terms of shapes, values, and lines, it would make a handsome nonobjective design; as it is, Crotty has merged his realism with strong design in a way that causes each one to enhance the other.

43. GEOMETRY IN LANDSCAPE—ANALYTICAL

CONCEPT. In the preceding section we saw how realism can be given structure by merging it with geometry. In this discussion, however, we are pushing toward a much more complex analysis of nature into a Cubistic mosaic pattern that no longer functions in the realm of realism but acts fundamentally as two-dimensional design. In its September-October, 1976 issue, *Art in America* published an interview with the veteran abstractionist Ilya Bolotowsky, who was quoted as saying, "Cubism was a good way to study structure. It can give structure to realism or it can lead to abstraction. Cubism is situated right in the middle, you might say. You learn to break up familiar objects to reveal the structure, and then you can go either to entirely pure abstraction or to semiabstraction or even to a form of realism with more structure underneath."

Cubism at its height was primarily an analysis of planes in pictorial space, an examination and comprehension of form within a rather complicated geometric system. Lines, planes, edges, and angles were constantly stressed in order to achieve structure, and subjects were often shown in multiple views in order to arrive at more interesting, complex relationships. Some of the Cubist thinking was related to Cézanne's reduction of volumes to three basic forms: cube, sphere, and cone; some of it was related to African carvings and sculpture; and partly, it was a revolt against Impressionism's colored dots and dabs in favor of the direction indicated by brushstrokes like Cézanne's, which produced not just color but constructed a form or volume. As Emile Bernard once wrote, Cézanne "always interpreted, never copied, what he saw. The seat of his vision was far more in his brain than in his eye."

Generally the Cubist method was: (1) an analysis of form in terms of planes; (2) a breakup of those planes; and (3) a reorganization or reshuffling of those planes into new formal relationships. Light and shadow were no longer necessary to express volume, which was to be accomplished only by the way in which the fragmented planes were joined, tilted, overlapped, or intersected. The fresh arrangement of planes was to be enjoyed for its own sake, as a new pictorial logic, not as descriptive rendering. All this, of course, is a more cerebral approach to nature, a conscious breaking up, pulling apart, and reassembling of planes in order to translate nature's volumes into abstract patterns arranged in a controlled depth. Design then becomes more important than realism. The artist's personal way of reorganizing nature is the main source of esthetic satisfaction.

It has been said for some years now that Cubism has run its course and is no longer relevant to current art. But I think it still represents a kind of discipline—a means of analyzing form and space—that will continue to be of value to painters in their search for ways to treat nature creatively.

PLAN. Transforming landscape into a geometric pattern is not quite so simple as painting a realistic landscape that suggests a geometric substructure beneath surface appearances. You must first fracture your landscape—break it up into major and minor planes—and then put the pieces back together again more interestingly and more inventively. It is like smashing a glass object into pieces and then reassembling them into a new form that did not exist before, one more appealing or exciting than the original object.

Quite obviously, this is studio work; it cannot be done outdoors on location. It means that a number of pencil, wash, and perhaps color studies will have to precede the final painting. You can do your exploration and analysis using a pencil and ruler on paper. Divide up your surface and actually show the planes as being separate from each other; but perhaps draw them so they overlap slightly, intersect, or tilt forward or backward in space. You should look for continuities—a line or edge that is picked up and continued again at some other point in the picture. Continuities of this sort keep the picture readable, preventing it from becoming disjointed and confusing.

Analyze the planes to see which ones come forward and which ones recede, but feel entirely free to violate perspective. Distort planes on one edge or another if it will improve the composition or the abstract design. One effective way to do such preliminary analysis is by means of collage, where you can cut out actual shapes (planes) and move them around on the surface until you find the best way to relate them to neighboring shapes.

Remember, you are working with flat shapes on a flat surface. Allow a sensation of depth here and there, if you wish, but see to it that in the end it is a coherent two-dimensional composition with no holes or projections.

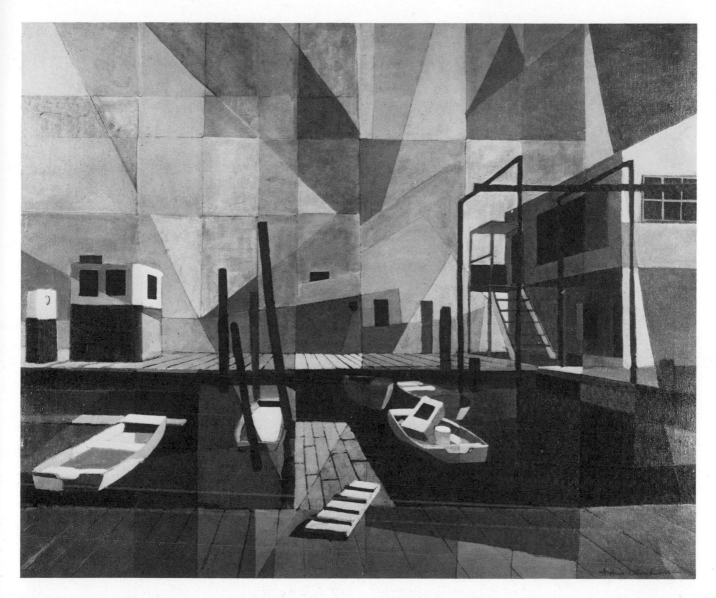

Bivalve, by Morris Blackburn, A. W. S., oil over tempera on canvas, 30″ x 36″ (76 x 91 cm). Private collection. Morris Blackburn is a painter to whom each picture represents a different challenge. While he is working on highly analytical, structured paintings, such as *Bivalve*, he may also be exploring the possibilities of calligraphy in Sumi ink washes. This painting, based on the methods of analytical Cubism, is a beautifully wrought mosaic pattern. Though he uses linear perspective sparingly in the docks and buildings, he composes his total surface in terms of two-dimensional design, and the viewer is more aware of artifice and pictorial structure than he is of the recession into deep space. He has established several linear continuities here: arbitrary lines or edges that begin at the middle or near the bottom of the picture and traverse the painting on the surface, vertically or diagonally, relating simultaneously to foreground, middleground, and background. This affirmation of the flatness of the design is also true of two principal horizontal continuities. Line is used as a foil for the handsomely patterned planes and masses; some lines define the edges of planes, others suggest perspective, while wharf structures and pilings are used for their heavier, weightier dark lines. Even the sky has been broken up, but in forms that relate closely to the lower part of the composition. This artist's work suggests that he believes every abstraction must have a basis in reality, but that in art true reality is based on abstract structure.

44. GEOMETRY IN LANDSCAPE—ABSTRACT, INTUITIVE

CONCEPT. A third way to treat landscape abstractly is to push it further toward pure design—anywhere from the semiabstract all the way to the brink of nonobjective art—but always with allusions to landscape origins.

The intellectual, analytical approach to landscape is valid for some painters, but not for all. Abstraction can be arrived at by more than one method. Strict logic, rigid philosophical programs, and a coldly analytic view toward what the eye perceives comprised the way of Cézanne, early Matisse, the Cubists, and Mondrian. But the other side of the coin is the use of intuition and trial-and-error to discover the abstraction implicit in nature. John Marin, Hans Hofmann, Richard Diebenkorn, Edward Corbett, and Syd Solomon are all painters who search for the structure in nature more through the act of painting itself than through systematic preliminary analysis.

The approach here is to work with a predetermined subject, whether general or specific, and develop it *on the canvas*. This is not done after many sketches, studies, simplifications, and reorganizations but is a direct, subjective, instinctual approach, adjusting and revising forms right on the canvas. The painter may have a general plan or format vaguely in mind before beginning a painting, but the idea is to watch what happens as the painting progresses and, using one's personal, instinctive responses, to integrate whatever forms might appear into the developing landscape image.

The end result should read as a firmly designed surface that refers to landscape, an ambiance, or to natural forces. This method is less tight, less systematized than the analytical approach, although reason and logic may enter in as the picture nears completion.

Essentially, the personality of the painter determines the method he will use in developing a landscape painting. Usually it is not long before an artist discovers which approach—the rational or the intuitive—is most effective and expressive for him. Nevertheless, the finished painting is still an abstract evocation or interpretation of nature. Only the means of arriving at it differ according to the makeup and working methods of individual artists.

PLAN. Some painters prefer to have a clear mental image of what their finished landscape painting will look like before they begin. Indeed, there is a certain security in knowing such things in advance. There are, however, two slight disadvantages to the totally preplanned picture. One is that you are quite likely, consciously or unconsciously, to repeat compositions or ideas done before—either by you or by another painter. Second, you may find that some of the excitement has been taken out of doing the actual painting because you gave all your energy and enthusiasm to the exploratory studies and haven't enough left to see you through the painting process for which you have been gearing yourself.

Try to limit yourself to only the vaguest of mental images before you start painting. Or do a series of twenty or thirty quick studies, and then throw them away or put them out of sight while you paint. Think of a general design format (start with a simple basic structure of only a few ruled lines, if you wish), but a format open enough to give you full freedom to invent, explore, take chances, and try alternatives. I'd suggest using an opaque medium such as oil or acrylic because you are trying out things as you go along, and continuous revisions are a necessary part of the business of organizing successful relationships of shape, color, and space. As the picture begins to take form under your tactful guidance, you can give more time to contemplation in order to criticize how well you are ordering and controlling your composition. Don't be in a rush to arrive at a finished picture too quickly; try one idea, then another, until you have brought the color-shape organization to the point where you feel you can do nothing to improve it.

Be willing to take risks. Take up the challenge of dealing with the unexpected and the unpredictable things that are bound to turn up and must be solved somehow. Your completed picture will be just as well constructed as one that was preceded by preliminary studies, but you will have fought it all out at the easel instead. Often that is more challenging and rewarding than knowing too early in the game just what the finished abstraction will look like.

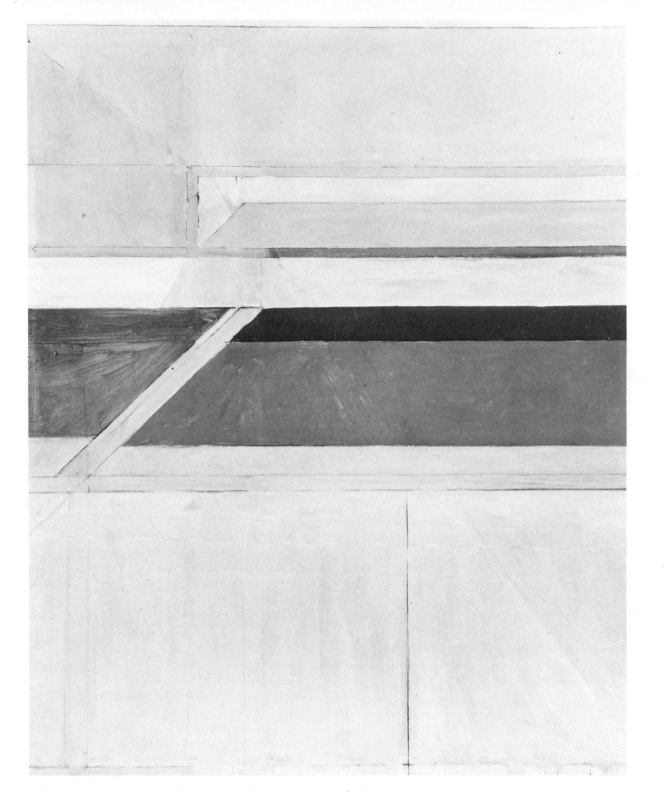

Ocean Park #34 by Richard Diebenkorn, oil on canvas, 100″ x 82″ (254 x 208 cm). Courtesy Fine Arts Collection, Heublein, Inc., Farmington, Conn. Richard Diebenkorn has pursued his distinguished career with an independence that is unique in our time. Starting out as a West Coast Abstract-Expressionist, he later went through a period of figurative painting. Most recently, his work has culminated in a series of canvases entitled *Ocean Park*—paintings which are heroic, severe, formal, monumental in scale, and all vertical in format. He works intuitively, directly on the canvas, beginning with a charcoal indication of structure. He builds first with thin paint, then adds, adjusts, scrapes, revises with thicker paint, redraws and repaints, until he arrives at a final image. He is quite willing to leave the signs of his struggle as an integral part of the picture—the pentimenti of charcoal and pencil lines, paint smudged and wiped off, and constant overpainting. Although Diebenkorn's is a highly abstract vision of landscape, there is invariably a sense of breadth, expansiveness, light, luminous color, and often areas that imply sky, ocean, beach, and meadow; nature is never entirely absent from his paintings. Everything fits together, yet nothing is ever pat or predictable. This is landscape by inference, a geometric translation of nature achieved by combining a painterly brush with a keen, uncompromising intelligence.

45. IMPROVISATIONAL LANDSCAPE

CONCEPT. Although the customary method of painting landscape is to observe a motif, then either paint directly from it or work up a series of studies that lead to a full-scale version, there is another route that could be taken. This is to begin with absolutely no subject in mind, start painting randomly and haphazardly, and then gradually discover the subject through the very act of painting. Instead of starting from nature and working toward a realistic or abstract painting, the artist starts with completely accidental relationships of color, shape, and pattern and slowly (often painfully) brings the picture back toward a landscape subject, whether abstract, semiabstract, or realistic.

In such improvisational painting, the artist does not refer to sketches, photographs, or memory as an initial source for his imagery. Rather, he carries on what might be termed a dialogue with what is happening on his canvas. As shapes and color relationships develop and interact in the picture, the artist responds by adding something here or revising a passage there, working purely in terms of evolving a strong design. The picture may gradually begin to suggest a subject as it evokes memories or associations within the artist. This method is based on the concept that many artists carry their landscapes deep within themselves, and the accident and chance that are the basic ingredients of improvisation allow—or provoke—those inner landscapes to rise to the surface and take form. Once the subject has been identified in the artist's mind, every subsequent decision and every touch of color are related to bringing out that landscape image in abstract or realistic terms, and the preliminary act of applying paint randomly has served its purpose. From there on, the picture can be consciously controlled and developed.

Improvisational painting is closely related to the automatist methods of the Surrealist painters, who elicited forms from their subconscious world rather than from outer reality. They deliberately used what Jean Arp referred to as the "laws of chance" and readily embraced the unplanned and the irrational as being more interesting and unpredictable than images consciously or logically arrived at. The same improvisational methods were used by Degas, who envisioned landscapes in his blurry monotypes and then retouched them with pastel to clarify the forms. The idea even goes back to Leonardo da Vinci, who urged painters to discover images and compositions by studying stained walls, embers of a fire, clouds, or mud.

PLAN. Since transparent watercolor is severely limited in its capacity to sustain prolonged revisions, an opaque medium is recommended for this approach, at least in the beginning. Later, as you become accustomed to improvisation, you can try watercolor for such paintings. But be prepared to throw away more than you keep!

First, clear your mind of all ideas about what you might paint. Even a vague notion of a subject could inhibit your ability to let forms evolve freely and naturally. You are not going after a subject like a bloodhound tracking a scent; you are going to begin by having fun with paint and color, following your impulses, instincts, and intuitions with relaxation. It takes considerable confidence and a carefree spirit to start a painting without knowing what you are doing. But here you must be willing to take chances, to try out crazy things, to enjoy paint and color for their own sake, until you begin to see something emerging that might become the picture's subject.

As the forms begin to suggest something to you as your own memories, experiences, and associations are brought into play, you may still use accidental applications of paint, except that now they will be used more purposefully to bring out and clarify whatever subject you have sensed there. Every touch or every brushstroke added, every revision made, from this point on is meant to develop and reinforce that central idea.

The picture in its final form may be mainly an abstraction of the more intuitive type, or you can tighten it into a more precise, formal abstraction. You can also carry it toward a semiabstract treatment, or you can keep refining it to the point of photographic realism. The improvisational approach can help you get out of old ruts and rid yourself of thoughtless, habitual, routine methods. You can also learn to accept the idea that nothing in the early stages is sacred or permanent, but that all things are possible until you accept or reject them. Your random beginnings end in detached self-criticism—no matter how wild those beginnings, your final goal is still to achieve some degree of structure and order.

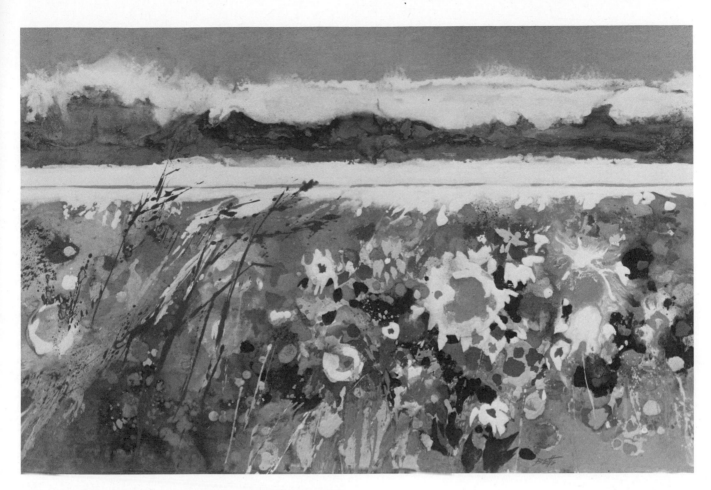

Beach Garden II by Edward Betts, N. A., A. W. S., acrylic on illustration board, 23″ x 35″ (58 x 89 cm). Courtesy Midtown Galleries, New York City. All my acrylic paintings start out with no preconception on my part as to what the subject will be or what the finished picture will look like; *Beach Garden II* is no exception. It was begun as totally random applications of paint; some of it was poured or flowed, some was sprayed, dripped, or spattered; both opaque color and transparent glazes were used to build up a surface that was complex in color and varied in textures. I played about with the painting, off and on, for several weeks before the beach garden motif began to suggest itself as I responded to chance combinations of color and shape relationships. To introduce a simple flat area as a foil for the color activity elsewhere, I painted in a bright blue sky at the top of the picture, then poured on a horizontal band of white paint, softening its edges with water sprayed from an atomizer. Most of my time was spent developing the foreground, using bright yellows, pinks, lavenders, oranges, greens, and whites, creating a beach garden effect—not literally, but interpreted purely in terms of loose touches of color and paint spattered or flung onto the surface. The flatness of the sky, the blurred softness of the seafoam, and the spots of intense color all had to be brought into relation with each other. Many areas were repainted a dozen times or more until they took on the look of spontaneity and naturalness that I was determined to achieve.

46. PHENOMENALISTIC TECHNIQUES

CONCEPT. An extension of the improvisational approach is the use of phenomenalistic techniques to produce landscape imagery. The picturemaking process as a phenomenon means that the painting is developed by allowing the medium itself to play a very significant part in forming the image. Where most painters insist on having full control of their medium, whether oil, watercolor, acrylic, encaustic, or ink, the phenomenalistic painters (who have included such artists as Boris Margo, Morris Louis, Paul Jenkins, and Helen Frankenthaler) exploit the natural behavior of their medium as the principal means of arriving at unusual forms, patterns, and textures.

In a technique of this kind, the evolution of the painting may be guided or partially controlled by the way the artist skillfully manipulates his unstretched canvas as he pours pools of paint over it and into it, or the way he tilts and bends the sheet of unstretched watercolor paper to allow the washes to flow freely across the surface. Phenomenalistic painting can also be done on stretched canvas, paper, or Masonite, but the effects are somewhat limited compared with the unstretched method, since the runs and flows of paint cannot be guided down the folds of loose canvas.

The artist admittedly has some control over what is happening, but the main idea is to let the paint do what it will—up to a point. It is then up to the artist to guide or nudge the paint here and there. But generally, the more natural the flow looks, the better; the idea is to keep the artist out of the painting process as much as possible. If a passage looks too consciously formed and betrays the presence of the artist's mind and hand at work, then a substantial amount of the phenomenalistic effect is lost forever: it looks too stiff, too formed, and is not consistent with the free-flowing effect of the rest of the surface.

Although a certain amount of control is possible—and desirable—on the artist's part, accident plays an important role. But not all accidents are happy ones. A reliance on repeated happy accidents is indeed a slim reed to lean on, and the phenomenalistic painter must exert as much unobtrusive control as he can to capitalize on accidents and to arrange or predict what might happen as a result of various manipulations of surface and medium. This technique also demands that the painter be doubly alert to recognize and accept what is good in the painting, but to reject rigorously what is not.

Phenomenalistic painting is not for everyone. It takes a vast amount of time, patience, and experience to learn to predict what may happen, to exert just the right amount of control, and to use the process for expressive purposes, and not just pretty accidental effects. In the right hands, however, phenomenalistic procedures are a way of expanding an artist's range of subjects, shapes, textures, and compositions; they are a supplement to his traditional techniques, but not necessarily a substitute for them.

PLAN. Phenomenalistic painting is for the experimenter, for one who is eager to take chances and willing to fail often. This technique requires paint that is quite fluid so it can be easily poured, dripped, or squirted onto canvas or paper. Premixing the colors in sherbet or cottage cheese containers is a good way to store them for use; larger containers would be needed for large areas or for very large canvases. Some colors can be fairly opaque, others very diluted or transparent.

A level work surface is important, whether a large painting table or a floor; check with a carpenter's spirit level to make sure your painting lies as flat as possible, so that the wet paint will not drift off where you don't want it. Drape your unstretched canvas over two or three poles of different heights set at various angles, and pour the acrylic paint onto the canvas from one end. Let the excess paint drain off into a container, and leave the canvas to dry as is, or put it out to dry on a level surface. Later, you can drape it differently over other supports and repeat the procedure, glazing another color over portions of your first paint application. Repeat the process until a landscape image begins to appear. Additions and revisions should be made using the same or similar techniques.

Much the same can be done with watercolor, using unstretched paper that is partly wet and partly dry. Pour watercolor over one section of the sheet, then tilt the sheet back and forth, or let the wash flow continuously across the sheet. Add more color here and there, if you wish, while it is still wet. Tack it down, allow it to dry, then repeat the process, pouring perhaps from a different direction, bending or rolling the paper to guide the flow.

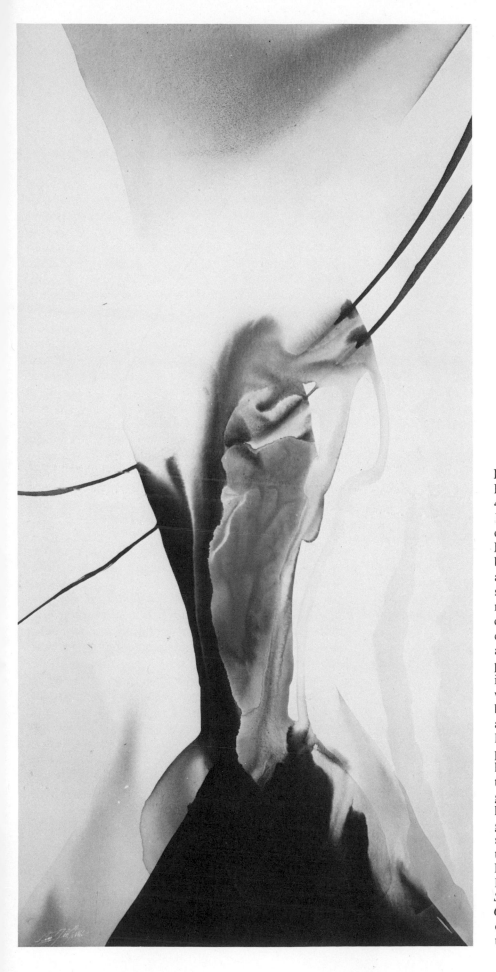

Phenomena Traces of the Tide by Paul Jenkins, acrylic on canvas, 80″ x 40″ (203 x 102 cm). Courtesy Martha Jackson Gallery, New York City. The early phenomenalistic paintings of Paul Jenkins were done in oil paint, but in recent years, he has found that acrylic is more versatile and more suited to his purposes. It should be noted that all his picture titles are preceded by the word "Phenomena," a constant reminder that his paintings are natural occurrences that result from pouring paint from a bowl. The canvas is stapled at two opposite corners to wooden supports whose angles have been carefully adjusted. He occasionally nudges the paint pools with a long-handled brush, but his favorite painting tools are ivory knives which he uses to guide, redirect, or open up the flow of paint. His colors vary greatly from painting to painting, but he is partial to bright, vibrant blues, greens, reds, and purples, using the stark white of his canvas to set off those colors to maximum advantage. His "Phenomena" titles often have landscape associations: *Delta Born*, *Salem Rock*, *Imago Terra*, *Sound of Grass*, but these are images born out of an inner state and a technical control that are uniquely his.

47. PERSONAL SIGNS

CONCEPT. Most of this book has been concerned with landscape imagery and, in a way, almost any painting of any subject is an image. However, I feel an image is a visual reference to a fairly specific motif or situation. It is closely related to a definite subject, and the number of ways an image can be formed and presented are many and various. Another way to approach landscape, however, is through signs and symbols. These may be expressed in realistic, abstract, or semi-abstract painting, and actually may be part of an image. However, their function is to suggest levels of meaning beyond that of the specific image.

First let us start with definitions. Signs and symbols are usually thought of together. But I prefer to deal with them separately here. This section will deal with the way signs are used in painting, and the three sections which follow will deal with various aspects of symbolism in painting.

We have become accustomed to thinking of signs as graphic indicators—traffic signs, corporate logos, displays, advertisements—usually an abbreviated message intended to convey a concept and elicit an immediate response from the viewer. Such signs in a most generalized way can be learned and passed on from person to person or from generation to generation. In the field of painting, however, a sign is somewhat different. It is an artist's personal shorthand, his pictorial handwriting, a system of marks characteristic of his own way of seeing things and putting them down on paper or canvas. Signs relate essentially to brushwork, but brushwork not used just for its own sake, but as the special way in which an artist makes his own marks which represent a tree, a rock, clouds, leaves, etc. These signs depend on their conciseness, their brevity, their impact, their character, to express whatever the artist has in mind.

Every fine painter has had a personal touch. Think of Hals, Daumier, Constable, Renoir, Cézanne, Seurat, Klee, Miro, Pollock, Soulages, Tobey. Each one's touch is individualized to the extent that you can immediately recognize the identity of the artist by seeing just a small fragment of one of his paintings because his touch, his use of painterly signs, is uniquely his. And if this touch, or shorthand, is extended into a whole system of signs, a landscape subject can be invoked on a quite different plane than that of representation or abstraction, and quite often such signs approach being symbolic.

PLAN. Signs and symbols are arrived at by two basic processes: *intuitive* and *intellectual*. Professional graphic designers are in the business of devising signs by the purely intellectual method. They use knowledge of art, optics, psychology, sociology, and history to create signs that tell us where to eat and where not to park our car. But your true value as a painter lies in your ability to create painterly signs as the result of intuitive processes.

As with any other form of painting, you can begin with observation of subject matter and then let your subconscious faculties take over and manipulate that subject, toying with it, running it through a series of variations, seeing how it can be pared down to essential lines and forms that sum up its characteristic qualities with fluency and immediacy. Try to develop certain signs or marks, natural gestures on your part—an offshoot of your handwriting—that directly project the idea of tree, of rock, of grasses, of smoke, of flowing water. Study Oriental calligraphy and nature symbols and then try to develop some of your own. Let what you see flow from eye to brain to fingertips in one swift continuous operation—no thinking, no hesitancy, no self-consciousness—just a quick intuitive response that gets to the heart of your subject in the most natural way possible. This requires years of work and practice and a profound and intimate knowledge of nature, but there is no better substitute for developing your own system of signs as they arise directly from your own intuitive responses and not someone else's.

The other method, an alternative to observation, is to indulge in a prolonged period of automatist drawing and painting (or "doodling") where you resort to your unconscious or subconscious world as a source of signs, using chance and associative techniques rather than visual contact, to establish a repertory of signs. Whichever method seems the most natural to you is the one to use. Both have their advantages.

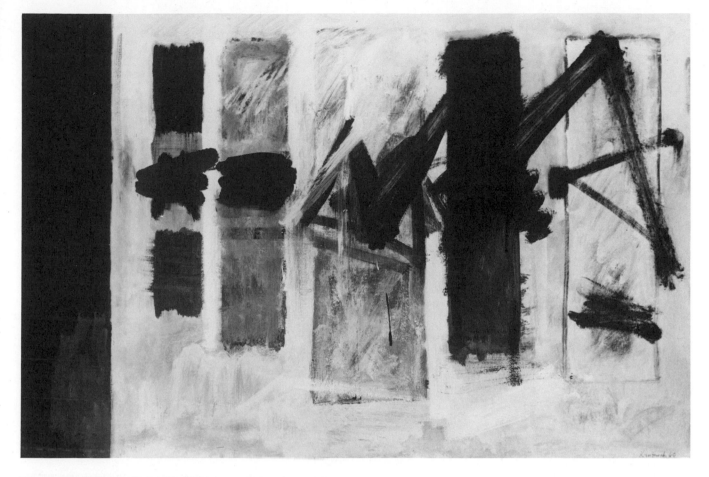

Island Movement through Fog by William Kienbusch, casein on paper mounted on board, 26¾" x 40⅛" (68 x 103 cm). Courtesy Kraushaar Galleries, New York City. William Kienbusch has dealt with his Maine subjects in a variety of ways, usually letting each subject affect his choice as to how it should be treated. In this painting he has reduced his subject to several gestural signs that refer not to a specific motif but to an idea: the way in which landscape forms appear and disappear in coastal fog. The forms themselves are somewhat ambiguous; they could be pine trees, rocks, or cliffs; but such particularization was not as much to the point for Kienbusch as his intuitive interpretation of island forms as they are affected by the drifting fog. Some edges are sharply defined as the fog thins out or as the forms emerge from the mists; but in other passages, edges are softened or lost altogether. Some forms are very clear and positive and come forward, while other similar forms move back into the picture space as they become veiled or blurred by varying densities of fog. There is no direct or obvious representation here, but an experience of nature has been recreated in terms of linear, gestural brushwork. We are as much involved in following the energetic movements of the painter's arm and brush as we are in reading his purely painterly, intuitive signs and symbols which function on the level of compressed suggestion rather than depiction.

48. LYRICAL SYMBOLS

CONCEPT. A symbol is on a higher plane of visualization than a sign. It is an attempt to universalize, to order a complex assemblage of ideas or content in a more generalized form. A symbol is more indirect than a sign and seeks to discover correspondences between art and nature or within nature itself. Rather than having a subject, symbols have content with many layers of meaning and at times verge on the mystical, since they are an attempt to communicate ideas or feelings rather than being simply visual interpretations through distortion or abstraction. A symbol is a metaphor that is self-contained and invokes associations, experiences, ideas, and emotions above and beyond the usual pictorial subjects. It is a condensation of essences at the very highest level of art.

Visual symbols that have been created by painters fall into two general categories—the *lyrical* and the *intellectual*. A lyrical landscape symbol is primarily intuitive and poetic. Characteristically, the lyrical symbolist painter does not operate within a system of theories, but rather deals with his material through feelings and instincts which have little relation to logic and predetermined procedures for reducing landscape to symbolic forms. He uses nature in a very generalized way as a source of forms, avoiding motifs, but trying for a more universalized statement of his relation to his environment and to the various phenomena of nature. He is not interested as much in resemblances to the actual forms as he is in revelations about them, and he comes to these revelations by a felt process, not by intellectualization.

A prime example of this method of dealing with nature in terms of lyrical symbols is the work of Arthur Dove, who in some ways stood outside the usual categories of early modernist painting. He was something of a loner who made no sustained effort to become part of the international art scene or the cultural establishment of his time; his personality tended toward treating nature in terms of symbols rather than abstract analysis and reorganization.

Dove did his share of abstractions, but they are not as memorable as his symbolic pictures. In a 1929 painting called *Fog Horns,* he successfully projected the idea of the sound of fog horns, using reddish concentric rings emanating from a foggy gray background. In a 1935 painting, *Cows in Pasture,* he suggested the wholeness of nature by fusing cows, hills, and some vegetal forms so that they are all slightly interchangeable; they resemble each other and are inseparably intertwined—equivalences of each other in a composition that is almost mystical. Dove was less interested in design as design than he was in using design to express the interrelationship of animal and land forms. Such intuitive and extremely private responses to nature set him apart from his other colleagues in the group associated with Alfred Stieglitz (John Marin, Marsden Hartley, Charles Sheeler, Georgia O'Keeffe); yet in the long run, it was his obsession with symbolic forms—his personal and slightly eccentric approach to nature—that makes Dove especially appealing to painters of today.

PLAN. Just as with intuitive signs, your lyrical symbols are created by allowing your inner feelings and instincts to be the instruments which transform nature into art. Lyrical painting is closely associated with poetic qualities, something which invites contemplation. Take time out for meditation on those aspects of nature which move you most deeply; explore them, see how they might be put into visual form. Follow your feelings as much as possible, and let your imagination play. Concentrate on your experiences and sensations, then begin to draw or paint randomly, keeping those ideas at the back of your mind as you work. Find graphic parallels or equivalents for those ideas, evolving your symbols as spontaneously as you can. Discover nature, discover yourself, and discover yourself in nature.

Another approach to the forming of symbols is to begin directly with painting improvisationally, and let the symbol appear as a result of the accidental behavior of your medium. As certain forms emerge, your inner self responds immediately and recognizes or identifies the content symbolized by those forms. Still another method to discover your own symbols is to work with cut and torn papers in a collage technique. Here again you must be especially alert to recognize certain shapes and shape relationships as having content that is the essence of some environment or natural force—cataracts, beaches, valleys, trees, oceans, clouds, winds, rainshowers. No matter what the source of your symbols or your method of evoking them, don't forget that their function is to communicate your concept or response to persons other than yourself.

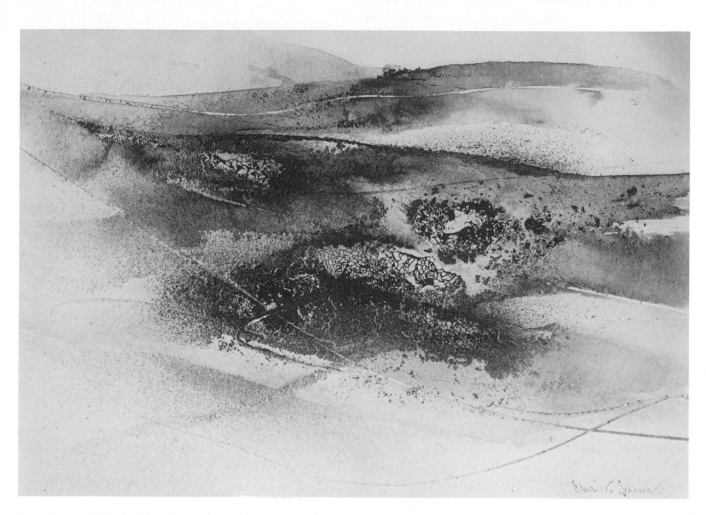

Landforms C-15 (Italian Series) by Albert Christ-Janer, mixed media on paper, 9″ x 13″ (23 x 33 cm). Collection Mrs. Virginia Christ-Janer. Many of Albert Christ-Janer's paintings have the quality of aerial views, a kind of poetic abstraction in which a loose, informal design is enhanced by soft atmospheric effects. His pictures are profoundly beautiful and sensitively felt, having the nuance and delicacy of Oriental ink painting contained within an overall composition that has been arrived at by intuitive, explorational, improvisational methods. The subtle textures, which are such an important part of his surfaces, were created by the use of mixed media techniques that include resists, inks, acrylics, and sand lightly sifted over wet applications of acrylic medium diluted with water. This painting is based on no specific motif, but is Christ-Janer's lyrical version of landscape. It is a generalized image in which nature has been translated into hazy, graceful forms and looping lines, gentle colors, an intricate network of cracks, clefts, and encrustations, as well as transparent overlappings of land masses and linear accents. He has projected an invented "inscape," a synthesis of his own visionary world with that of the outer visible world. The result is a symbol, both poetic and personal, that has the look and feel of landscape, but in terms of essences rather than particulars. Photo courtesy of University of Georgia Art Museum, Athens, Ga.

49. INTELLECTUAL SYMBOLS

CONCEPT. At the other extreme from the lyrical symbol is the intellectual symbol. Here intuition is minimized or eliminated altogether in favor of a rational, cerebral approach to expressing nature in the form of a symbol. The intuitive symbol may be the result of a "spontaneous combustion" within the artist, but the intellectual symbol (which is just as creative) arises from calm, orderly analysis. The painting has a rigor and clarity to it that is often missing in pictures that depend on the artist being at the receiving end of a rush of inspiration.

Synthesizing of landscape associations also takes place here, but the intellectual painter arrives at essences, at universalization, through a more conscious method in which the parts are fitted together precisely. Often emotional qualities are retained in the finished painting, but they exist within a framework of disciplined order. Symbols here depend for their appeal on the fact that the artist's mind has come to grips with nature's forms and has organized them into a clearly visible formal structure in which little or nothing has been left to chance.

The painter who works in terms of intellectual symbols does not rely on subconscious forces to help him create. He relies instead on conscious manipulation of the ideas and forms implicit in his general subject. This process is well exemplified by the landscape-oriented compositions of the minimalist painter, Ellsworth Kelly. This method may sometimes produce paintings that have a dryness or coldness some viewers find objectionable, but many other viewers are much attracted to paintings and symbols that represent application of logic and discipline. Generally, symbols arrived at intellectually are less painterly in appearance and texture than those formed by an intuitive, pantheistic artist; the technical means for conveying the symbol are subject to the same firm control that was brought to the intellectual refinement of the symbol itself.

The intellectual painter tends to be more exact in his references, more painstaking to see to it that his symbols are indeed as universal as he can make them. There is a reason behind every decision, and all parts of the picture are fully thought out as to both compositional structure and the way in which the symbol is intended to affect the spectator and communicate exactly what the artist wanted to convey. It is much like the Symbolist poets who searched consciously for the exact word—the *only* word—to express the precise shade of meaning they were after. Similarly, the intellectual painter strives for exactitude in both pictorial structure and the symbol he has perfected so carefully.

PLAN. Depending on your personality and background as a painter, you will soon find out whether you are an incurable Romantic or a dyed-in-the-wool Classicist. The subjective, intuitive approach to symbols (and to painting in general) does not work equally well for everyone, and if that proves to be true in your case, then undoubtedly you would do better to work in a more intellectual vein, so that you have the security of knowing what you are doing and why you are doing it. A symbol has been defined as "material which represents something immaterial," and obviously that cannot be achieved easily by lying back and letting inspiration supply all the answers. Therefore, the intellectual approach to creating symbols leaves less to chance than intuitive methods; in this lies its real strength.

First you must know what it is you want to say about your landscape idea or experience. Next comes the exploratory phase in a variety of media—pencil, charcoal, crayon, ink, wash, watercolor, or small oil or acrylic studies—because this is something that must be developed very slowly, very deliberately. There is no room here for instant gratification. Your exploratory phase should be executed in several media because each medium will contribute something special to the evolution of the forms toward which you are working. Your guiding impulse at this stage is to condense, distill, and simplify the material to its most meaningful and expressive state.

In the last phase you can begin the painting itself. All the preparatory thinking and visual exploration are behind you; but that does not mean you should resist following any impulses that seem to offer an enrichment or refinement of your landscape symbols. It is the spirit of logic, clarity, conciseness, and refinement that will ultimately assure presentation of your symbol in its most forceful manner, and this is the greatest advantage of using intellectual discipline in the process of symbolforming.

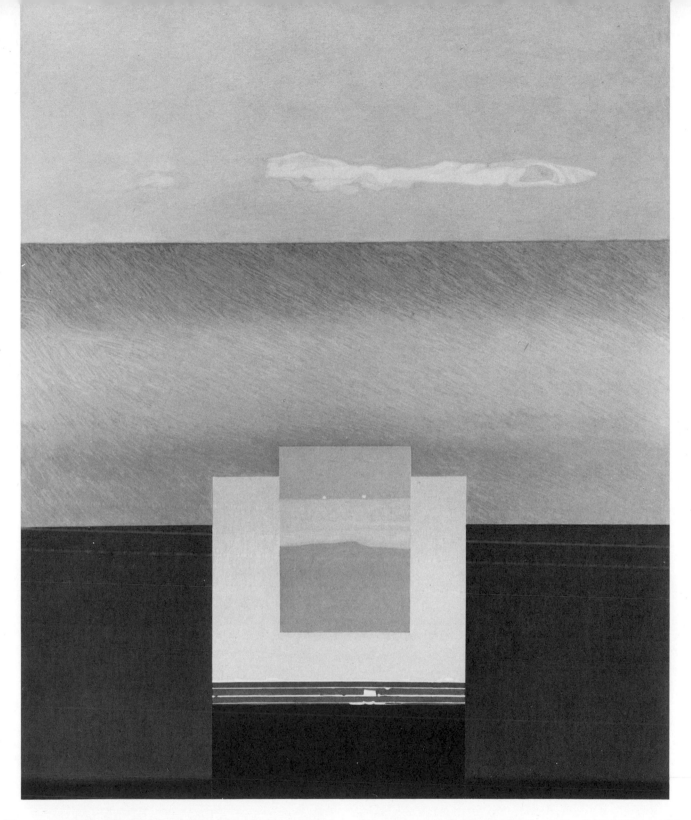

Evening and the Morning by Ernest Velardi, Jr., gouache on cold-pressed illustration board, 36″ x 30″ (91 x 76 cm). Ernest Velardi, Jr., is a West Coast painter whose work in the past few years has become increasingly spare, simple, and austere. This painting is very tightly organized. Although it is primarily a symmetrical design, there are slight variations here and there (the clouds, the brushy quality of the large central area, and the slightly irregular white lines near the bottom edge of the picture) that give the surface some relief from too much perfection or too much symmetry. There are few recognizable elements here, but there are strong allusions to nature: a sky with clouds, a mass of land or possibly ocean, and, at the base of the picture, a dark land mass against which is set a geometric arrangement of superimposed planes. This dark mass is a sort of picture within a picture. All pictorial elements have been pared down to essentials, with no seductive surfaces and no painterly razzle-dazzle. It is intellectually ordered, formal, serene, refined, and, though it is thoroughly flat in concept and treatment, there is an indefinable sense of breadth and vast spaces—a timelessness—evoked by Velardi's symbolic approach to his landscape theme.

50. PERSONAL SYMBOLS

CONCEPT. I have already mentioned the fact that a symbol is meant to communicate, but there are those times when artists also develop a system of symbols that are most meaningful only to themselves. Over a period of years a painter tends to create, almost unconsciously, his own language of forms, a repertory of signs, symbols, and images that relate directly to his own private feelings and experiences, and he then comes to work exclusively in terms of that language. Usually there is no deliberate attempt to alienate himself from his audience or to widen the gap by using esoteric language; he simply turns to his personal symbols as the most natural way to paint his responses to his environment.

It is quite possible for an artist to keep channels of communication open by using signs and symbols that have universal meaning. Certainly the painter needs and wants to exert as much control as he can over the way his message is interpreted by the viewer. But as his art matures and becomes very much his own, he digs deeper and deeper into himself toward an understanding of nature and man's relation to it. At this time it is likely that he will come to feel most at home with his private language of forms, and that he may care considerably less whether the art world in general keeps up with him.

A case in point here would be Arshile Gorky, whose themes were universal (growth, change, death, sex, personal crisis), but his symbols were extremely private, and probably part of their fascination was their intentional ambiguity. He was obsessed with translating his ideas into symbols, because conventional descriptive painting was inadequate to that task. Gorky's complex symbols, with vegetal, human, and embryological allusions and associations, were his sole concern to the extent that his art was more important to him than understanding and recognition in the world beyond his immediate circle of friends and colleagues.

So, if an artist seems to retreat into a private world of symbols, it may not be out of narcissism, perversity, or arrogance; it may be out of necessity. That may be the only means he knows to give pictorial form to his innermost visions. Such projections of an interior world may not always be readily accessible to even a highly sophisticated art audience, but when you come right down to it, there are those occasions when a work of art may transcend its audience. It is the work of art as deep personal expression which is the artist's most important concern.

PLAN. This plan is a long-term one, and you should not expect to devise a private language of signs and symbols over a weekend. Your principal job is to stay in close contact with nature in every way and on every level possible. If you find that symbolic translations of nature are your most effective way of dealing with the outer world, you should begin by creating symbols that are recognizable, that have some universal significance, that are reasonably available to your audience. Your more personal and possibly enigmatic symbols will evolve later, not out of arbitrary decisions, but out of your deepest responses over a very long period of years—and I do not mean five or ten years, I mean twenty-five, thirty, or forty years. It takes a lot of looking, a lot of contemplation and meditation, and a lot of drawing and painting before you gradually—almost without being aware of it—develop a set of signs and symbols that for you are metaphors for landscape, that connect nature and art with you as the connecting link. Indeed, the time should come, and you should look forward to it, when the philosopher in you takes over from the technician.

If, after many years, you arrive at this repertory of forms, naturally, organically, unselfconsciously, out of profound need to express landscape content in a particular way that is yours alone, do not feel apologetic to yourself or to others if not everyone responds readily to your work. If only a few people are touched genuinely by your paintings, if only a few have the sensitivity and perception to share in your world of forms, that may have to be reward enough. You will never get rich, but you will be secure in the knowledge that you have produced a body of work which is an honest, creative, and uncompromising projection of your inner visions, As the song goes, "Who could ask for anything more"?

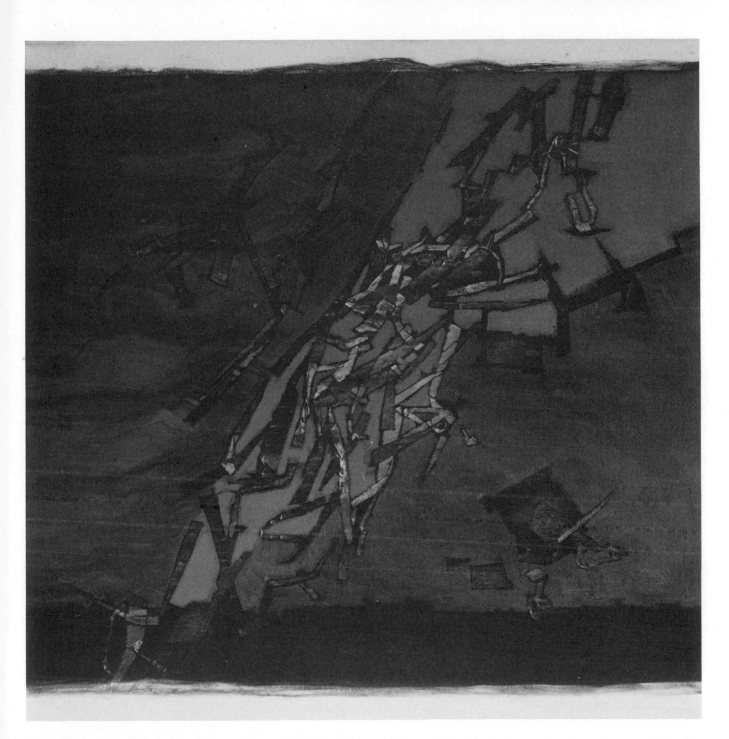

Wind Path by Carl Morris, acrylic on canvas, 72″ x 72″ (183 x 183 cm). Courtesy Kraushaar Galleries, New York City. The art of Carl Morris has always had close associations with landscape, but in its broad aspects, rather than as scenery. His paintings are concerned with weather, light, atmosphere, erosion, geological forms, and fiery origins. When dealing with such content, realistic painting methods fall far short of communicating the depth of the artist's almost visionary or mystical connections with his natural environment, which in this case is the Pacific Northwest. Symbol and metaphor are the more logical means of expressing such elemental forces, and the symbols Morris has evolved over the past thirty-five years are very much his own. *Wind Path* uses private symbols for natural manifestations: it could refer to the twisted fragments left in the wake of a hurricane or a tornado, or it could be the wind's eroding effect on coastal cliffs. The forms may be ambiguous, but the important thing is that the artist's knowledge, passion, and vision have been united to bring forth a painting which has many layers of associations. It is a landscape entirely Morris's own—poetic and painterly—in which few elements are identifiable, but many meanings are subliminally sensed.

COLOR GALLERY

Contemporary landscape painting depends above all on the element of color—as surface, mood, design, space, structure—and an artist's personal way of dealing with color is crucial to the success of his paintings. The paintings here are examples of a wide variety of contemporary color attitudes that should develop your color awareness and give you a taste of the many ways in which color can function in your paintings. Color is such a complex and boundless experience that the most I can do in the pages that follow is to barely scratch the surface of color's full potential.

Each color plate, adhering to the general format of this book, is accompanied by two captions, one discussing a specific color concept and the other demonstrating how the painting exemplifies that color concept or device. It should be noted, too, that many of the color plates are related to ideas discussed in the "Notes on Color" that follow these paintings. Once you have absorbed the principles illustrated in this section, the next step is to do some color experimenting of your own—which is where the real challenge and excitement begin.

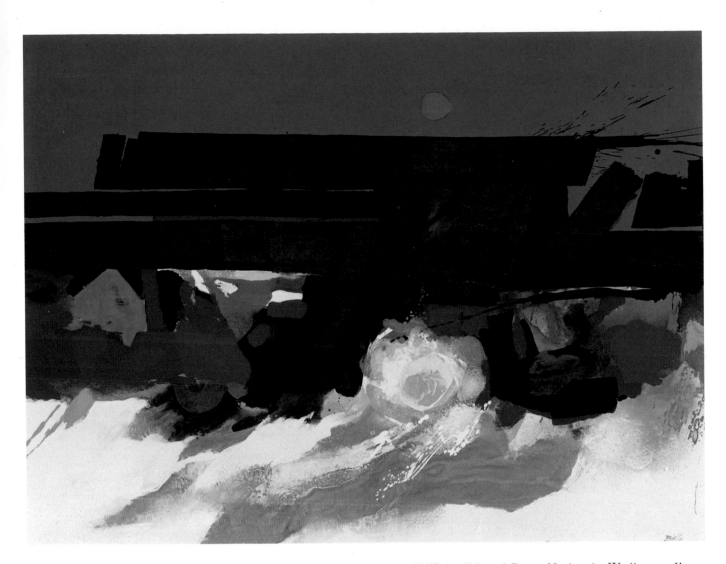

Primary Colors. Using the primary colors as the dominant ones in a painting is considered a poor idea by some artists, probably on the basis that they are too pure and too obvious. But if a few secondary or intermediate colors are introduced as a foil for the dominant primaries, then red, yellow, and blue can still be used as a highly effective color scheme. The trick is not so much in the character or intensity of the colors used, but in the proportion of one color to another. If the primaries are used in equal amounts and intensities, they might tend to cancel each other out. But by controlling the quantity of each, and by using limited amounts of some subordinate colors, keeping all the colors of about equal intensity, the primaries can then be kept from appearing too raw or garish.

Dark Cliffs by Edward Betts, N. A., A. W. S., acrylic on Masonite, 30″ x 40″ (76 x 102 cm). Courtesy Midtown Galleries, New York City. This painting is dominated by a range of several blues, in the upper and lower areas. The reds and yellows have been restricted to much smaller shapes and areas, together with a group of subordinate colors that set off the primaries and help to relate all the colors throughout the surface. One bright green was used as a color accent, but was not repeated again elsewhere. Most of the colors were used in their purest form, straight from the jar, with very few intermixtures of paints. Instead of relying on neutral grays to soften the impact of so much strong color, I used large masses of black and white. The blacks were usually overpainted with rich blues and purples so that they still had a coloristic quality, acting as dark color rather than as a deep black hole in the picture surface.

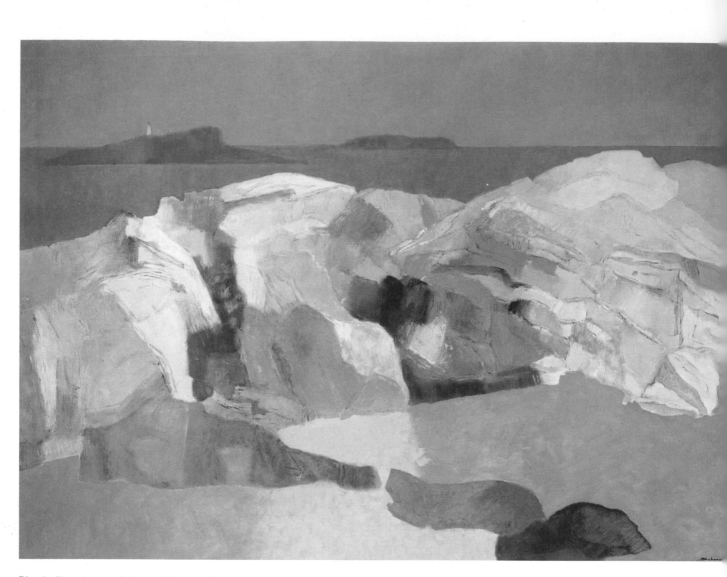

Single Dominant Color—Warm. One way to achieve color control is to work within a range of values of a single dominant color. In order to prevent a too monochromatic look, lesser quantities of some analagous colors can be added. When painting in the warm color range, it might be best to use orange or red-orange as the dominant color, then use reds for any dark areas and yellows for lighter, brighter areas. Almost any picture is more coherent if it has a single basic color identity—a red painting or an orange painting—but here the idea is to explore the range of possibilities within a very severely restricted group of warm colors. The picture may even be helped by the fact that some normally cool areas will have to be inventively translated into warm ones.

Summer at Salter's Island by Jason Schoener, oil on canvas, 44″ x 60″ (112 x 152 cm). Courtesy Midtown Galleries, New York City. Schoener has used orange as his dominant color, deepening it with red for his darker tones and lightening it with yellows. In addition to the full range of values of his dominant warm color, he has varied the surface with other related colors such as golden yellows, pale yellows, pinks, deep reds, and a few touches of almost pure white. As a minor color accent he chose a very bright, intense pink. Note that sky and ocean, which would ordinarily have been treated in the cool range in a painting based on descriptive color, have been treated as two different values of a deep orange. This unexpected use of his dominant color changes the look of reality for pictorial purposes and reinforces the luminous warmth of the picture as a whole.

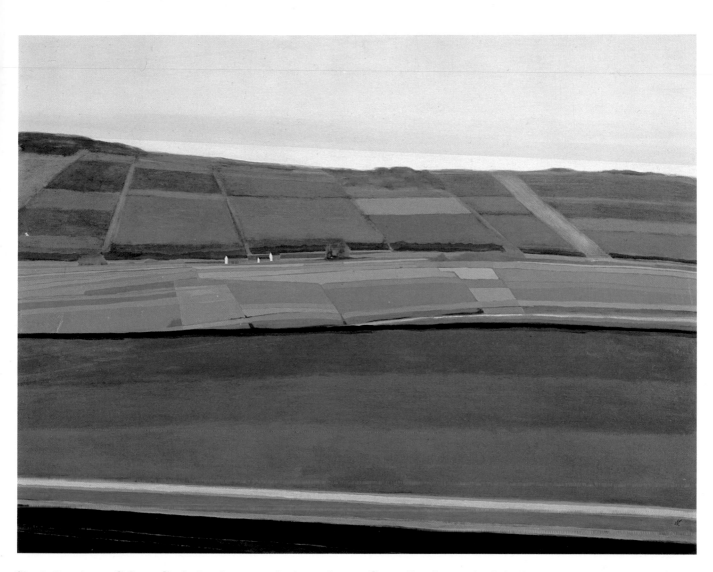

Single Dominant Color—Cool. Another way of using a single dominant color is to work with cool blues or greens. There are so many blue pigments available that varying the blues is not much of a problem. With greens, however, painters are apt to be less successful. It is important to be aware of the tremendous variety of greens in nature: moss, grass, trees, shrubbery, waves, rocks, fruit, and vegetables are all distinctly different. Paintings in which blue is dominant tend to be a little too cold for most tastes; but green, because of its yellow content, is a warmer cool color, and therefore offers a more ingratiating spread of variants. Greens that are too acid or raw must be modified by the addition of yellows or oranges. In fact, many painters avoid tube greens, preferring to mix their own.

Green Landscape by John Laurent, acrylic and oil on Masonite, 36″ x 48″ (91 x 122 cm). This painting contains an astonishing variety of warm and cool greens, and the only passages that are not green are the rare accents of bright and deep yellows, a shot of blue, and the tiny whites of the farm buildings. This is not a tonal painting, dependent on contrasts of light and shadow; its relations are purely those of color against color, warm against cool, bright against subdued. There is no cheap or garish color here, as in many paintings that are predominantly green, but the subtle color changes within the overall green are most sensitively adjusted to each other. No color area jumps out of its place; all are firmly anchored to the surface within the overriding structure and order that pervade the total composition.

Muted Color. As a change of pace from strong colors, it is advisable to try some paintings done in muted colors—colors that have been deliberately neutralized or are offbeat personal color mixtures in which the color is used at less than full intensity. Keep in mind, though, that it takes an experienced colorist to work entirely within a subdued range and still avoid dirty color. If more than three colors are mixed together, there is a risk that the fourth color will unpleasantly neutralize the others, so the simpler the mixture, the better. Then, too, if all areas are muted to about the same degree, the picture may take on a rather glum appearance. This can be prevented, or given a lift, if one or two of the colors are just a shade purer than most of the others.

Break by Syd Solomon, oil and polymer on canvas, 24″ x 30″ (61 x 76 cm). There is no intense color in this painting. The color preferences are highly individual in a limited range of dominant purples and browns, with minor areas and accents of reds, blues, and neutrals. The group of basic colors employed here is deceptively simple, which is one reason the colors relate so well. Also the fact that they are muted colors is another reason why the color scheme is so successfully orchestrated. The only color used at full saturation is the deep red; the purples at lower left and lower right are relatively fresh and clear, but the rest of the picture is subdued. Color interest has been added by the manner in which the artist used his paints both opaquely and transparently, using heavy impasto, delicate glazes, and stainy washes to enrich the color surfaces.

Accents of Bright Color. Often a picture relates almost *too* well in terms of color and tonality, and it cries out for some kind of shock or a jarring note—something that will jolt the surface out of its pleasant predictability. Corot often used a tiny touch of bright red as a color accent in his generally green and tan landscapes, a device as useful and appropriate now as it was in his day. Red, of course, is not the only color that will fulfill this function; it could be a shot of blue-green, bright pink, white, chartreuse, or any bright color that is complementary to the color and tone of the rest of the picture. The main thing is not to fall into the trap of using such accents routinely. If such a device becomes an artist's trademark, chances are he is using it thoughtlessly and misusing its effectiveness.

Nature's Chasm by Richard Phipps, watercolor on paper, 18″ x 24″ (46 x 61 cm). This watercolor was painted in a limited palette of green, blue, and brown. Using a full range of transparent watercolor techniques, Phipps coaxed as much variety as possible out of the restricted group of colors. The entire picture is handled transparently, except for two opaque color accents: a horizontal streak of bright red and another smaller dab of darker red. The upper red is the brighter of the two, providing a welcome foil to the cool tones of the painting. But if it had been the only red accent, and the sole exception to the general transparency of the painting, it might have seemed too isolated. The best solution was the introduction of the second, more subdued red, which caused the bright red to become a more natural part of the total surface.

117

Low Key. If a scale of values from light to dark runs, say, from 1 to 10, a low-keyed painting would be one in which the major part of the surface is made up of values in a range from 7 to 10. This does not necessarily mean that all low-keyed pictures contain no lighter values for relief or contrast, but it does mean that the general impression of such a painting is that its prevailing values are on the dark side. Working within this arbitrary range is another way of ensuring unity or coherence of both colors and values, and often the low-keyed colors contribute to the mood or are otherwise expressive of the pictorial content. Usually the subject itself helps determine the range of values that is most appropriate.

Owl's Creek I by Glenn R. Bradshaw, A. W. S., casein on rice paper, 24″ x 39″ (61 x 99 cm). The geological overtones of Glenn R. Bradshaw's paintings are borne out by his changing palettes that vary from cool grays to fiery oranges and reds. In this picture his value range for the major areas of the composition begins with dark middle values and goes down to the deepest darks possible. From that group of generally low-keyed shapes and rhythms, he jumps to a central lighter area and some splashes of very light color that are made all the more watery and contrasty by the depth of the values with which they interact. The variety of rich but subtle dark tones combined with the flowing character of organic forms suggests elemental forces deep in the earth, a personal landscape interpretation reinforced by the low key of the picture as a whole.

High Key. Using the same scale of values from 1 to 10, a high-keyed painting would be limited to a range of about 1 to 3. This would imply a painting done in pale pastel tones, but another possibility for a high-keyed painting is one in which many of the colors are selected because they are naturally bright and intense, such as certain yellows, oranges, and greens. To relate closely to these intense colors in terms of a dominant high key, other colors would then be mixed in very light values. Again, a restricted value range is a help in maintaining consistent color quality and control throughout the surface. A few darker colors might be introduced for variety or contrast, but they should be fairly intense so as not to create a "hole" in the picture.

Summerscape II by Edward Betts, N. A., A. W. S., acrylic on Masonite, 42″ x 50″ (107 x 127 cm). Courtesy Midtown Galleries, New York City. In this painting the high-keyed colors were employed to project the feeling of light and warmth. Cadmium yellow medium straight from the jar was the major color, pale blues and greens were used as subordinate colors, and accents were created with pink, orange, violet, and green. To keep the picture high in key, cadmium orange and permanent green light were selected to represent the very darkest values, and pure white was the lightest. In addition to the three colors used unmixed, other colors were lightened with white to bring them into the same value range as the yellow, orange, and green. This resulted in a group of colors that were all of equal or near-equal intensity; therefore, color relations, or color vibrations, were stressed more than tonal or value contrasts.

Low Color Contrast. In the same way that one works with contrasts of light and dark values, it is also possible to work with contrasts of color. By low color contrast I mean painting with a few colors in similar tonalities, whether in a bright or a subdued range. Instead of strong oppositions of hue, value, and saturation, low contrast is a matter of reduced opposition and gentler relationships within a more homogeneous group of a limited number of colors. The real advantage of low color contrast is the overall harmony and control that is possible by working with a few colors and avoiding harsh or dramatic color contrasts. When using this approach, it is advisable to limit the colors to no more than five and to plan the range of values before beginning to paint.

Hunterdon County, New Jersey by Betty M. Bowes, A. W. S., acrylic on Masonite, 20″ x 35″ (51 x 89 cm). Except for a few white accents and a few dark masses, Betty M. Bowes has restricted her colors to a middle-range tonality. Since the color areas are so similar in value, their main differentiations are in changes of hue, and in warmth and coolness. Since the artist chose to disregard strong value contrasts or extreme variations of color intensities, low contrast unifies all parts of the picture. She has achieved considerable variety through her oppositions of simple and complicated color masses in the central area of the painting. The hazy subtle color is a marvel of simplicity, since she has made the most of the blue, green, purple, yellow, and brown to which she limited herself.

Accents of High Color Contrast. High color contrast involves strong oppositions of hue, value, and color saturation. This means it is possible to use many colors in a wide range of values and intensities and to work with both contrasts of tonal values and with vibrant clashes of bright color. The artist therefore has more leeway to work with as broad a palette as he feels is necessary to his landscape and to use contrasts that will give him a wider variety of exciting color interactions than would low color contrast. This freedom is a boon to artists who revel in color, but it requires enough control to prevent the picture from becoming a disordered riot of rich color.

New Moon Tide by Gretna Campbell, oil on canvas, 52″ x 56″ (132 x 142 cm). Courtesy Ingber Gallery, New York City. The fresh, lively colors in Gretna Campbell's paintings of Maine stem largely from the fact that she always paints directly from nature after previously exploring her subject in preliminary drawings. Allover, vigorous brushwork is an essential part of her landscape interpretations, but it is the high color contrast that really projects her direct response to nature's rich range of color as filtered through her own color sensibilities. A moderate amount of tonal contrast exists here, but the special distinction of her art lies in her exhilarating use of color contrasts to create light, air, and space. Her method of constructing landscape out of color and heavily loaded brushstrokes, though realistic in style, is influenced by her early training as an abstractionist.

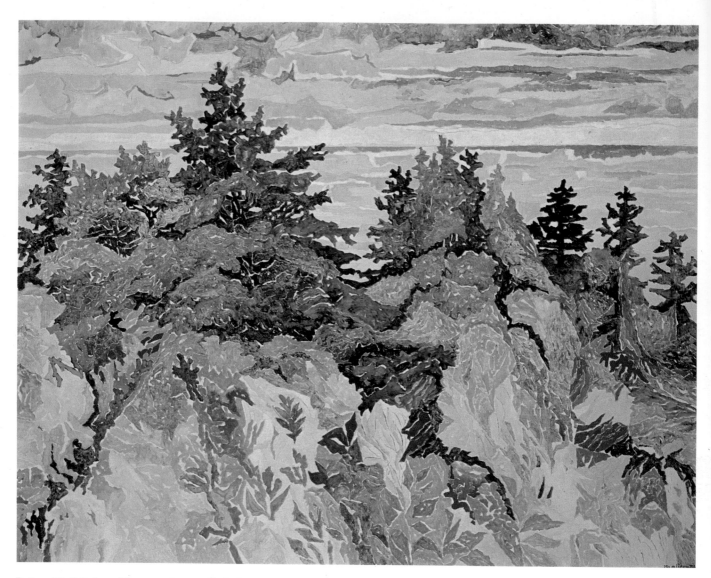

Intensified Color. To use colors at their full intensity or saturation is to use nondescriptive color that deliberately departs from the tonal range of realistic color seen in light and shadow. When dealing with intensified color, it is best to intensify all the colors to about the same extent, otherwise jumpy color relations will result. Some are too pure and bright, while others are so dull and tonal that the overall color orchestration is disrupted. When they are equally intensified, however, they relate more consistently to each other. This approach leaves the artist free to be more inventive in using color for its own sake—forcing color, altering it, or intensifying it for pictorial reasons instead of painting in a conventional range of tonal color.

Pines Against the Sea by Hans Moller, N. A., oil on canvas, 48″ x 60″ (122 x 152 cm). Courtesy Midtown Galleries, New York City. This is an example of an artist intensifying nature's colors and forcing them out of their normal context of tonal relationships. Trees are treated not only as greens, but also as pure blue; purples, oranges, and reds have been used at full saturation; and even the sky has been broken up into a series of bright streaks with vivid accents of strong color. The mosaic-like treatment of color is consistently rich over the entire surface, and Moller's sole concern is the contrast of color against color, avoiding any suggestion of light and shadow. Even though all the color is equally intensified and handled more or less flatly, there is still a logical recession of the colors from foreground to background within the picture space.

Color Mosaic. In a mosaic color treatment the picture surface is activated by a multitude of color strokes and dots placed side by side. The canvas is to be viewed not as deep space, but as an allover color field composed of zones and clusters of very small units of color. Large areas of color can be established in the beginning, but they are only preparatory masses against which the small strokes of vibrating color are to be applied. The final surface is experienced as a pattern of color that may suggest planes or masses, but its main visual impact comes from the contrasts of innumerable varied spots of interwoven color. It is the complex activity set up by these mosaics or tapestries of color units that opens up a different way of perceiving and enjoying color in landscape.

Sea Path, Ischia III by Morton Kaish, acrylic on panel, 48″ x 60″ (122 x 152 cm). Collection J. C. Penney Company, New York City. Courtesy Staempfli Gallery, New York City. There is such a profusion of small color units in this painting that it might at first seem formless and casually composed. On the contrary, Kaish has treated his floral landscape as a basically flat, controlled, allover patterning of color clusters that have a clearly discernible movement across the surface. The darkest mass containing the strongest color relations is in the left foreground; above it are a number of soft-edged diagonally flowing color masses slanting from upper left toward lower right. As they near the right edge, the masses disperse and open up, and the zone is more diffused. His subtle and vibrant flower patterns are less flowers than they are an exuberant playing about with color spots. This picture is not about flowers, it is about color.

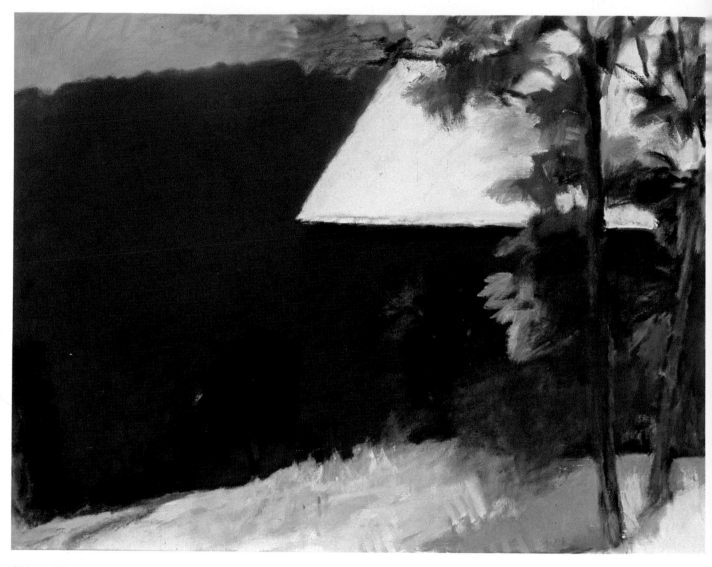

Color Masses. Painter-teacher Charles Hawthorne continually urged his students to see color simply, to stay with simple color forms, and to aim above all for beautiful relationships between major areas of color. Whistler, too, had based an art on exact relationships of just a few carefully selected colors adjusted to each other with the utmost sensitivity. In learning to use color, the big masses of color are established first, and only after that is it possible to work toward a further color breakup in some areas. Working with masses does not mean that color is applied flatly, since some slight color variations and loose paint textures help to enliven the surface; but there should be an effort toward color simplification and a reduction of the painted landscape to only its essential color areas.

High Barn by Wolf Kahn, oil on canvas, 42″ x 52″ (107 x 132 cm). Courtesy Grace Borgenicht Gallery, New York City. Wolf Kahn's intense, luminous colors have more to do with art than with nature, though he requires direct contact with nature as a stimulus for his color ideas. Most of his landscapes of the past few years were begun on location during summers in Vermont and finished later in his New York studio during the winter. For Kahn, color is a sensuous delight, yet he generally reduces his landscape forms to the fewest number of color masses whose severity is softened by his casually brushed edges. In *High Barn* the big broad masses are relieved by more open, active brushwork in trees and bushes. His compositions are dense, compact, and firmly designed. The strength of his art lies not only in the opulence of his color, but also in the absolute simplicity of his landscape vision.

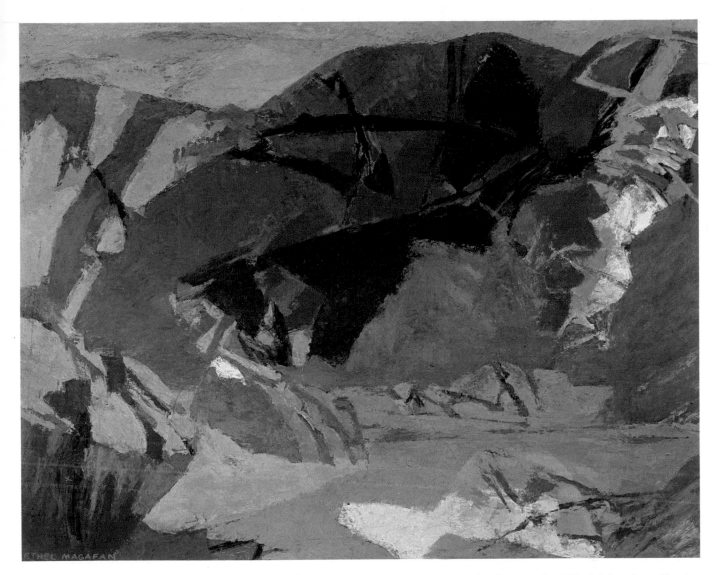

Color Patterns. In tonal painting value patterns are of great importance, with clear contrasts between lights, middle tones, and darks, and no two adjacent values the same. The same necessity for color patterns is true in coloristic painting. Pattern, of course, is a matter of controlling the value or color arrangement throughout the surface. Values or colors are not treated as isolated units but designed in regard to the total painting. The colors must be patterned in relation to each other and as an overall grouping, with clearly defined changes from area to area in terms of warm and cool, hue, and saturation. Coloristic paintings do not rely on tonal relationships, but if the colors can be matched to a tonal structure, a picture may gain extra strength.

Beside a Mountain Stream by Ethel Magafan, N. A., A. W. S., oil on panel, 33″ x 42″ (84 x 107 cm). Courtesy Midtown Galleries, New York City. Despite scumbled, textured surfaces of Ethel Magafan's paintings, color areas are handled as basically flat forms. Each shape or mass has a specific color identity, and the picture as a whole has been treated as an overall patterning of those colored shapes. There are definite contrasts from area to area: ochre against blue, red against purple, light green against red or deep olive, and so on. Where adjacent values are virtually identical, as in the blue of the water against the dark ochre of the foreground shore, the differentiation of hue and of warm and cool separates the two areas. The color is equally rich throughout the picture, so her firmly designed color pattern is crucial to the form and readability of the composition.

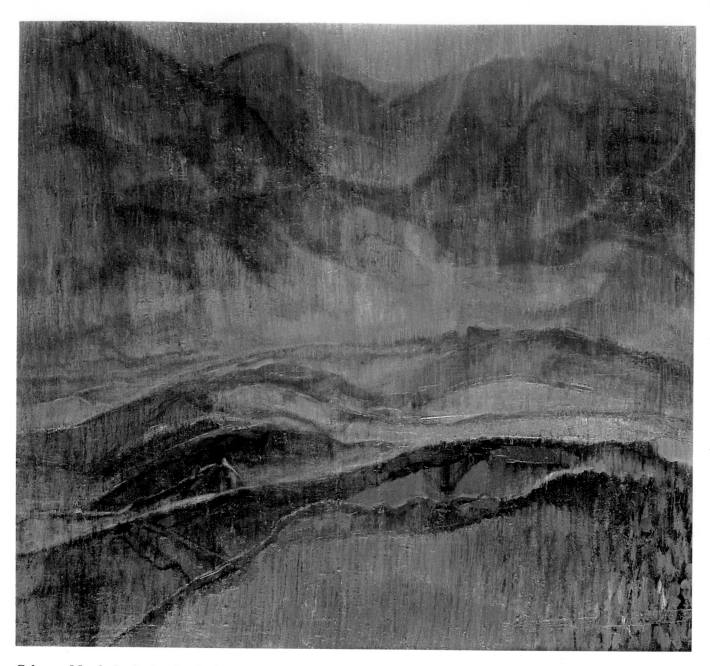

Color as Mood. In the last hundred years or so there has been an increased interest in exploring emotional responses to color. Though it has proven nearly impossible to assign a precise emotional quality to each of the colors, it is undeniable that the high or low key of colors, or their warmth or coolness, do indeed have certain universal associations which are predictable enough to be of use to the painter. Certain yellows or oranges arouse feelings of warmth or joy; reds are associated with excitement or violence; blues and greens can be serene, somber, or depressing. The same landscape painted in a warm palette will have a distinctly different mood than when painted in a cool range, and the artist uses this knowledge to intensify the emotional aspects of his landscape motif.

A Soft Day—Connemara by William Palmer, N. A., oil on canvas, 28″ x 30″ (71 x 76 cm). Courtesy Midtown Galleries, New York City. Although he is known for his sunny, colorful paintings of upper New York State, William Palmer has similar affinities with Ireland. Here, in order to emphasize the mood of the rain-drenched hills, he has limited his normally brilliant palette to a very cool one, ranging, at its warmest, from a green-yellow through a variety of cold blues and greens. The presence of any warmer, cheerier color than the green-yellow might jeopardize the quiet, moody quality of the lush landscape seen here as if softened by a drizzling rain. (Even the repeated verticality of the brushstrokes reaffirms the downward movement of the rain.) The landscape forms themselves are purposely kept generalized, since this is not a travel souvenir, but an evocation of weather and mood through color.

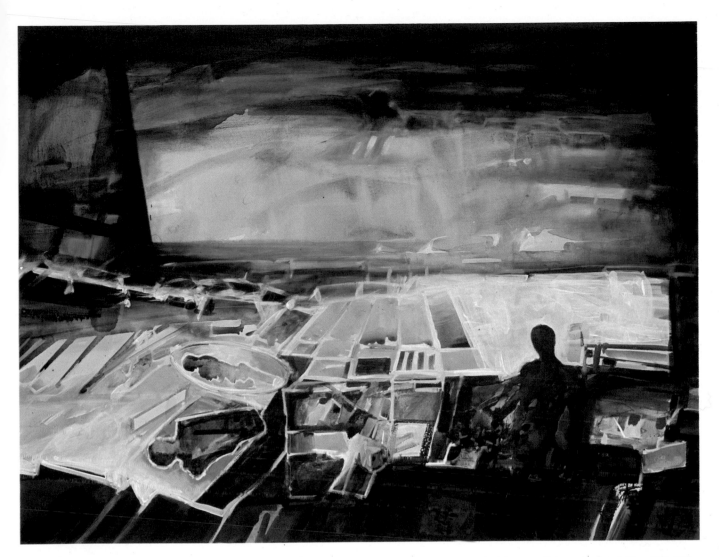

Color as Space—Warm and Cool. Paul Cézanne was quoted as saying, "I'm trying to show depth *only* through color." Since his time many painters have engaged in the problem of making color do the work previously done by linear and aerial perspective: causing forms to come forward or recede through the progressive as well as recessive properties of the various colors. The simplest way to accomplish this is through the use of warm and cool color relationships, utilizing the principle that warm colors come forward in a picture and cool ones recede. An extra factor to be considered, however, is that color intensities also affect a color's position in space, so an intense cool color would easily come forward ahead of a deep-toned warm color. Otherwise, the warm-cool principle is wholly effective in creating depth.

Surfdoom by John Hultberg, oil on canvas, 38″ x 50″ (97 x 127 cm). Courtesy Martha Jackson Gallery, New York City. John Hultberg is a painter obsessed with forms dramatically receding into deep space. Toward that end he uses strong linear perspective beginning with sharply defined foreground forms and ending with blurred forms farthest from the picture plane. That would have been more than enough to express the kind of depth that interests him; but even without the help of linear and aerial perspective, the picture would still have deep spatial qualities because of the way Hultberg used warm yellows, oranges, and reds in the foreground, and then cold blues in the distant background. This recession from warm to cool supports his use of perspective, but it also functions quite independently of it.

Color as Space—Structural Color. Another saying of Paul Cézanne's is, "When color is richest, form is fullest." This concept led later artists to the conviction that the correlation between color and form is what painting is really all about. By working with complex interrelationships of many colors, carefully adjusting one to another, it is possible to suggest not only that colors have various positions in depth within a picture, but also that color can be used to suggest volumes existing within that pictorial space. In this way the painter is using color structurally.

Promontory by David Lund, oil on canvas, 56″ x 48″ (142 x 122 cm). Courtesy Grace Borgenicht Gallery, New York City. Color carries the force of structure and space in this beachscape. Form is realized not through light and dark contrasts, but by adjustments in color intensities, warmth and coolness, and varying densities of the paint itself. The immediate foreground is done in high-keyed stains. The beach rocks contain the fullest use of structural color relationships with volumes emphasized by the brushy painterly handling. And the sky is a flat cool mass, but rich enough as color to stay on the picture plane and yet remain in its place behind the rock forms.

Color as Space—Intentional Reversal. Where a logical recession of forms in space is achieved by tone or color relations, or a combination of both, another method creates a sense of space more unpredictably. Taking into account the integrity of the picture plane (working within limited depth, avoiding illusionistic deep space), some painters purposely violate or reverse normal color procedures and still maintain a readable picture space. Instead of receding from bright or warm colors in the foreground toward dull or cool color in the background, they place relatively subdued colors in the foreground and more intense colors in the rear, toward the top of the picture. The background thus comes forward slightly, the foreground tends to recede slightly, and an equilibrium of the two is created in which the flatness of the picture surface is overtly stressed.

Wequasset (central panel of a triptych) by Paul Zimmerman, N. A., oil on canvas, 50″ x 60″ (127 x 152 cm). Although this is only the middle section of a three-part painting, it is a completely self-contained composition. Working in a warm, ruddy palette, with only scattered accents of cold greens, Zimmerman reserved his most brilliant reds for the hilly areas in the distance. The yellows in the foreground are mainly ochres and are generally more neutral than the reds. But by being the largest, lightest mass in the painting, they still retain their position nearest the picture plane. The intense reds, on the other hand, do not recede and are unexpectedly insistent; by coming forward as much as they do, they create an unusual spatial relation which provides a mild visual shock and reemphasizes the tension between two-dimensionality and three-dimensionality within the picture space.

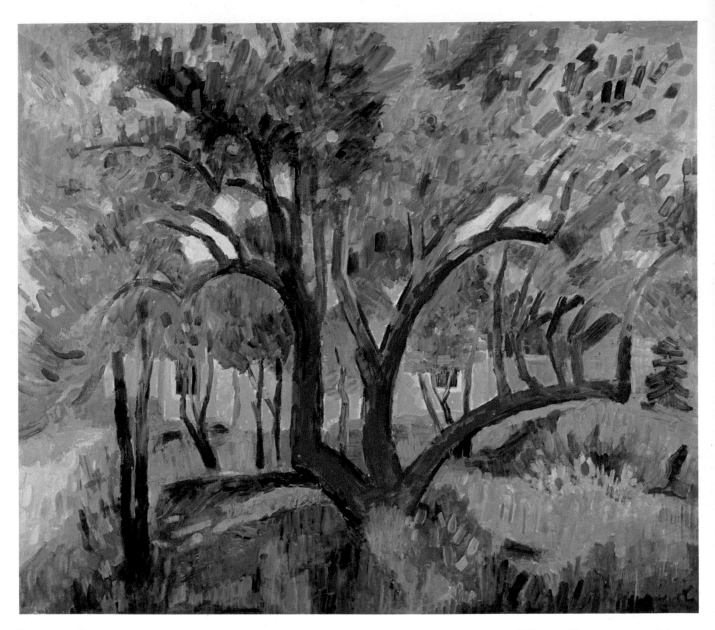

Invented Color. One of the liberties of modern color practices is the freedom to invent our own colors and not to be enslaved by the colors of nature. Since a painter is constructing a work of art, not copying nature, he is quite free to invent colors to suit the needs of his picture. Skies do not need to be blue, foliage does not have to be green, and tree trunks do not have to be brown. A painter should feel justified in making any color changes or using even the most improbable colors if they improve his picture. In fact, it is not a bad idea to introduce some outrageous color at the beginning of a picture and then try to gear all subsequent colors to it, just to see how much can be done with completely unreal but consistently related color.

Summer—Apple Tree and Yellow House by Karl Schrag, oil on canvas, 50″ x 58″ (127 x 147 cm). Courtesy Kraushaar Galleries, New York City. Karl Schrag once said, ". . . I believe that the outward appearance of nature is but the shell of a deeper and richer world that I wish to understand . . ." His continuous search for ways to translate nature into art is invariably in terms of color, not only as expression, but as exploration of color for its own sake. In this painting the only way he could keep the brilliant yellow of the house in its proper place in the picture was to interpret the color of the apple tree in front of it as an intense magenta—not "real" perhaps, but pictorially appropriate. Note also that some of the tree foliage is blue, not green. This painting demonstrates that invented color is often more coherent or expressive than the colors that actually exist in nature.

Color as Light. Painters have always realized that pigment colors are not the same as colors perceived as light rays; yet the urge to paint light itself—its transient effects, its vibrance, and its brilliance—has become a fascination, and sometimes an obsession, for a great many artists. The best of the Impressionist painters made the study of light the actual subject of their paintings, and even before their time, Turner and Constable were attracted to the idea of capturing light and atmosphere in colored paints. Juxtapositions of color intensities and contrasts of warm and cool are both more effective at suggesting light than obvious contrasts of lights and darks. And the greatest mistake a novice can make in attempting to paint light is to use too much white. Color, not white paint, is the way toward luminosity.

Muir Creek I by Joseph Raffael, oil on canvas, 66″ x 81″ (168 x 206 cm). Courtesy Nancy Hoffman Gallery, New York City. Joseph Raffael's paintings create a heightened awareness of nature through close-up concentration on detail, creating a feeling of intimacy through their intensity. He deals in ephemeral views of landscape, such as rushing water or reflections in a creek, yet his compositions must be considered as formal images not casual snapshots. Some of his most lyrical works, such as *Muir Creek I*, are concerned with the action and breaking-up of light into units of color touches. Here pure whites are used only for the brightest sparkles; the rest of the painting is done in rich yellows and dark mosaic patterns of deep but intense cool colors. Although he uses photographs as source material, his pictures are not static and literal, but are primarily experiences in paint.

Flowing Color. Paint does not always have to be applied with a brush or knife. Transparent stains, washes of oil and acrylic, and watercolor all lend themselves to flow methods in which paint is dripped, poured, or brushed onto the picture either in direct or wet-in-wet techniques. The canvas or paper is tilted, bent, or folded to encourage a natural flow of the paint across the surface. Usually several drying periods must be allowed between paint applications to prevent an uncontrolled merging of the wet colors, which produces a series of formless areas and muddy color. When used in a controlled manner, however, working for both hard and soft edges, combining the planned with the accidental, flow techniques are a means of achieving unusual organic shapes and patterns.

Raindrops: Life: Tears by Barbara L. Green, watercolor on paper, 30″ x 40″ (76 x 102 cm). Except for her autobiographical paintings, most of Barbara Green's watercolors, even the most abstract, have their origins in landscape. In this painting she has immersed herself in her medium and, to a certain extent, has let the color loose to flow as it will. Yet the viewer is always aware of the artist's hand guiding the washes as she responds to chance effects and incorporates them in the overall composition. By restricting her color range to no more than three or four colors, she has maintained mainly warm and cool color relations and eliminated the risk of colors neutralizing each other when too many are permitted to blend together. Instead of filling her surface, she has used the flat white of her paper to contain and set off the fluid color zones.

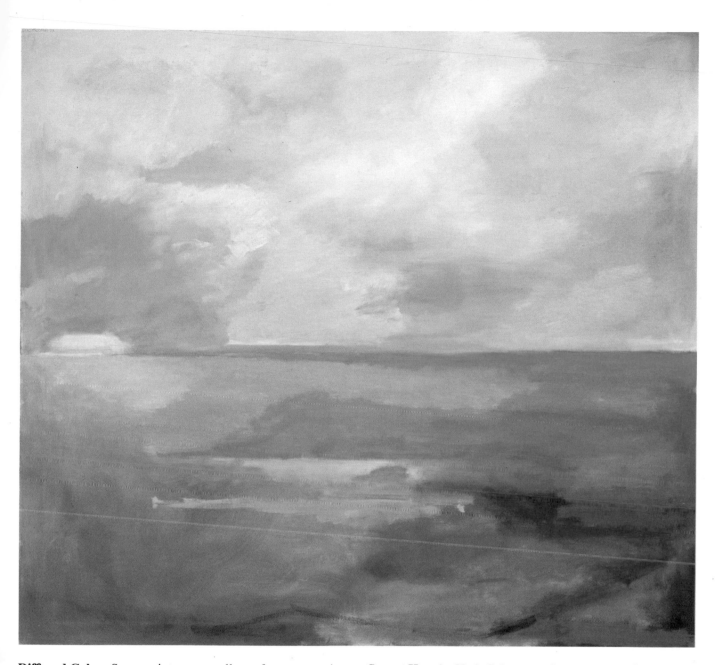

Diffused Color. Some painters naturally prefer strong, crisp color definition and forceful contrasts of value. But others are more concerned with atmosphere and nuance, with gentler relations of both color and value. Indeed, there are certain conditions of light, weather, or time of day when the clear-cut, contrasty approach is not at all appropriate. Diffused color is used when light is misted or dimmed, and edges are not as important as the blending of one color into another. So, with less emphasis on contrast and pattern, subtle inter-relationships of the colors themselves become a greater pictorial necessity. In turn, the softened color areas convey a sense of luminosity, atmosphere, and space that can often be achieved in no other way.

Sunset Haze by Hyde Solomon, oil on canvas, 54″ x 60″ (137 x 152 cm). Courtesy of Poindexter Gallery, New York City. In this severely divided composition the color activity carries the entire burden of visual interest. The colors are clean and clear—no neutrals at all—with the most color weight confined to the lower section of the picture. The sky is generally in a higher key, which gives both the lower and the higher zones a color identity. However, there is enough exchange of warm and cool in both areas so that the total surface retains its unity. The sky receives its luminous, atmospheric quality through the use of color diffusion, whereas color changes in the ocean area are slightly more defined. The few straight, hard edges serve as a foil for the softness of the rest of the picture.

Color Glazes. Superimposed washes in transparent water-color techniques are essentially a glazing method. In opaque oils or acrylics, glazing is a matter of painting transparent mixtures of color over a lighter, often textured, underpainting. The use of glazes in opaque painting media has several advantages. It can be a way of breaking down form and color into two separate processes, first creating tone and form, then adding color glazes. It also adds variety to the paint surfaces so that there is an interplay of both opaque and transparent (glazed) passages. Finally, glazing offers color effects that simply cannot be matched, in terms of depth and luminosity, by direct opaque applications of paint. It is an additional color resource that should be used oftener than it is.

Skyforms W-39 by Albert Christ-Janer, mixed-media on board, 20″ x 30″ (51 x 76 cm). Collection Mrs. Virginia Christ-Janer. Albert Christ-Janer was particularly sensitive to nuances of color and texture, and this is typical of his mixed-media painting in which he exploited combinations of textures, inks, paints, resists, and color glazes. He was a born experimenter, continually trying out new ideas, new techniques, and new materials to stretch the possibilities of his personal kind of lyricism. Large areas of this painting were first built up with heavy impastos of light paint or modeling paste, and there is some use of sprinkled sand to add to the textural undercoat. However, it is the subtle glazing—the evanescent washes of color, or those applied full strength and then wiped until only the faintest breath of color remains—that invests the picture with its poetic delicacy and sense of atmosphere. Photo courtesy of University of Georgia Art Museum, Athens, Ga.

Color Reticence. Even if a painter delights in rich, vibrant color, it does not mean that he is always obliged to use color at full strength. If he is aware of the total body of his work, or even if he is only working toward a one-man show, he should make some effort to paint in more than one color range. He should do this to avoid a look of monotony, if nothing else, but also to avoid habitual, repetitious use of too-familiar colors. Color reticence means holding back once in a while, working only in a range of neutrals, and deliberately restraining one's customary lush color instincts in favor of a more reserved palette. A grouping of neutral colors can often be quite expressive of certain subjects or moods, or it can be used simply as a change of pace from what may have become a fairly predictable color range.

Raga on a Foggy Coastal Morning by Alan Gussow, oil on canvas, 60″ x 67″ (152 x 170 cm). Courtesy Washburn Gallery, New York City. After passing through a period in which he painted in a style and technique that was closely allied to Impressionism, Alan Gussow has gradually changed his attitude and technique to a kind of painting that is more formalistic, personal, and even symbolic. In his words, he is "treating nature as a source rather than as a scene." Despite the atmospheric implications of the title, the format of this painting is rigorously structured; but the structure is allowed to dissolve into more casual irregular forms in the lower area. The color is as strictly controlled as the design and is handled in a severely restricted range of blues and grays that express the mood of the foggy shoreline. At the same time they are enjoyable as beautifully adjusted color relations in their own right.

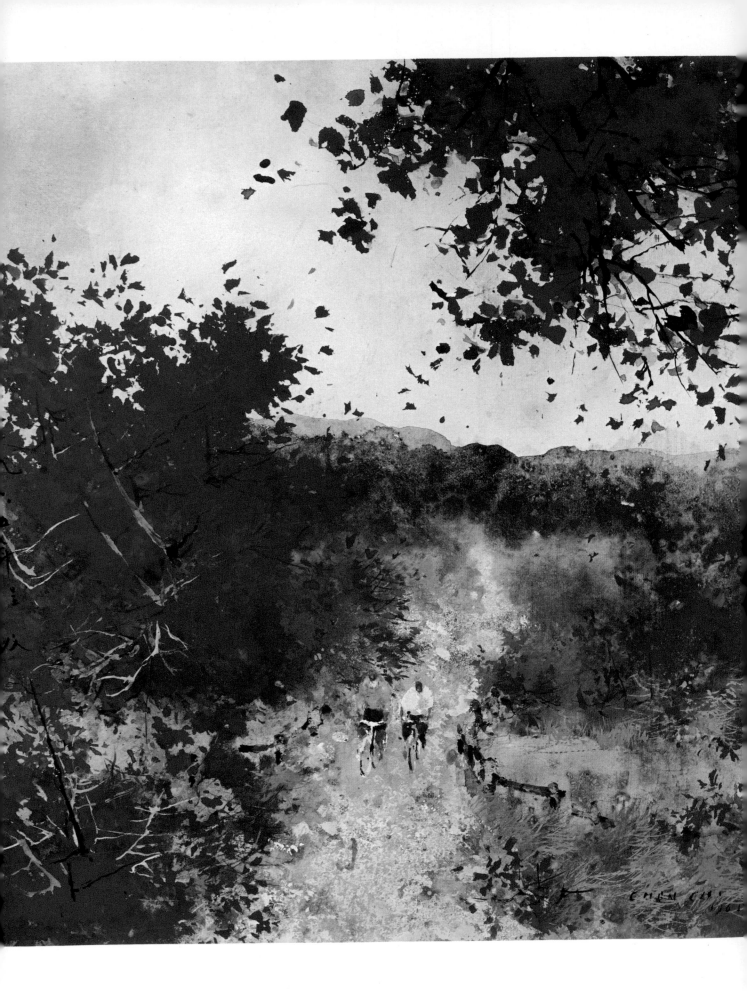

Color Shock. We are taught so much about striving for attractive or tasteful color relationships that it takes considerable nerve to let loose on color occasionally and try for visual shock—for color so powerful and intense that it has an overwhelming impact on the viewer. A fearless use of pure color is excellent therapy for a painter whose color is pleasant but dull, since it is healthier to feel fully at home with all kinds of color than to settle permanently into a too safe and familiar group of colors.

Autumn Red by Chen Chi, N. A., A. W. S., watercolor on rice paper, 19″ x 17″ (48 x 43 cm). Courtesy Grand Central Art Galleries, New York City. Though best known for his subtle, silvery color, Chen Chi is versatile and courageous enough to use the most intense colors when a picture requires it. The glowing, brilliant reds and bright yellows are relieved by blurred, less intense colors elsewhere in the picture. The strong color expresses autumn, but it also creates spatial recession from the richest reds of the foliage at upper right to the cool tones of the mountains. It was no small feat to force color to the brink of excess and still keep it under full control.

NOTES ON COLOR

One of the major stumbling blocks for many painters is the matter of color. I wish there were some foolproof system or some one book I could recommend that would provide answers to all the problems involved in using color. But there just isn't one. I have found that, in the long run, handling color is almost entirely a question of prolonged personal experience. What looks good on the printed page of a book does not always carry over into the painting you happen to be working on; often the only way to solve a color problem is by trial-and-error and sheer perseverance.

No one book or no one system has all the answers. I am not even sure that any system at all, whether devised by a color theorist or a paint manufacturer, is really desirable. Color is too complex and can be used in too many ways to be subject to rigid rules and regulations. In the search for color knowledge, it is of course natural to want to find some rules, general or specific, that offer security—a sure-fire method for dealing with color rationally, without room for error. There are indeed people who have formulated some color theories, but like Hambidge's "Dynamic Symmetry," such theories tend to restrict creativity rather than support it. I would rather see a painter struggle to find his own way of using color successfully, rather than rely on arbitrary rules which may seem to apply to selected masterpieces but which do not necessarily fit all pictorial situations.

For beginning art students, color is almost exclusively a matter of *seeing* accurately and then mixing paint correctly. Later on we discover that simply copying the color before us is not quite enough. It is necessary to be concerned with color *relationships*. The needs of the picture must be served not only by "true" color but also by color harmonies and contrasts through which all the colors in a painting are consciously controlled and interrelated. Color decisions must be made for the picture as a whole.

If we carry the experience of color still further, we find it can be used most creatively not just as mild adjustments for the sake of compatibility and readability, but in highly personal ways and for radical purposes and distortions. Color relationships can become one of the basic reasons for the picture's existence. Color is, then, much more than merely a descriptive tool. It becomes a primary means of achieving esthetic organization and expressiveness on the highest level.

Some people are probably born colorists. I think immediately of Monet, Degas, Bonnard, and Vuillard. But the majority of painters must begin as tonalists, working principally with *values*. Until the time when color skills have been developed, the painter must depend on a tonal range of lights, middle tones, and darks to give his paintings structure and strength. As ways with color become a more important part of his equipment, true color might then replace these graded values in the picture-forming process. But attention to tones or values must never be wholly discarded in favor of color for color's sake. If the color relationships are beautiful enough in themselves, tone becomes correspondingly less important to the look of the picture. If this idea were carried to its extreme, it would mean that if the color in a painting is extraordinarily ravishing, a tonal pattern might well be dispensed with altogether, and never be missed.

TWO COLOR CATEGORIES. In my view there are two major categories of color—descriptive and nondescriptive—and most painters lean toward one or the other. *Descriptive color* is tonal: and color is treated as a range of values that go from the lighter, brighter colors to the deep, dark colors at the other end of the scale. Descriptive color shows how things look to the human eye, with little or no apparent distortion. This sort of tonal color is strong in light-dark contrasts and has the ability to suggest deep shadow and distant space. Most color, from the Renaissance right through early Impressionism, was tonal, descriptive color, based on perception of lights and darks in nature. That encompasses painters such as Rembrandt, Claude Lorrain, Corot, and Inness, as well as more contemporary painters such as Bellows, Hopper, and Wyeth.

Descriptive color (tonal color) is based, above all, on *color values*.

The other use of color is *nondescriptive color*, in which tonal values are of little or no importance, and color is used in more creative ways. Contrasts of light and dark values are seldom seen. More often, the painter relies on color contrasts of warm against cool; contrasts of complements on the color wheel (red against green, yellow against violet); or juxtapositions of colors that are of equal or near-equal intensity (such as a vivid pink against a bright orange), causing color bounce or vibration.

And instead of the aerial perspective found in most tonal paintings—in which distant planes are treated as cooler and paler—the progression and recession of the colors themselves can be used to create a sense of depth or space. For instance, a lavender is pushed forward by the ochre adjacent to it; or color planes may recede gradually from a yellow in the foreground to ochre, to vermilion, to red, to olive-green.

With a touch of perversity, some artists reverse the

conventional recessions in realist painting, which usually go from bright tones nearest the picture plane to neutrals in the distance; instead, they place neutrals in the foreground and paint bright oranges or acid greens in the distant areas, thus making the viewer more conscious of the actual flatness of the picture surface. Rather than creating an illusion of depth, they deliberately bring rear planes forward and let foreground planes appear to recede, a kind of visual shock that can be refreshing rather than disturbing if handled well.

Nondescriptive color is something that can be used intellectually, in the interests of space or design (Cézanne, Matisse, Braque); or emotionally, as a means of intensified personal expression (Van Gogh, Gauguin, Nolde); or simply as a feast for the eyes (Bonnard, Redon, Matisse). Frequently, nondescriptive color is used as purely a source of sensual enjoyment—colors selected for their qualities as luscious or handsome combinations that may have very little to do with the way things look to the human eye.

Nondescriptive color is based, above all, on *color intensities*. In nondescriptive color, value contrasts count less than the use of color against color, the use of stronger, more intense colors, or the optical effects of color vibration. Contrasts of *color intensities* and *color intervals* take precedence over tonal contrasts.

FUNCTIONS OF COLOR.

Before beginning a painting, it is advisable to have a clear idea of just what function color is to perform in that painting. Color can serve several purposes and can function differently in different paintings, but it should be immediately apparent to the beholder that the artist has used his color toward some quite specific purpose, that he was not confused or ambiguous in the way he chose to handle color. Let's take a look at color's various functions.

Description. This is probably the most basic use of color—to tell how things appear—color as information. Generally, if you stick to what you see, the painting will be sufficiently convincing, though you may have to make minor changes here and there for the sake of the picture as a whole. If, for instance, a roof is so close to the sky in color and value that the two areas are not clearly distinguishable from each other, then it is your obligation to change the color or the value, or both, in order to make those areas more contrasted and therefore more readable.

Expression. When color is used as expression, it evokes a mood or expresses an emotion or a state of mind. Color is consciously employed to not only convey just how the landscape looks but also to arouse in the beholder the same feelings the artist experienced. The same landscape motif painted in warm colors and then again in cool colors will produce two quite different responses—one happy and sunny, the other chilly and gloomy. This is one means of exerting some

control over how the spectator should react to the painting. Telling the visual truth isn't enough; you have to give a few hints about the attitude or emotion behind the picture. Color can suggest such feelings without being too obvious about it.

Composition. In terms of composition, color can create a sense of space and can indicate the relative spatial positions of the various areas within the picture by bringing some forms forward and setting others farther back. Although the general rule is that warm colors advance and cool colors recede, quite obviously a bright, intense cool color would jump forward ahead of a deep, dull warm color. Nevertheless, thoughtful use of color can help clarify just how areas relate to each other, while avoiding static flatness and achieving a feeling of movement forward and backward within the picture space.

In addition to color as space, color is also used for compositional emphasis or focus. Where picture areas might tend toward being equally interesting, color can help distinguish which forms are of more interest than others. Strong color provides an extra wallop where it is needed to direct the viewer's attention; similarly, color neutralization can subdue areas that are too bright or are demanding more attention than they deserve.

Decoration. For decorative purposes, color is not usually descriptive "real" color but is color used for its own sake, in consciously planned harmonies that are more important than the subject they refer to. Decorative color is assumed to lean toward the artificial, both in terms of truth to nature and in terms of emotional content. Color as decoration is meant to appeal to the eye rather than to stir the emotions.

Incidentally, I have never entirely understood why "decorative" has become such an ugly word in art; if you really want to dismiss a work of art once and for all, you call it "decorative," and that finishes it off. We tend to give higher regard to paintings that create profound experiences for the viewer, on either an emotional or an intellectual plane. Decorative paintings, failing to offer that kind of nourishment, are looked upon as "armchair art"—pleasant, soothing, comfortable, undemanding, and not much more. Yet I suspect that one of the basic origins of art was for decoration, and that in the right hands, it is a perfectly honorable tradition.

At any rate, decorative color is a matter of selection and arrangement, controlled balances and relationships most effectively used in paintings such as murals, whose primary function is to enhance interiors or exteriors.

Color as Light. Color has long been studied by artists as a means of expressing or interpreting light. The range of pigmentary colors is, of course, a very limited one compared to color considered as light rays; but this fact has not diminished the fascination or the challenge

of trying to manipulate paints so as to convey a sense of the radiance and brilliance of light.

The two artists who come readily to mind in this connection are Turner and Monet. In many instances, both artists succeeded in making light and the effects of light the true subject of some of their finest paintings. Subject matter was frankly used as nothing more than a vehicle, an excuse, for painting. Their real obsession was the way in which a picture could produce an optical effect of blazing, blinding light. Broken color, rich glazes, color oppositions, color high in key and intensity—all were used in an attempt to capture and match the sensation of light in nature.

It did not take either painter long to find out that light is suggested not so much by value contrasts of light and dark as by a rich range of color that minimized the use of white. Many novice painters seem to think that if enough white is used, they will achieve an effect of brilliant light. But all they really end up with is a bleached-out, chalky painting. Brilliance comes from using strong, intense, saturated colors, not liberal amounts of white paint.

If you can identify which of the above functions of color is to operate in your picture, it should give you a greater sense of purpose and control as you start organizing your painting. Although it is conceivable that more than one of these functions might be involved in a painting, a picture should nevertheless be based on a single prevailing attitude toward color. Your early decision about that attitude will make for a strong, unified painting.

COLOR SCHEMES. Most painters realize that if their color is to appear orderly and coherent—harmonious—there must be some conscious selection of a group of colors that look well together. I have never read any books by interior designers on the subject of color, but I am willing to bet that someone has devised a system for choosing color schemes, such as selecting four analagous colors plus an accent of a complementary color. I favor intuitively found color schemes and am very much against restrictive formulas that reduce all painters to uniform thinking on any aspect of art.

In any case, consciously or unconsciously, color schemes are an inevitable part of every painting and something that must be dealt with in one way or another. They are the color plan on which a picture's whole color structure is built.

Before I discuss ways of determining color schemes, let me remind you that the list of specific colors in any color scheme is not really as important as the proportion of those colors to each other. I could propose a color group that includes olive, red-brown, orange, lavender, dull yellow, and gray. This might be a perfectly workable group, but to make it a truly satisfying color experience depends on *how much* yellow, *how much* lavender, *how much* gray. If they were all used in equal amounts, I cannot imagine that the color relationships would be at all interesting—nothing more than a checkerboard of colors in which each tends to cancel the others. It is necessary, therefore, to decide which one or two will be the dominant color or colors, which two or three will be subordinate, and which one or two will serve as minor color accents.

There are a number of ways you can set about finding a color group or color scheme. I shall discuss several of these below.

Subject-suggested. The most direct way to decide on a color scheme is to look at the subject itself. In a realistic painting you get most of your color ideas simply by observing what is actually there. Any color areas that do not seem to relate properly can be modified slightly to fit in better with the rest of the picture. In an abstract painting, color can still be suggested by the subject or theme, but the artist is much freer to omit, change, or add new colors that suit his design or spatial problems.

Predetermined. This approach means that you can disregard the colors that exist in or are suggested by the subject and, instead, decide in advance that an arbitrarily chosen set of colors will be used. They may be warm or cool, or simply a group of colors you find personally satisfying. This color plan can then be adapted to a landscape subject without a thought of being true to nature; a pictorial color selection takes precedence over the actual colors of nature. Of course, there should be some connection between the landscape motif and your predetermined group of colors. But after finding your color scheme first, you then either find a motif to fit it as appropriately as possible or else intentionally disregard nature's colors and substitute your own.

Discovery Through Painting. If you are unable or unwilling to commit yourself to a color scheme beforehand, it is still possible to arrive at one simply by painting. This would be a trial-and-error process, in which you try out various possibilities by putting down any and all colors that may occur to you. You then select, eliminate, and adjust until you have settled on some color relationships that both please you and function successfully within the picture. This is somewhat hit-or-miss, to be sure, but it has the advantage of frequently producing unexpected, intriguing color groupings that might not occur to you if you depend entirely on a formula or on your own powers of invention.

A lot of unpredictable things can happen in the course of painting, some of them happily accidental, others the result of spur-of-the-moment decisions—inspiration, if you will. The experienced painter does not reject these because they do not fit in with his plan. He seizes a promising opportunity and flows along with whatever is happening on his canvas. Color is one of these unpredictables. It does not have to be determined in advance, but can be allowed to develop quite naturally, almost of its own accord.

It it comes easily, that is fine; but if it comes too slowly and agonizingly, it could cause the artist to throw up his hands in despair. Each person has to find by himself his own best method for deciding on color arrangements, whether they are to be logically predetermined or discovered improvisationally during the painting process itself. I would certainly recommend that you have at least some general notion of a major color or two before beginning the painting. Then, perhaps, let the other colors reveal themselves as the picture progresses. Leave a little something—but not everything—to chance.

Pictorial Sources. Another way to discover color schemes is to refer to existing paintings or color photographs. If a color grouping has worked for someone else and you consider it applicable to your own work, give it a try, at least to get yourself started and the picture under way. It's better than having no plan at all. Also, a great deal of color photography has stunning color combinations that are quite usable in paintings.

So, a still life by Braque, an interior by Bonnard, or a photograph by Eliot Porter or Irving Penn could very well provide color ideas for one of your new landscape paintings, whether realistic or abstract. Study paintings by such established masters as Gauguin, Vuillard, or Matisse or by Milton Avery, Karl Knaths, Stuart Davis, or Helen Frankenthaler, and record those color schemes which attract you, also noting the relative proportions of each color.

This is not a procedure to be followed indefinitely, for eventually you will develop your own color preferences; but in the beginning stages of color awareness, it can at least provide a point of departure.

COLOR CONTROL. How a painter controls color is often the measure of his taste, skill, and ability as a professional artist. Many beginning painters find that their color seems to get out of control: it is too raw or too bleached out; it is too various and confusing or not sufficiently varied to engage the eye; or it is dirty and dull. Whatever it is, in one way or another it is unsatisfying to them and to their audiences. I think I have already suggested that experience with color is a lifelong process. In the meantime, there are several basic ways of working toward color control, so that the painter feels greater authority in his handling of this elusive, complex aspect of painting.

Limited Palette. By far the simplest way to control color is to restrict severely the number of colors set out on your palette. Even a full palette need not contain more than twelve or thirteen colors. The fewer you can get by with, the better. In a simplified, limited palette, any intermixture of colors is possible and permissible. It also means there is little or no chance for creating jarring, disturbing color relations, since there are so few colors that all the color mixtures are bound to have something in common.

Below are given some limited palettes, working from the most basic (one warm and one cool color) on up to nearly full-range palettes. In most of these palettes, green is not included among the colors, since greens are usually quite cold and almost always need to be modified by a warm color. Also, many painters prefer to mix their own greens. Black also is not usually included here, because a black that is blacker than black tube pigment can easily be mixed from thalo blue, alizarin crimson, and a very small touch of burnt sienna.

Note: If oils or acrylics are being used, titanium white should be added to each of these lists.

Palette 1
Thalo blue
Burnt sienna

This palette, consisting of one warm color and one cool color, is about as limited as it is possible to get. Even so, the blue has a faint touch of green, the brown has a strong element of red, and the range of neutrals that can be mixed is surprisingly varied for such a simple combination of colors. The palest tint of burnt sienna comes out as a rather delicate pink.

Palette 2
Cadmium red medium
Cadmium yellow light
Cobalt blue

These are the three primary colors: red, yellow, and blue. Mixtures of these yield a range of vivid colors that include a rich orange, a bright green, and some interesting lavenders and purples. Working with a basic group such as this has the benefit of forcing the painter to be more than usually thoughtful about how each color must be mixed; without a wide assortment to choose from, each mixture is arrived at far more consciously. Here, too, the chances for a wider range of neutrals are increased; and indeed, these should be used whenever possible to offset the occasional rawness of some of the stronger color mixtures. The challenge here is to see how much can be done with so little.

Palette 3
Burnt sienna
Yellow ochre
Ultramarine blue

Here we have muted versions of the three primary colors; the mixtures possible are somewhat subdued and neutralized because of the inherent restraint of these pigments. For example, blue and ochre will produce a soft olive-green; blue and sienna in varying proportions will give a wide range of both warm and cool grays; and the mixture of ochre and sienna will result in a coppery orange. This palette provides somewhat more color control than Palette 2. Unless the blue is used in too pure a state, all will hold their place on the picture surface without popping out at the viewer.

Palette 4

Ultramarine blue
Viridian
Cadmium yellow light
Cadmium orange
Cadmium red light
Alizarin crimson

This palette is broadened to include a green as well as the blue, and also four colors from the warm side of the spectrum. It excludes any browns or neutrals. With these colors it is possible to mix your own browns, without having to rely on those that come in tubes. (Usually mixed browns are more personal and interesting, anyway.) The addition of viridian helps in achieving a broader range of cool tones than is possible with only one cool color. Mixed with cadmium red light or alizarin crimson, the green gives some quite subtle neutrals, far more ingratiating than the battleship gray resulting from mixtures of black and white.

Palette 5

Ultramarine blue
Terre verte
Burnt sienna
Burnt umber
Yellow ochre
Venetian red
Ivory black

This is basically a group of earth colors, and like the simpler Palette 3, it has a built-in capacity for harmonious color mixtures. All the colors, with the possible exception of blue, are duller, neutralized versions of the brighter colors usually found on most palettes. This very restraint is appealing to the color tastes of many artists. This palette was first proposed to me as being appropriate for figure painting, but I found it was also useful for many landscape subjects. For a person still unsure of himself when it comes to orchestrating color throughout a painting, this is an excellent beginning palette, to which other colors can gradually be added as the artist gains in experience or as the subject requires.

Palette 6

Thalo blue
Cerulean blue
Cadmium yellow light
Cadmium orange
Cadmium red light
Cadmium red deep
Alizarin crimson

This might be called a high-intensity palette that contains no greens and no neutrals. The two blues—a brilliant, cold blue and a light, subdued blue—will yield quite a variety of greens when mixed with cadmium yellow and cadmium orange. The trick here, of course, is to learn to mix these brilliant colors so as to reduce their intensity, bringing about color relationships that tend toward subtlety rather than harshness. Or, if they are to be used more or less full-strength, with only limited mixing, then these colors have to be played off against one another until some kind of color balance is achieved. Generally it is best to try mixing no more than two colors together; by the time a third or fourth color is added to a mixture, there is greater risk of getting muddy color.

Palette 7

Ultramarine blue
Cerulean blue
Burnt sienna
Burnt umber
Raw sienna
Cadmium yellow light
Cadmium orange
Cadmium red medium

This is an expanded palette in which a neutral blue and three subdued earth colors are set against several brighter cadmiums, and as such it represents a reasonably well-balanced group of colors. Raw sienna is quite versatile in that it relates well to other browns. At the same time, when slightly lightened in value, it is near enough to yellow to substitute for yellow ochre. This palette provides a far greater range of color intensities than is possible with any of the preceding palettes.

Common-color Mixture. In this method, a single color is added in lesser or greater amounts to every paint mixture. For instance, it could be yellow ochre which is added to *all* mixtures made on the palette. Color control comes from the fact that there is a color factor common to all the colors that appear in the painting. The colors are thus unified in the same manner that viewing a landscape through a color filter would unify all the colors present. I consider this method somewhat tedious and mechanical, but it does seem to work for some artists.

A Key Color. Karl Knaths, a great American colorist, was fond of selecting in advance one color to which all the other color areas were to be related. This "key color" was not necessarily the predominant color in the painting; sometimes it was a fairly strong color accent, such as vermilion, but it might also be a pale lemon yellow, barely discernible under a scumble of cool gray. Once this key color had been determined, it became the controlling element for the picture's entire color system. All the other colors were selected to relate to it by referring to the Ostwald color chart; this is a system devised by Wilhelm Ostwald, a distinguished German chemist and author of *Colour Science* (2 vols.) and *The Ostwald Colour Album*, both published in 1933 (London: Winsor and Newton).

Following the Ostwald system, a key color of burnt orange could lead to the selection of a range of colors that included rust, olive-green, lavender, two warm neutrals and a cool one, light yellow, and a spot of

bright red—all used in varying amounts and proportions. All the colors throughout the surface were thus bound together by this one color to which they were all keyed.

To vary this method, Knaths would start by determining a predominant color for the major part of the picture surface, possibly a soft yellow. Then he would introduce a color contrast strong enough to maintain itself as a focal area or color climax, such as a bright green. From that point on, he related still other colors (golden yellow, deep red, purple) to the original pair, continuing with color areas of successively lesser interest (patches of pink, light green, orange), until there was a general cohesion of color relationships over the whole surface. In this method, those first *two* colors set the key, establishing a control for all the color selections that followed; the artist then took pains to see that all the colors stayed in their place on the picture plane.

Tonal values were of little interest to Knaths, except insofar as they represented a distinction between subdued and saturated colors. And very often he severely limited his range of colors: it has been noted that in a Knaths landscape with twenty-two distinct colors, thirteen were closely related blues.

For the reader who wishes to experiment with such color systems, I might point out here that there are several systems besides the Ostwald charts used by Knaths. the Munsell system, illustrated in color in *Webster's Third New International Dictionary* (Springfield, Mass.: G. & C. Merriam, 1959); *The Painter's Palette* by Denman Ross (Boston: Houghton Mifflin, 1919); Josef Albers' *Interaction of Color* (New Haven: Yale University Press, 1971); and the book I personally prefer, Johannes Itten's *The Art of Color* (New York: Van Nostrand-Reinhold, 1973). Also see the Bibliography in this book.

But as I have said before, I am somewhat suspicious of all color systems. Though Knaths may have used Ostwald's charts as a general starting point for his color structure, I am convinced he also used his intuition and his unerring eye to make color adjustments required by the particular painting he was working on.

Restricted Color. By restrictions, I mean setting limits not so much on the list of colors to be used, but on the range of values from light to dark, or from warm to cool. A painting with too many values may become cluttered, disturbingly jumpy, and confusing. A picture that has no overall unity, in terms of being primarily a warm or a cool painting, may be similarly confusing to the eye. Therefore, it is usually necessary to restrict the range of values to being generally high in key or generally low in key, with just enough contrast to avoid monotony. In terms of warm and cool, it is desirable to make a clear decision quite early about whether the picture will lean toward a warm or a cool tonality, again with enough contrast here and there to prevent visual boredom.

Controlling color does not have to constitute an eternal hurdle for the painter, since the longer he paints, the more easily and naturally he should find ways to control color relations. It's just a question of knowing *who* is really in control. And you can be sure it's not those inert blobs of pigment on your palette!

STUDIO NOTES

COLOR

Make your picture a color statement, not just a landscape.

Analyze everything you see in terms of the colors you might mix in order to paint it. Your eyes should never be off-duty.

Get rid of your brown paint, especially raw umber. Burnt sienna is very useful, but the clumsy use of raw umber has ruined more student paintings than I care to think about. Remember: the first color the Impressionists discarded from their palettes was brown.

Don't paint the background without looking at the foreground. The color of the background depends entirely on its relation to the foreground.

Dark shadows should be colors, not black holes. Your darks will have more depth if you see the color in them.

Get the big color masses first. Later on you can look for variations within those masses.

Paint what you know as well as what you see. If you merely copy the colors that are there, the form may not explain itself; expressing that form is more important than carelessly using colors that disguise the sense of volume.

Avoid grays that are absolutely neutral. Push them toward color grays such as green-gray, purple-gray, pink-gray, or ochre-gray.

Not all trees have brown trunks and branches. Depending on the light, the weather, and the season, some are gray, some are purple, some are blue, some are black—and some are brown. Don't assume brown, look and see what is there. Look for the particularities of color.

In abstract painting, black can be used as a color equal to all others. In realistic painting, black is forbidden. In the wrong hands it can create a deep hole in the picture, rather than acting as a color area on the picture plane.

Vary the selection of colors on your palette every now and then. Force yourself to work with pigments with which you are less familiar. Color mixing should be a matter of thought and conscious decisions, not a repetitious formula or habit.

If you have fallen into timid color habits, try painting with pure color straight from the tube for a period of about two weeks. You may be reassured to discover that, for one thing, the sky does not fall in when you use pure color; you will also get acquainted with an ex-panded range of color. Put the whole keyboard at your disposal; don't limit yourself to just those colors with which you are most at ease.

If a note of color seems too bright or out of key, your natural impulse is to subdue it. Instead, try intensifying the *other* colors in the picture and bring them into relationship with the "offender." By subduing that bright spot, you might end up with a painting that is too predictable.

Each brushstroke and each area should be a separate, specific color choice, related to the others, but different. And don't just paint general darks, paint darks that have a rich color quality to them. You can't easily get color in your lights, but it is in the darks that you can use deep, saturated color.

The greens, as they come straight from the tube, are usually too cold. They require a bit of warming up with colors such as ochre, raw sienna, or the cadmium yellows and cadmium orange.

Repetition of colors or forms within a picture is effective only up to a certain point. After that it becomes monotony.

SKIES

Think more about the sky itself and less about paint.

For a busy, complex subject, keep the sky relatively flat. Think of it as background, not a whole picture in itself. If the sky is to be the most important part of the painting, however, then keep the foreground simple and uncluttered.

Paint the sky that is there. It sets both the key and the lighting for your painting. Become accustomed to studying skies and don't fall into the trap of painting all your skies alike. If you showed a group of your paintings together, it might look as though you knew how to paint only one sky, regardless of subject or locale.

I used to be amused by the old rule that some of the sky color should be repeated in the foreground, but I have discovered there is a reason for the rule: too many skies are a raw blue that separates itself from all the other areas in the painting. There must be some color echo that will bring them together. Skies don't always have to be pure blue, anyway.

Don't dash in the sky with verve and daring and then suddenly lose your nerve and settle down to treat the rest of the picture stiffly and timidly. Maintain that first

assurance right to the very end and handle the entire picture in a consistent spirit.

ROCKS

In painting rocks, don't panic and become confused. Study them calmly and consider them as sculpture, as volumes seen under a certain light source. Look for the light, middle, and dark values while analyzing the major planes; get those down first. Later you can include as many of the minor forms as you really need to project the idea of rock convincingly. Unnecessary detail breaks up the planes into too many fragments, and the feeling of solid mass is lost.

In too many paintings the rocks have the solidity of cotton-candy.

DESIGN AND COMPOSITION

Whether you are painting realistic or abstract art, you usually start out with a rectangle (paper or canvas), and then use nature to suggest how that rectangle may be divided up most interestingly.

Most beginning painters see all parts of the landscape and their picture with equal clarity and detail. It takes considerable experience to begin to see things in terms of masses, to sense where to use detail, and where and when to simplify and subordinate.

Contemplation—condensation—transformation—revelation.

Intense observation leads the painter toward his ultimate goal, which is comprehending and revealing essences.

I don't believe in the idea of a "focal point." There should not be a single point at which the eye must eventually arrive, a point around which the whole picture is constructed. I like to think of a painting as having a climax somewhere, an *area* where color, or perhaps a whole cluster of shapes, reaches some sort of culmination on the picture surface. But then, maybe that is just a matter of semantics.

PATTERN

Strong darks give your picture structure and drama. But don't forget those middle values; they are what tie your lightest lights and your darkest darks together. Without those middle tones your painting would be too jumpy with too much contrast.

If you lose control of your black-and-white pattern when you work in color, check on the picture by photographing it (in black-and-white) with a Polaroid camera. You can tell instantly how well your values are holding up. Or visualize to yourself how that painting might look if it were reproduced in a newspaper.

If you look at the shaded side of a building long enough, it will begin to appear lighter than it really is, much like coming indoors after being out in bright sunlight. Your eyes become accustomed to the darkness. So, instead of looking into the shadows, look at the sky next to that area and sense out of the corner of your eye how dark that shadow really is.

TECHNIQUE

Areas that are too flat or uneventful can be made more interesting by introducing variations of color, value changes and contrasts, or heavier paint textures.

Some people who work in oils or acrylics become lazy painters—they rely on being able to correct and repaint if something in the picture is not quite right. In the beginning, they aimlessly paint in any old color, planning to change it later. Why not try to be right the first time? You'll waste less paint and paint more pointedly right from the start.

When you apply color to paper or canvas, it will look strong and rich in the beginning stage, but as other areas are filled in, you may discover that the first color is not as rich as you thought, because now it no longer relates just to the white surface, but to several other colors. In watercolor, it's a good idea to brush in a few large, general areas and get rid of as much white paper as possible early in the game. And in oil or acrylic, it is good to start the painting on a high-keyed, toned surface, such as a wash of gray, ochre, or earth red.

Paint texture is not much more than surface ornament. Keep it in its place and use it with discretion as only one of the many elements involved in painting.

Avoid what I call "generalized" painting. Every stroke, every touch of the brush, should have a specific purpose and contribute to the whole.

Don't depend on "happy accidents," but do all you can to create situations which allow those accidents to happen.

Don't let the wet-in-wet watercolor technique make you nervous. It's not so much a technique as a state of mind.

If the viewer is too aware of your technique, it is like someone commenting on the fine quality of your framing—there must be something wrong. Technique should be subordinate to other things; it should not be too apparent.

Conquer technique, make it a part of you—and then forget it. There are far more important things to consider.

USING PHOTOGRAPHY

Some photographs are so beautiful they should be left alone, and not used as a source for paintings. They may

look most enticing as ideas for paintings, but the artist should accept the fact that the camera may have already made the statement far more beautifully or eloquently than any painter can. If you can't surpass it, leave it alone.

If you want to use a camera as an aid in painting, combine your photos with your on-location sketches of the same subject. Your sketches will show you what your eye really saw without distortions; the snapshot records the details. Between the two, you have your source material, but it is a mistake to depend solely on the photographic image.

If you use the camera really responsibly, you won't need to apologize for using one.

INTUITION

Trust your intuitions more. No need to find a reason for everything.

A painter cannot afford to be inflexible. Follow along with the picture even though it seems to be straying from your original plan. It may know where it is going better than you do.

Sometimes I jab in an accent of color or a dark just because I suddenly feel the picture requires it. It's an impulsive action. The mark doesn't necessarily refer to anything specific; but if the picture needs it, in it goes, logical or not.

In the creation of art, intuition and reason are two sides of the same coin.

Welcome your obsessions. Find your theme and dig into it deeply rather than skim over many surfaces.

Let the picture flow directly out of you without stopping to think too much. Save the tidying up until later.

INFLUENCES

There is no shame in looking to the masters—traditional or modern—for your influences. But see to it that you absorb only the timeless *principles* in their work, not surface effects or mannerisms.

I think we tend to be attracted most to those paintings which are in many ways unlike our own, something we wish we could have done. Those pictures that are too close to our own work have little appeal; probably we could have done them as well, or better.

The pictures you admire are not always the same ones that influence your work. There are many paintings, old and new, that I love very deeply, but they have absolutely no bearing on my own immediate artistic concerns. Enjoy as many different kinds of paintings as you can, but select your influences very carefully.

Forget what you and others have painted before; try to surprise yourself.

GENERAL REMARKS

Sheer labor will never replace inspiration. Ten minutes of sitting and thinking in front of your canvas are worth days of aimlessly pushing the brush around.

Don't distrust pictures that come easily—be grateful.

Say what you have to say in the picture, then get out. There is no need to chatter on after you have made your point.

Inevitability. The completed picture should look as if it had evolved with total naturalness, as if it could have been done no other way.

Self-indulgence is not the same thing as self-expression.

Finishing the painting does not mean killing it.

Paintings beget paintings. Each one leads to the next. The main thing is to get a momentum going.

Don't rely on travel to picturesque places to solve the shortcomings in your work. The problems involved in painting are exactly the same whether your studio is in Italy or Indiana.

Stand away from the picture and ask: would this picture really explain itself clearly to someone who had never seen the subject?

Leave a few imperfections in the painting. Don't correct everything to the degree that it is too perfect, too right. Be willing to let it look as though it had been done by a person, not a machine. Correct the important things but not the unimportant ones.

Make the picture look as though you really enjoyed painting it. I've seen pictures that looked as though they had been a dreary chore, as though the painter almost hated painting.

When in doubt, simplify.

The older I get, the longer it takes me to paint a picture. I know more than I used to, and I'm much harder to please.

The time it takes to do a painting is unimportant. I used to be able to do an excellent portrait head in one hour, but what, aside from facility, does that prove? These days I can spend weeks or months on a painting and then have to face the realization that it is an utter failure. The fact that it took all that time does not make it any better.

Make your gesture *be* the object you are representing.

I don't care how radically new you think your idea is, I can show you that someone else has done it before—two thousand years or two months ago—and probably did it better. Be you, not new.

The longer you work on a picture, the less it depends on

the actual subject and the more it takes on a life of its own.

Let your pictures tell you who you are.

Our paintings never come out as well as we visualize them beforehand. But probably that is what keeps us painting. It's the carrot in front of the donkey—maybe the *next* one will be better.

If you think an abstraction is easier to paint than a realistic picture, then we're all in trouble. A good abstraction is just as hard to paint, maybe harder, than a good realistic painting. Abstract art should not be used as an escape from discipline. Poor abstraction is just as bad as poor realism.

Sometimes what seems to be a mistake may turn out to be a clue to finishing a painting in a way that improves your original intentions.

Every so often take your painting out of the studio and into another room. Look at it in another environment, in a different light. Get a fresh slant on it.

If you feel the picture needs something, look out there in front of you and chances are you will find that vertical, that accent of color, or that dark note right there in the actual landscape. Maybe it is not in just the place you need it, but all the same it is there, and you won't have to invent something or fake it.

You will confuse yourself by listening to criticism of your painting from too many people. Select one or two persons whose taste and background in art you trust, and listen only to them. Regardless of what they tell you, it is *your* picture, and you are totally responsible for it. The final decisions are up to you.

Make it look as though you know what you are doing, even if you don't.

If you get a fresh idea while you are working on a painting, don't change horses in midstream and try to incorporate it in that painting. Finish the picture on its own terms, being consistent with the way you started. Save your new idea for the next painting. If you overload one picture with too many changes of attitude, it usually ends up having no attitude at all.

Don't search for a style. Let it come to you effortlessly on your part, as the inevitable outcome of how you see and how you feel.

Only the completely disciplined artist can paint freely. In the hands of undisciplined painters, freedom becomes sloppiness.

Be absolutely honest and natural; paint what you *must* paint, not what you imagine is expected of you. If you stick with that attitude, you are never on slippery ground You know where you stand as an artist, and so do other people.

Over the long haul in an art career, patience is the great secret.

BIBLIOGRAPHY

America 1976, Catalog of the Bicentennial Exhibition sponsored by the United States Department of the Interior. Hereward Lester Cooke Foundation, 1976.

Baur, John I. H. *Nature in Abstraction*. New York: The MacMillan Co., 1958.

Betts, Edward. *Master Class in Watercolor*. New York: Watson-Guptill Publications, 1975.

Brooks, Leonard. *Painting and Understanding Abstract Art*. New York: Reinhold Publishing Co., 1964.

Brooks, Leonard. *The Painter's Workshop*. New York: Van Nostrand-Reinhold, Publishing Corp., 1969.

Brommer, Gerald F. *Landscapes (Insights to Art Series)*. Worcester, Mass., Davis Publications, Inc., 1977.

Carpenter, James. *Color in Art*. Cambridge, Mass.: Fogg Art Museum, Harvard University, 1974.

Chaet, Bernard. *Artists at Work*. Cambridge, Mass.: Webb Books, Inc., 1960.

Cheney, Sheldon. *Expressionism in Art*. New York: Tudor Publishing Co., 1939.

Chipp, Herschel, ed. *Theories of Modern Art*. Berkeley and Los Angeles, University of California Press, 1969.

Clark, Kenneth. *Landscape Into Art*. Boston: Beacon Press, 1961.

Ehrenzweig, Anton. *The Hidden Order of Art*. Berkeley: University of California Press, 1971.

Forel, Oscar. *Hidden Art in Nature*. New York: Harper & Row, 1972.

Gonzalez, Xavier. *Notes About Painting*. Cleveland and New York: World Publishing Co., 1955.

Hale, Nathan Cabot. *Abstraction in Art and Nature*. New York: Watson-Guptill Publications, 1972.

Itten, Johannes. *The Art of Color*. New York: Van Nostrand-Reinhold Publishing Corp., 1973.

Kepes, Gyorgy. *The New Landscape*. Chicago: Paul Theobald and Co., 1956.

———*Sign, Image, Symbol*. New York: George Braziller, 1966.

Leepa, Allen. *The Challenge of Modern Art*. New York: Barnes-Perpetua Paperback, 1961.

Loran, Erle. *Cézanne's Composition*. Berkeley and Los Angeles: University of California Press, 1943.

Roszak, Theodore. "In Pursuit of an Image." *Quadrum No. 2*, November 1956, pages 49-60.

Watkins, C. Law. *The Language of Design*. Washington, D.C.: Phillips Memorial Gallery, 1946.

Wolberg, Lewis R. *Micro Art: Art Images in a Hidden World*. New York: Harry Abrams.

INDEX

Abstract-Expressionists, 35, 92
Airborne Camera, 18
Albers, Josef, 143
Allan, William, 52
Alla prima, 54
American "luminist painters," 40
Armory Show, Duchamp's painting exhibited at, 72
Arizona Highways, 9
Arp, Jean, 100
Art In America, 96
Art Nouveau, 68
Art of Color, The, by Johannes Itten, 143
Art Students League, New York, 56
Artist's Studio in an Afternoon Fog, The, 40
Ash Cove, 47
Auburn, 95
August Morning, 25
Autumn Red, 137
Autumnal Complexities, 19
Avery, Milton, 64, 66, 84

Bacon, Francis, 58
Beach Garden II, 101
Beach–Low Tide, 65
Beck, Margit, N.A., illus. by, 19
Bellows, George, 12, 40, 54, 90
Benton, Thomas Hart, 70
Bernard, Emile, 96
Beside a Mountain Stream, 125
Betts, Edward, N.A., A.W.S., illus. by, 83, 101, 113, 119
Betts, Jane, illus. by, 23
Bivalve, 97
Blackburn, Morris, 84, illus. by, 97
Blake, William, 58
Blue and Red Latitudes, 77
Bogaert, Bram, 88
Bogart, Richard, 54
Bolotowsky, Ilya, 96
Bonnard, Pierre, 30, 38, 40; quoted, 56, 78, 90
Boon Island, 81
Bosch, Hieronymus, 58
Boudin, Eugène, 10
Bowes, Betty M., A.W.S., 84, illus. by, 87, 120
Bradshaw, Glenn R., 92, 118
Braque, Georges, 36, 88
Break, 116
Brice, William, 86
Browne, Sir Thomas, quoted, 9
Bryden-Wills, Betty, illus. by, 69

Burchfield, Charles, 9, 22, 24, 40, 46, 70, 90
Button, John, illus. by, 45

Calcagno, Lawrence, 92
Campbell, Gretna, illus. by, 121
Canaletto, Antonio, 24
Cézanne, Paul, quoted, 8, 127; 12, 24, 54, 72, 90, 94, 96, 98, 104

Chadbourn, Alfred, N.A., illus. by, 85
Chase, Edward Merrit, 10
Chi, Chen, N.A., A.W.S., 76, illus. by, 27, 137
Chinese ink drawings, 54
Chirico, Giorgio de, 58
Christ-Janer, Albert, 54, illus. by, 107, 134
Circular paintings (tondi), 36
Cleft, 88
Color, accents of bright, 117; accents of high contrast, 121; categories, 138; control, 141; diffused, 133; flowing, 132; functions of, 139; glazes, 134; high key, 119; intensified, 122; invented, 130; as light, 131; low contrast, 120; low key, 118; masses, 124; mood, 126; mosaic, 123; muted, 116; notes, 144; palettes, 141-142; pattern, 125; primary, 113; reticence, 135; schemes, 140-141; as space: intentional reversal, 129; structural, 128; warm and cool, 127; shock, 137; single dominant: cool, 115, warm, 116
Colour Science, by Wilhelm Otswald, 142
Coming and Going Over the Footbridge, 73
Constable, John, 10, 12, 16, 22, 26, 52, 90, 104
Coiner, Charles, N.A. illus. by, 31
Corbett, Edward, 98
Corinthian Sails, 87
Corot, Jean Bapiste Camille, 10, 16
Cotman, John Sell, 64
Cows in Pasture, ref. to, 106
Crotty, Thomas, illus. by, 49, 95
Crown, Keith, 84
Cubism, 96, 97
Cubists, 18, 54, 72, 98

Dark Cliffs, 113
Dark Tide Zone, 17

Daumier, Honoré, 104
da Vinci, Leonardo, 100
Davis, Stuart, 62
Davies, A. B., 58
Dehn, Virgina, 78
Degas, Edgar, 40, 44, 72, 100, 138
De Kooning, Willem, 90, 92
Delaunay, Sonia, 36
Demuth, Charles, 20, 90
Design and composition in painting, 145
Dickinson, Preston, 20, 84
Didactic painting, 9
Diebenkorn, Richard, 38, 98, illus. by, 99
Dodd, Lamar, 84
Dodd, Lois, 28, 38, illus. by, 39
Dove, Arthur, 20, 86, 106
Downspout, 67
Duchamp, Marcel, 72
Dynamic symmetry, 12, 138

Eakins, Thomas, 90
Eilshemius, 58
Ensor, James, 58
Estes, Richard, 38
Etnier, Stephen, 44, illus. by, 47
Evening and the Morning, 109

Feininger, Lyonel, 84
Fog Horns, ref. to, 106
Forel, Oscar, 34, 78
Frankenthaler, Helen, 92, 102
Frieze of Dancers by Edgar Degas, ref. to, 72

Garver, Walter, illus. by, 25, 43
Gauguin, Paul, 16
Giotto, 64
Glimpse of the Sea, 23
Gorky, Arshille, 32, 90, 110
Gottlieb, Adolph, 92
Goya, Francisco, 58
Graves, Morris, quoted, 58
Green, Barbara L., 132
Green Landscape, 115
Green Passage, 31
Greene, Balcomb, 84, 86
Gussow, Alan, 78, illus. by, 79, 135

Hallam, Beverly, 89
Hals, Frans, 104
Hambridge, 138
Hartell, John, 54
Hartley, Marsden, 106

Hassam, Childe, 10
Hauled Out, 41
Hawthorne, Charles, 42, 124
Henri, Robert, 56
Hidden Art in Nature by Oscar Forel, 34, 78
High Barn, 124
Homer, Winslow, 9, 10, 16, 22, 26, 40
Hopper, Edward, 12, 20, 22, 38, 40, 42, 44, 90, 94
Hotel del Coronado, San Diego, California, 21
Hultberg, John, quoted, 58; illus. by, 59, 127
Hunterdon County, New Jersey, 120

Ice Cream Dream I, 51
Ice Glare, 40
Impressionists, 42, 44, 78
Influences, in painting, 146
Ink painting, 90
Inness, George, 10, 40
Interaction of color in painting, 143
Intuition, and painting, 146
Island Lilies II, 33
Island Movement through Fog, 105
Island to Horizon, 93
Jackson, Billy Morrow, 76, illus. by, 15
Japanese ink drawings, 54
Jenkins, Paul, 102, illus. by, 103

Kahn, Wolf, 124
Kaish, Morton, 78, illus. by, 123
Kantor, Morris, 70, 84, 86
Kelly, Ellsworth, 108
Kent, Rockwell, 12, 16, 54, 70
Kepes, Gyorgy, 78
Klimt, Gustav, 78
Kienbusch, William, 92, illus. by, 93, 105
Klee, Paul, 62, 104
Knaths, Carl, 143
Kokoschka, Oskar, 16, 90, 92

Landscape painting, and format, 11; and first decisions, 8; and medium, 11; and response, 9; and subject, 8
Landforms C-15, 107
Lane, Fitz Hugh, 26, 40
Laurent, John, 65, 81, 84, 115
Lawrence Tree, The, by Georgia O'Keefe, 20
Levi, Julian, 9
Life (magazine), 18
Looking Down, 69
Louis, Morris, 102
Luminism, 33
Lund, David, 57, 84, 128

Magafan, Ethel, N.A., A.W.S., 84, illus. by, 125
Margo, Boris, 102

Marin, John, 20, 84, 90, 106
Masaccio, 64
Matisse, Henri, 38, 64, 98; quoted, 68
Mazur, Michael, 30
Meeting of Two Poets, The, 23
Micro Art: Art Images in a Hidden World by Lewis R. Wolberg, 34, 79
Miró, Joan, 104
Mitchell, Joan, 92
Moller, Hans, 84, 122
Mondrian, Piet, 36, 42, 61, 98
Monet, Claude, 10, 30, 33, 40, 54, 72, 78, 92, 138
Monoliths, 35
Moreau, Gustave, 58
Moore, Henry, quoted, 9
Moore, Robert Eric, A.W.S., 84; illus. by, 29, 71
Morris, Carl, 35, 92, 111
Motherwell, Robert, 90
Muir Creek I, 131
Muybridge, Eadweard, 72

National Geographic, 18
Nature's Chasm, 117
New Landscape, The, by Gyorgy Kepes, 78
Newhall, Beaumont, 18
New Moon Tide, 121
Nicolaides, Kimon, 56
Northern Spaces, 83
Nude Descending a Staircase, ref. to, 72

Ocean Park #34, 99
O'Keeffe, Georgia, 9, 20, 26, 64, 66, 70, 90, 100
Old Woman Paring Her Nails, ref. to, 40
Olitski, Jules, 88
Oriental painters and painting, 26, 28, 68
Ostwald, Carl, 142, 143
Ostwald Colour Album, The, 142

Painter's Palette, The by Denman Ross, 143
Palm Beach Harbor, 37
Palmer, William, N.A., 84, 126
Pattern in painting, 145
Pearlstein, Philip, 44
Peterdi, Gabor, 78
Phenomena Traces of the Tide, 103
Phipps, Richard, 84, 91, 117
Photography, aerial, 18-19; for compositional reference, 44; and distortion, 20; and painting, 145-146; and reflections, 38
Photomicrographs, 34, 78
Picasso, Pablo, 36, 88
Pines Against the Sea, 122
Piranesi, 24, 58
Pissarro, Camille, 78

Pollock, Jackson, 104
Porter, Fairfield, 44
Post-Impressionists, 44, 78
Poussin, Nicolas, 94
Pressly, Thomas, illus. by, 67
Promontory, 128
Pre-Renaissance art, 68

Raffael, Joseph, illus. by, 33, 78, 131
Raga on a Foggy Coastal Morning, 135
Raindrops: Life: Tears, 132
Red Cloud, 53
Redon, Odilon, 58
Reflection: Light and Sound, 55
Rembrandt, 40
Renaissance painting, 16, 62
Renoir, Auguste, 104
Rich, Daniel Cotton, 94
Road to Royal, 15
Roberts, Kenneth, 81
Rocks, in painting, 145
Rock Garden, The, 79
Romanticism, 33
Rooftops: Red Warehouse #8, 45
Rosenblum, Robert, 45
Ross, Denman, 143
Rounding Point Loma, 91
Rowan, Dennis, illus. by, 51
Ryder, Albert Pinkham, 58

Sargent, John Singer, 8, 22, 90
Sea Path Ischia III, 123
Seurat, Georges, 78, 90, 94, 104
Seurat and the Evolution of La Grande Jatte, by Daniel Catton Rich, 94
Schoener, John, 84, 114
Schrag, Karl, 130
Schueler, Jon, 52, 54, illus. by, 55
Shadows of Morning, 63
Shed #1, 61
Sheeler, Charles, 20, 62, 84, 106
Simpson, David, illus. by, 77
Siskind, Aaron, 34
Sisley, Alfred, 78
Skies, in painting, 144
Skies of Monhegan, The, 52
Skyforms W-39, 134
Snelgrove, Walter, quoted, 58
Snow Man, 13, 22
Soft Day–Connemara, A, 126
Solomon, Hyde, 52, 76, 78, 92; illus. by, 53, 133
Solomon, Syd, 92, 98, 116
Solstice, 57
Soulages, Pierre, 104
Soutine, Chaim, 82
Spencer, Niles, 62, 84
Spring's Slow Explosion, 59
Spruce, Everett, 84
Stella, Joseph, 20
Stieglitz, Alfred, 106
Suiseki, 34

151

Sumi ink washes, 97
Summer–Apple Tree and Yellow House, 130
Summer at Salter's Island, 114
Summerscape II, 119
Sunday Afternoon on the Island of "La Grande Jatte," 94
Sunset Haze, 133
Surfdoom, 127
Surrealists, 100

Tam, Ruben, 72, 84; illus. by, 17
Tàpies, Antoni, 88
Technique, in painting, 145
Thelin, Valfred, A.W.S., illus. by, 37
Thieme, Anthony, 40
Third New International Dictionary, 143
Tidal Marsh, 75
Tide In, 71
Trio of Windbirds, 29
Tripetti, Corinne, illus. by, 73
Tobey, Mark, 58, 78, 104
Tondi, 36
Tondo, 36
Turner, J.M.W., 10, 22, 40, 52, 54, 90
Twachtman, John, 54

Van Gogh, Vincent, 16
Velardi, Ernest Jr., illus. by, 109
Viaducts, 43
Vickery, Robert, 22; illus. by, 13
View of Kennebunkport, 85
Vuillard, Edouard, 38, 78

Wagemaker, Jaap, 88
Webster, Larry, A.N.A., A.W.S., illus. by, 61
Welliver, Neil, 30
Wequasset, 129
Weston, Edward, 34
Whistler, James McNeill, 16, 54
White Patio with Red Door, 66
Whitney Museum of Art, New York, 40
Wind Path, 11
Window Landscape, 39
Winter, 27
Wolberg, Lewis R., 34, 78
Wolf's Neck, 49
Women Combing Their Hair, 72
Wood, Grant, 70
Wyeth, Andrew, 9, 12, 16, 24, 38, 40, 44, 72, 90

Zimmerman, Paul, N.A., 63, 75, 76, 84, 129

Edited by Connie Buckley
Designed by Bob Fillie